I MUST STUDY POLITICS AND WAR THAT MY SONS
MAY HAVE LIBERTY TO STUDY MATHEMATICS AND
PHILOSOPHY, GEOGRAPHY, NATURAL HISTORY, NAVAL
ARCHITECTURE, COMMERCE, AND AGRICULTURE, IN
ORDER TO GIVE THEIR CHILDREN A RIGHT TO STUDY
PAINTING, POETRY, MUSIC, ARCHITECTURE,
STATUARY, TAPESTRY, AND PORCELAIN.

JOHN ADAMS
SECOND UNITED STATES PRESIDENT
1735–1826

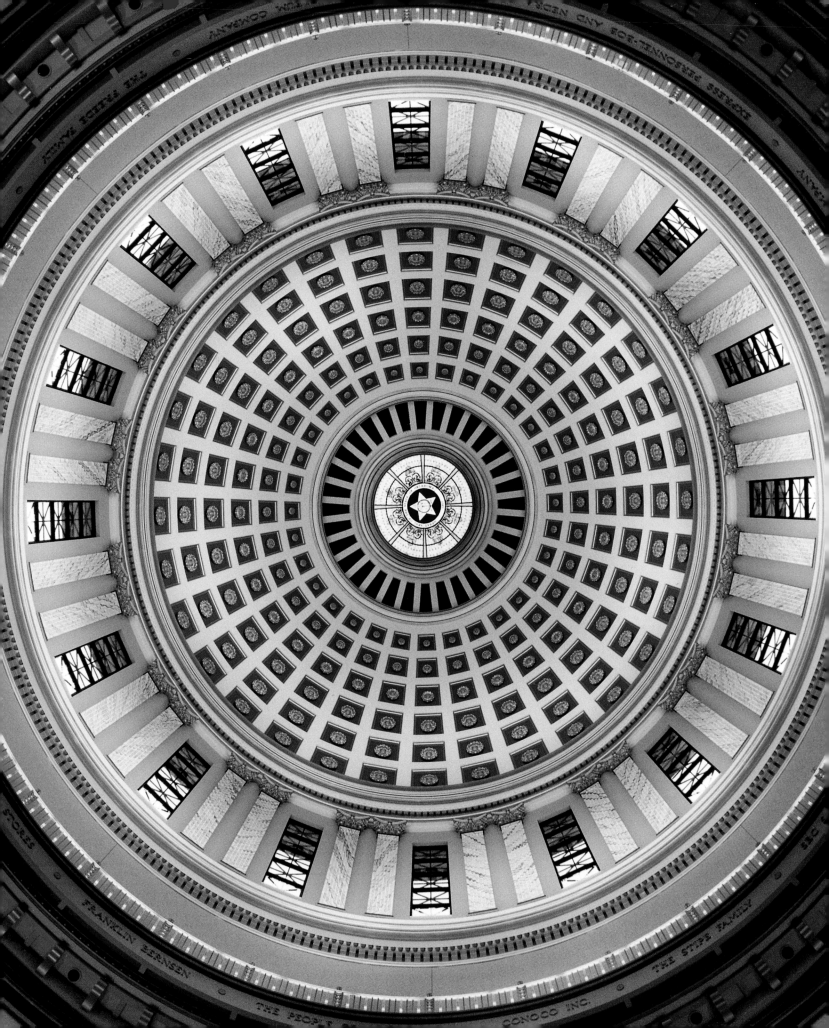

ART
TREASURES
OF THE OKLAHOMA STATE CAPITOL

BY BOB BURKE, BETTY CROW, AND SANDY MEYERS

FOREWORD BY GOVERNOR BRAD HENRY

*To: Pat Jestin
Thanks for all your
work for Tulsa
Enjoy
Sen. Charles Ford
1/2006*

A PUBLICATION OF THE OKLAHOMA STATE SENATE HISTORICAL PRESERVATION FUND, INC.

OKLAHOMA CITY, OKLAHOMA

AN OKLAHOMA CENTENNIAL PROJECT

Printed in China

Published by the Oklahoma State Senate Historical Preservation Fund, Inc.
in cooperation with the Oklahoma Arts Council,
the Oklahoma Heritage Association, and Friends of the Capitol, Inc.

OKLAHOMA STATE SENATE HISTORICAL PRESERVATION FUND, INC.
Senator Charles R. Ford, President

OKLAHOMA ARTS COUNCIL
Pat Evans, Chair

FRIENDS OF THE CAPITOL, INC.
Paul B. Meyer, President

OKLAHOMA HERITAGE ASSOCIATION
Clayton I. Bennett, Chairman

International Standard Book Number 1-885596-34-0
Library of Congress Catalog Number 2003109631

DESIGN, EDITORIAL, OVERALL PRODUCTION: CAROL HARALSON, *Carol Haralson Design*
EDITORS, OKLAHOMA HERITAGE ASSOCIATION: GINI MOORE CAMPBELL, ERIC DABNEY

PAGE SIX: Detail, *Theodore Roosevelt Signing Proclamation,* by Mike Wimmer

PAGE EIGHT: Detail, *Discovery and Exploration,* by Charles Banks Wilson

THE ENDSHEETS of this book feature an original blueprint of the Grand Staircase of the Oklahoma State Capitol prepared by the architectural firm of Solomon Layton and S. Wemyss Smith. Courtesy Meyer Architects.

THE FRONTISPIECE shows the interior of the Oklahoma State Capitol dome (this image also appears on section divider pages throughout the book). The Great Seal of the State of Oklahoma, centered in a brilliant stained glass skylight, is the artistic creation of Triffo's Glass Arts, Oklahoma City. Jim Triffo and Pat Woods hand-cut over 9,000 individual pieces of glass for the skylight, which was then leaded together with more than a mile of lead came. The skylight is over twenty-three feet wide and weighs 1,710 pounds. The stained glass state seal centered within it is just over six and one-half feet in diameter and hangs the equivalent of nineteen stories above the first floor's mosaic state seal. Triffo has created or restored stained and etched glass throughout the capitol, including the vast skylights in the Senate and House of Representatives chambers.

PUBLICATION OF *ART TREASURES OF THE OKLAHOMA STATE CAPITOL*

WAS MADE POSSIBLE THROUGH CONTRIBUTIONS FROM

BANCFIRST

HOWARD AND BILLIE BARNETT

G.T. AND LIBBY BLANKENSHIP

JOSEPH E. AND PATTY CAPPY

JOANNA CHAMPLIN

TOM AND HILLARY CLARK

DOLESE FOUNDATION

WALT AND PEGGY HELMERICH

WILL K. AND VI JONES

FRANK AND CATHY KEATING

THE KIWI CLUB OF OKLAHOMA CITY

CAROL LACKEY

ROBERT AND ROXANA LORTON

ROB AND BARBARA MCCUNE

MELVIN AND JASMINE MORAN

SANDY AND STEWART MEYERS

JACK H. AND MARGARET M. NEELEY

JACKIE POE

NORRIS PRICE FAMILY

HENRY AND JANE PRIMEAUX

JON STUART

JEAN MARIE WARREN

MOLLIE WILLIFORD

ANNE AND HENRY ZARROW
 FOUNDATION

MAXINE AND JACK ZARROW FAMILY
 FOUNDATION

JACK AND JAN ZINK

ANN ALSPAUGH

CHESAPEAKE ENERGY CORPORATION

MEGAN CLEMENT

PAT EVANS

FRANKFURT-SHORT-BRUZA

LINDA AND MARC FRAZIER

HOWELL GALLERY

WEDNESDAY REVIEW CLUB

JIM MEADE

MR. AND MRS. RICHARD RATCLIFFE

MARILYN TORBETT COMPANY

MR. AND MRS. RAY H. SIEGFRIED III

IRA SCHLEZINGER

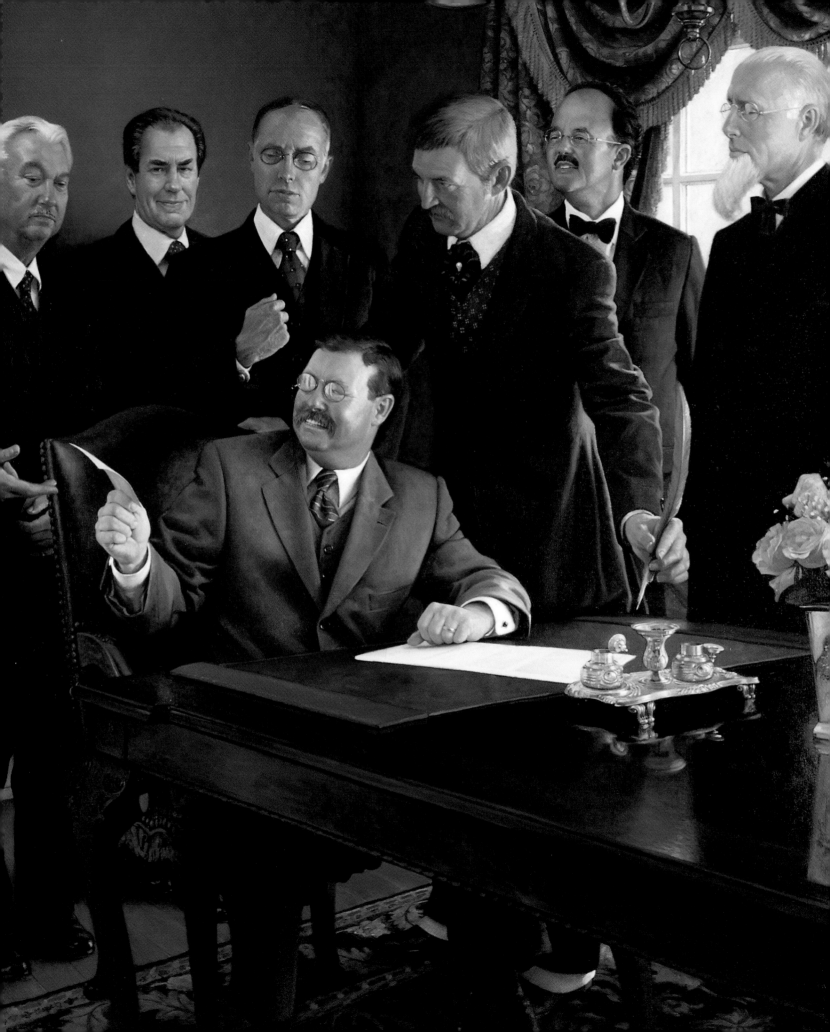

CONTENTS

ACKNOWLEDGMENTS

WE ARE THANKFUL TO MANY PEOPLE for making this book possible. From the conception of this project, we believed that to convey the complete story of the art treasures of the state capitol, we needed information about the artists, their approach to their commissions, and the importance of the works of art. There is a special story behind each of the more than 100 works of art that adorns our capitol.

The artists who remain alive were especially generous in granting interviews. Charles Banks Wilson, Wilson Hurley, Enoch Kelly Haney, Joan Marron LaRue, Mitsuno Ishil Reedy, Mike Larsen, Jean Richardson, Gary and Marrilyn Adams, Jeff Dodd, Mike Wimmer, Harold T. Holden, Ross Myers, R.T. Foster, Sandra Van Zandt, Jo Saylors, Wayne Cooper, Kathryn Richardson, and Barbara Vaupel provided information about their paintings or sculptures.

We are also grateful to Suzanne Tate, deputy director; Karen Sharp, visual arts director; Scott Cowan, capitol galleries curator; and Margie Stephens, executive secretary, at the Oklahoma Arts Council; Dr. Mary Jo Watson, curator at the Fred Jones Jr. Museum of Art; Ken Meek, curator at Woolaroc Art Museum; Lou Kerr, chair of the Capitol Preservation Commision; Windy Mahsetky-Poolaw at the Oklahoma City Museum of Art; Pam Hodges in Senator Charles Ford's office; Charles E. Rand and M. J. Van Deventer at the National Cowboy and Western Heritage Museum; Joan Gilmore, journalist; research librarian Pat Lowe at the Will Rogers Memorial; Suzanne Silvester at the Melton Art Reference Library; Gary Heerwald at the Oklahoma Department of Central Services; George Humphreys, house staff; and Betty Casey, senate staff.

Also, thanks to Jim Tolbert at the Full Circle Bookstore in Oklahoma City; Oklahoma Supreme Court clerk Gregg Albert; Marilyn Jacobs, Susan Gilley, and Judith Clark at the Jan Eric Cartwright Library; attorney general Drew Edmondson; Kathy Jekel at the Oklahoma Secretary of State's office; Darcus Smith, Deanna Biddle, Barbara Namminga, and Barbara Johnson at the Belle Isle Library in Oklahoma City; Sue Hall; Ann Meeks; Robert Burke; and special production assistants Stephanie Graves Ayala and Eric Dabney.

Also extremely helpful were capitol architect Paul Meyer, secretary of transportation Herschal Crow; the staff of Governor Frank Keating and Governor Brad Henry; executive director J. Blake Wade and administrative officer Georgiana Rymer of the Oklahoma Centennial Commission; Kitty Pittman at the Oklahoma Department of Libraries; and Mary Ann Blochowiak, Rodger Harris, and Sandy Smith at the Oklahoma Historical Society.

Bob Burke, Betty Crow, Sandy Meyers

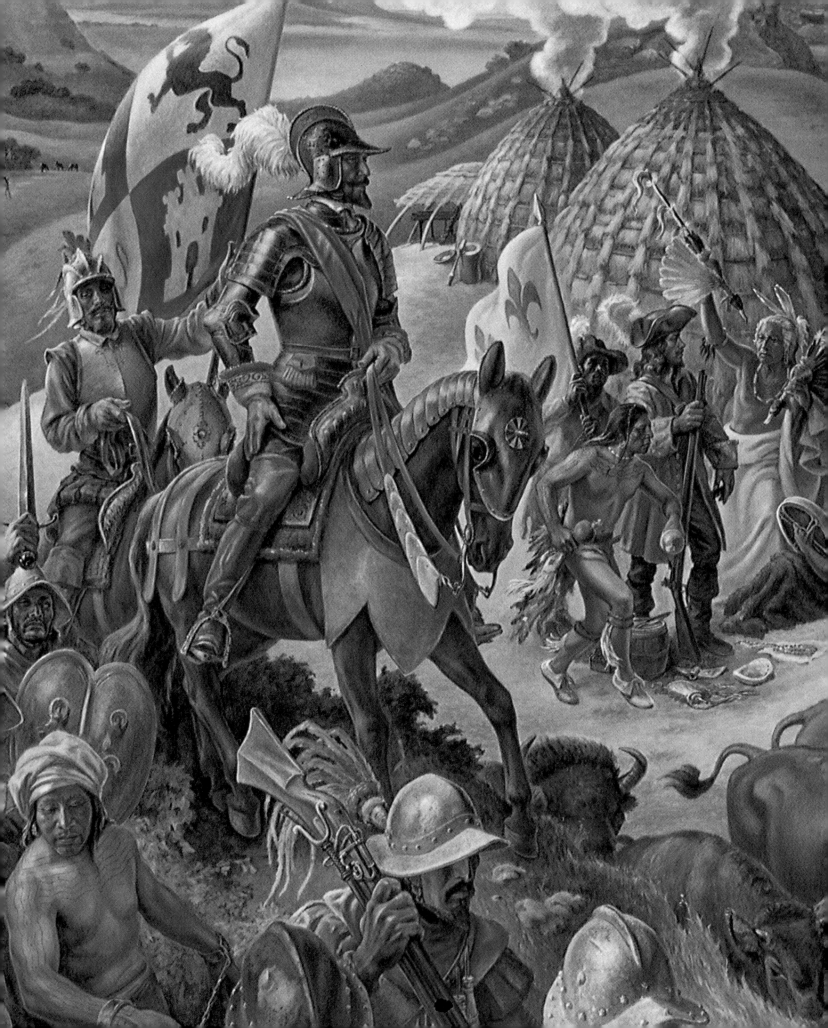

WALKING THROUGH OUR NEWLY-DOMED ROTUNDA and through the halls and corridors of the capitol now reveals not only the machinery of government, but major works of art. Murals, landscapes, portraits, and sculptures tell the history of an ancient place, but a young and vibrant state.

All the fine arts have been part of the Oklahoma experience for a very long time. Exquisite artifacts from the Spiro Mounds tell of Native American genius in sculpture, pottery, and jewelry. Plains Indians painted remarkable drawings on ledger book pages provided by traders and soldiers. Those ledger drawings gave way to the Six Kiowas, and then to an abundance of American Indian paintings rich in history and symbolism. Modern artists have taken their rightful place alongside the best in America in every media imaginable.

Oklahoma's great diversity in human talent is magnificently represented in the works of art that adorn our state capitol. Visitors will meet world-renowned ballerinas, soldiers, citizens, leaders from many American Indian nations, larger-than-life statesmen, authors, historians, judges, oilfield workers, farmers, ranchers, inventors, actors, business leaders, and newspapermen. Perhaps no other state can claim such diversity in its culture, its people, and its history.

GOVERNOR BRAD AND FIRST
LADY KIM HENRY

The art tells our story. Oklahoma Kiowa poet N. Scott Momaday wrote that the Indians came first, "From the North, where silence lies/There came the people with dogs/Long ago, when dogs could talk . . . " Then, after the Indian migrations, "Others came upon the rolling plains/They bore books and learning/They bore the Word of God/They bore the machinery of nationhood . . ."

The search for oil, the proud agricultural tradition, the sacrifice of Oklahoma soldiers, and the nearly forgotten contributions of social reformers and frontier tradesmen are pictured. Our history is laid out on canvas—the Indian migrations, the signing of the Louisiana Purchase, and the presidential proclamation of Oklahoma as the forty-sixth star in our nation's flag.

From Coronado, our first western tourist, to Jim Thorpe, perhaps the world's greatest athlete, the people that are Oklahoma are remembered in paint, canvas, bronze, and stone. "We know we belong to the land," are not just the words of Rodgers and Hammerstein's "Oklahoma!"—now our state song. They are a part of our history on display in the art of this historic capitol.

I am proud of Oklahoma, and grateful for the contributions of many who have worked tirelessly to make certain that Oklahoma's seat of government is enriched by the art of our finest painters and sculptors. Kim and I strongly support efforts to maintain and enhance this tradition.

Brad Henry, Governor of Oklahoma

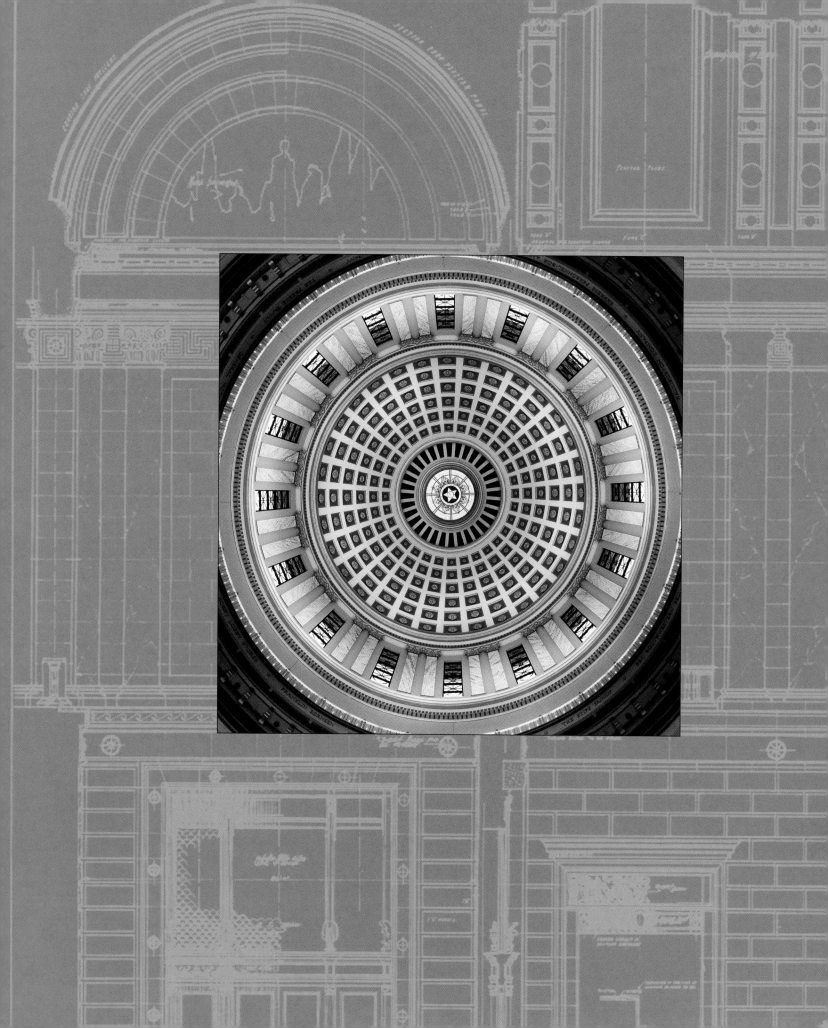

THE CAPITOL BUILDING

ADORNING THE CAPITOL:
THE ROLE OF THE OKLAHOMA
ARTS COUNCIL

A *vision* FOR OKLAHOMA

THE MURALS

THE SCULPTURE

CENTENNIAL MEMORIAL PLAZA

1

Oklahoma's seat of government was housed in borrowed buildings for the first few years following statehood in 1907. Guthrie was the state capital until a statewide election in 1910 officially passed that honor to Oklahoma City. Governor Charles Haskell appointed a capital planning commission to facilitate the transition. Members of the commission were Tate Brady of Tulsa, chairman, future governor J.B.A. Robertson of Chandler, and Dr. Leo Bennett of Muskogee, whose wife had been the Indian Territory "bride" in the mock wedding of the two territories on the steps of the Carnegie Library in Guthrie at statehood.

Planning began almost immediately to construct a building that would house state officials, the legislature, and the highest courts in the state. Two noted Oklahoma City business leaders—developer and state representative I. M. Putnam and street car system owner John W. Shartel—offered the state 1,600 acres of land and $1.7 million cash to locate the capitol in far northwest Oklahoma City, the area that would later become Putnam City. The Oklahoma House of Representatives liked the Putnam-Shartel offer. However, the state senate and a local committee of Oklahoma City civic leaders, Charles Colcord, C.G. Jones, Edgar S. Vaught, and Edward K. Gaylord, recommended what they felt was a better site for the capitol at Northeast Twenty-third Street and Lincoln Boulevard on a wind-swept parcel of prairie. The Twenty-third Street land, to be donated by J. J. Culbertson and William F. Harn, was perched on a hill from which one could see much of the

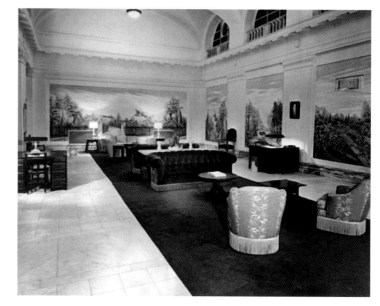

A 1943 PHOTOGRAPH SHOWS EARLY ATTEMPTS TO DECORATE THE WALLS OF THE CAPITOL IN A LOUNGE AREA.

A VISION FOR OKLAHOMA

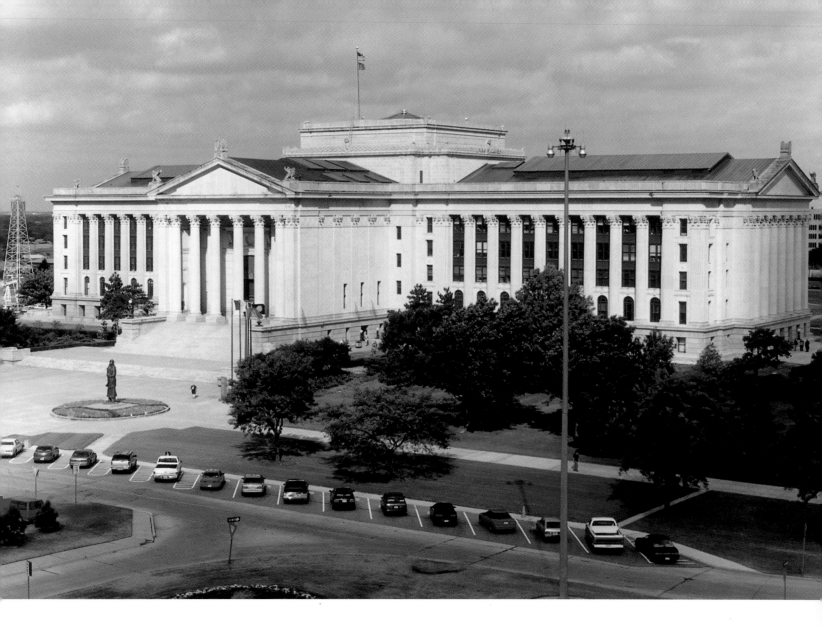

FOR EIGHTY-FIVE YEARS, THE
OKLAHOMA STATE CAPITOL
WAS DOMELESS.

capital city. The location was affirmed at a mass meeting on December 11, 1910, at which twenty-five businessmen signed bonds for $5,000 each to guarantee the state a "free" capitol. The deciding issue was that a capitol on Twenty-third Street was only seven minutes from the downtown area while a capitol at the alternative location on the Interurban line would be a thirty-minute street car ride away.

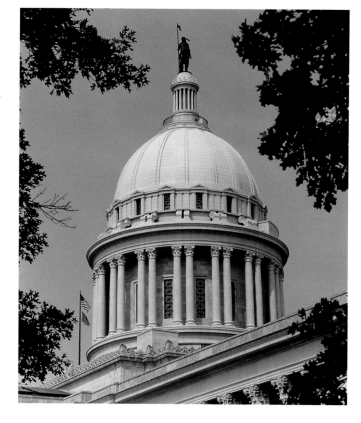

The architectural firm of Solomon Layton and S. Wemyss Smith was chosen to design the capitol. As a visionary lead architect, Layton conceived his plans in the Greco-Roman or neoclassical architectural style. Ground was broken on July 20, 1914, just two days after money for the building became available. After a period during which the state government hired day laborers to work on the building, the Stewart Construction Company was hired to complete it on a budget of $1.515 million, or about seventeen cents per square foot. Governor Robert L. Williams tapped the cornerstone into place on the capitol's northwest side on Statehood Day, November 16, 1915. The four-ton granite stone is from Tishomingo, Oklahoma, and holds fifty historical items from 1915, including a silver teaspoon presented by members of the Masonic Lodge in McAlester and copies of the previous day's editions of several Oklahoma newspapers. Presiding over the Masonic ceremony at the laying of the cornerstone was Grand Master A. E. Monroney, the father of later United States senator Mike Monroney. Governor Williams, who was in constant touch with the construction superintendent, paid close personal attention to the project. He believed the capitol should have only three floors, so as not to be too pretentious. Architects and construction foremen worked together to add a basement and two mezzanines, granting the governor his wish, and everyone was happy. Governor Williams moved into the capitol on the first day of 1917, six months before the building was completed. The Sixth Legislature convened in the unfinished building the following day. On June 30, the state officially occupied the building.

The exterior of the capitol is made of Indiana limestone complemented by pink granite quarried near the southern Oklahoma town of Troy. Floors throughout the building are made of Alabama marble. Vermont marble was used for the wall bases and stairways. The outside steps and tables along the Grand Staircase are made from the black granite of Cold Springs, Oklahoma. The capitol covers nearly eleven acres of floor space; it has thirty-three vaults and 650 rooms. Eight winged lions, symbolic of dignity and victory, were placed on the building's roof. Stately Corinthian columns surround the building, and thirty-four massive steps stretching across its breadth lead visitors to the second story of the south entrance.

THE NEW STATE CAPITOL DOME DOMINATES THE LANDSCAPE IN NORTHEAST OKLAHOMA CITY. THE DOME AND ITS CROWNING FIGURE, *THE GUARDIAN*, CAN BE SEEN FROM MILES AROUND.

FACING: FINE ART AND ARCHITECTURE ARE COMBINED AT THE STATE CAPITOL.

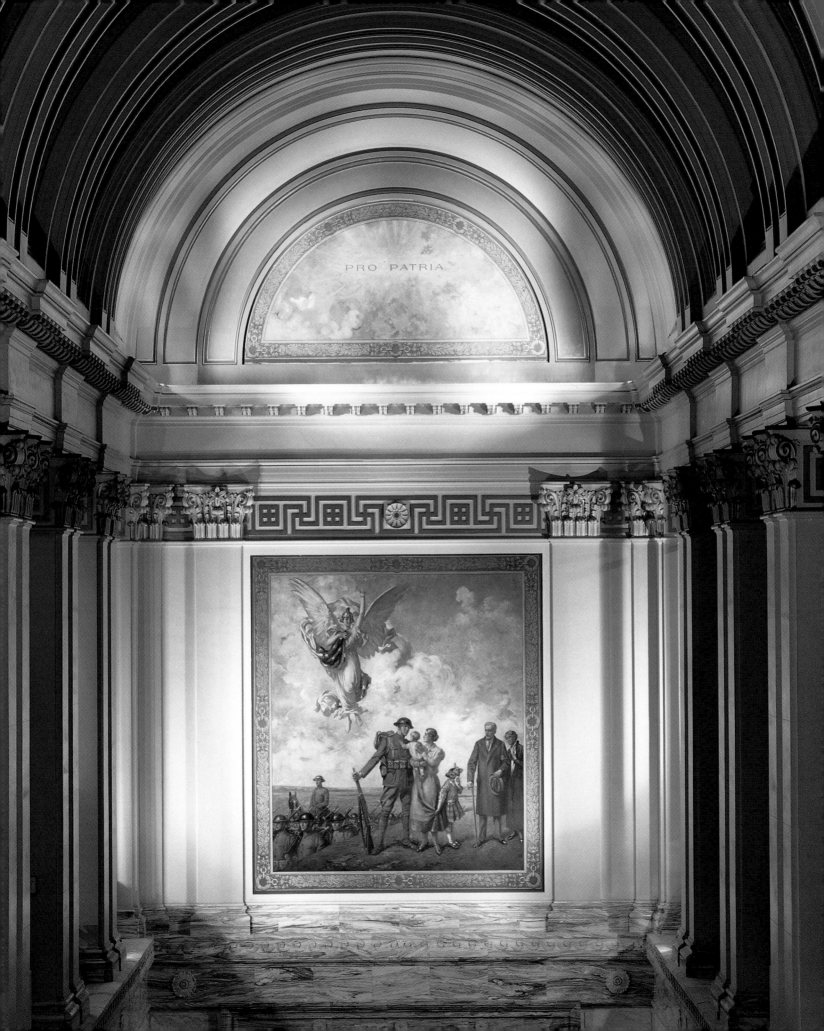

Layton originally designed the capitol with a dome. However, funding problems resulting from shortages of iron during World War I caused the legislature to scrap the plan, leaving the capitol ceiling looking unfinished. To address this problem, a concrete saucer structure was added, creating the appearance of a shallow dome from the interior. The Oklahoma State Capitol was one of only two capitol buildings constructed to have domes but which did not have domes attached initially. The other was the United States Capitol in Washington, D.C. President Abraham Lincoln refused to stop construction on the dome on the U. S. Capitol during the Civil War as a statement that the Union would prevail.

Over the years, Oklahomans thought of adding a dome or some structure that rose above the saucer dome. In 1926, the State Board of Affairs proposed building a tower rather than a dome. The square tower would have risen eight stories above the capitol to provide additional office space for growing state agencies. The legislature turned thumbs down on the office tower idea. Eight years later, in 1934, the state seal of Oklahoma was inlaid in the ceiling, although the plaster seal contained many mistakes.

Governor Henry Bellmon worked with the Oklahoma City architectural firm of Frankfurt-Short-Bruza in the mid 1960s on a dome proposal which never got off the ground. Other plans for a dome fell by the wayside, although Carol Gwin of Oklahoma City began a grassroots effort in 1988 to raise money to build a dome. A decade later, Frankfurt-Short-Bruza completed a feasibility study on a dome at the request of the Oklahoma Department of Central Services. Fred Schmidt was the lead architect on the design team.

In 1999, the Oklahoma Capitol Complex and Centennial Commemoration Commission was organized with J. Blake Wade as executive director, and fund raising for the capitol dome began. In April, 2001, Capitol Dome Builders, a joint venture involving Manhattan Construction Company and Flintco Inc., began work on the project. Governor Frank Keating was the driving force behind efforts in the closing years of the 20th century to add the dome to the capitol. His tireless devotion to the project made it happen. The dome was completed in the fall of 2002 and was officially dedicated on November 16, 2002, in an elaborate ceremony. The cost of the dome, $20.8 million, came primarily from private donations. Major donors included Phillips Petroleum Company, the Donald W. Reynolds Foundation, Herman and LaDonna Meinders of Oklahoma City, SBC Southwestern Bell, the Grace and Franklin Bernsen Foundation, Conoco, Inc., Bob and Nedra Funk of Piedmont, the Freede family of Oklahoma City, Halliburton Company, General Motors, Hobby Lobby Stores, and the Stipe family of McAlester.

Finally, Oklahoma's state capitol was adorned with a dome—just as architect Solomon Layton had envisioned it as he labored over his drawings eighty-seven years before.

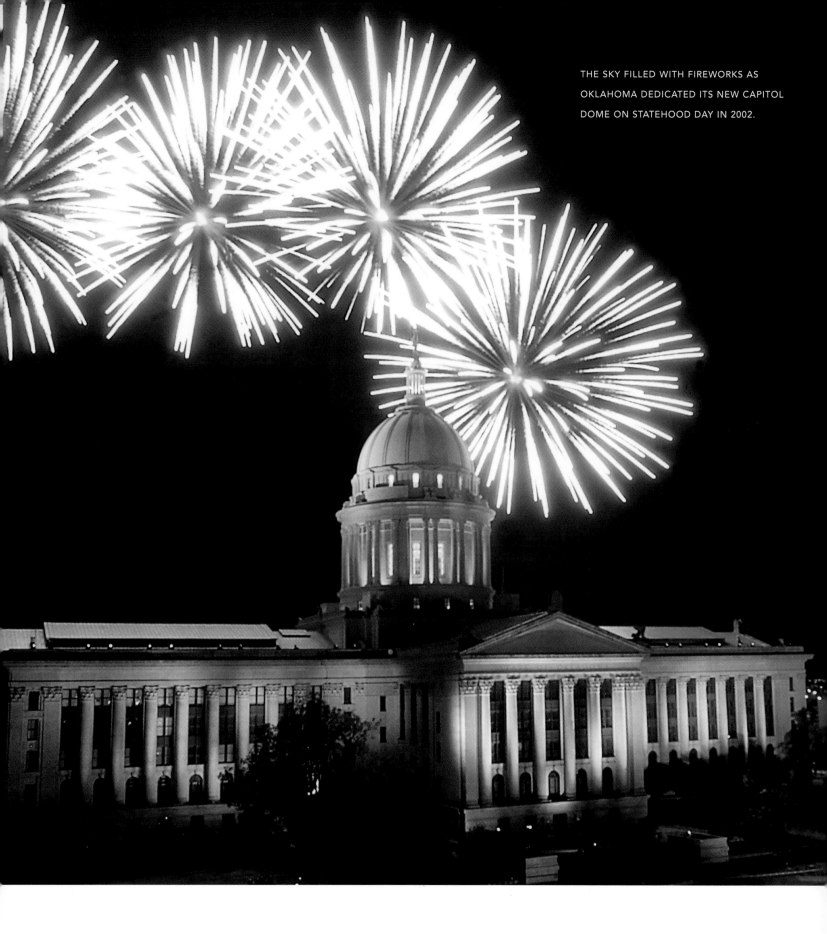

THE SKY FILLED WITH FIREWORKS AS
OKLAHOMA DEDICATED ITS NEW CAPITOL
DOME ON STATEHOOD DAY IN 2002.

A VISION FOR OKLAHOMA

When Henry Bellmon became governor of Oklahoma in 1963, it had been more than thirty years since any work of art had been permanently placed in the state capitol. Indeed, the capitol had little art—only a few portraits in a courtroom and the panels of the Pro Patria mural. Bellmon appreciated art and recognized that cultural development was needed to continue the progress Oklahoma had made. He appointed an advisory panel— the Governor's Council for Cultural Development—to advise government on how to complete the interior design of the capitol and to increase the awareness of Oklahomans about their cultural past. Oklahoma City arts leader Dannie Bea Hightower chaired this panel, which listed as its primary objective "to study, plan, advise, and recommend programs that will further the arts in the State."

BETTY PRICE, EXECUTIVE
DIRECTOR OF THE
OKLAHOMA ARTS
COUNCIL.

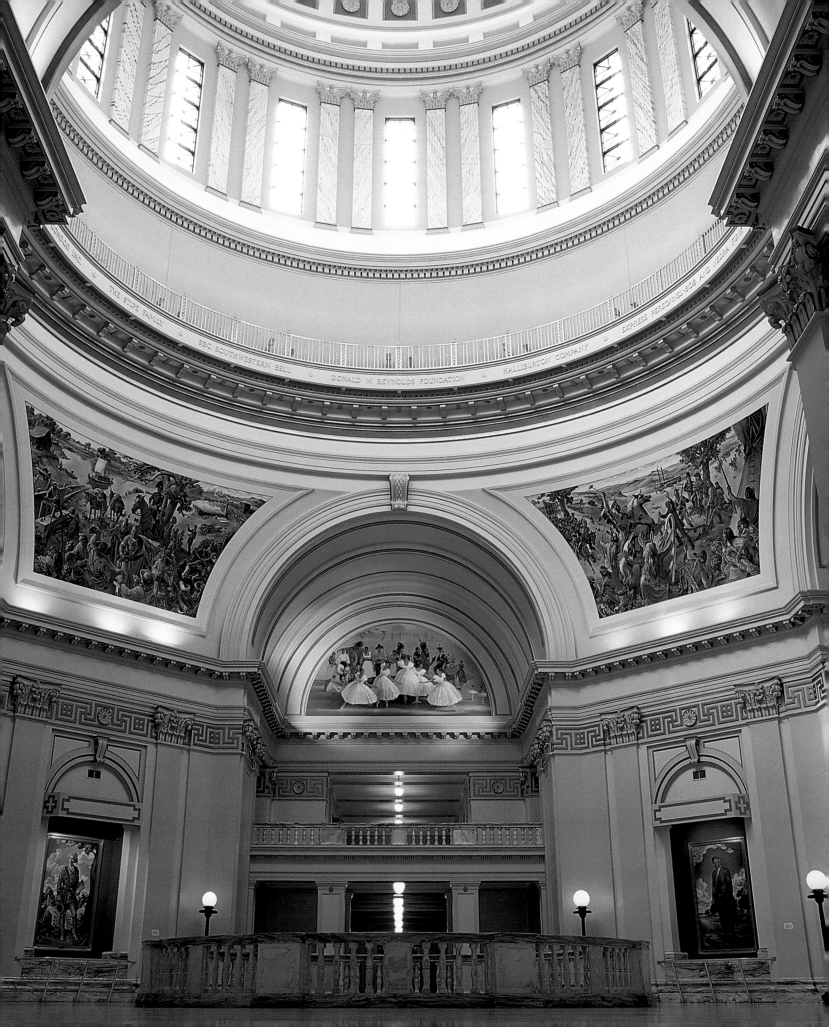

Bellmon pledged support for any effort to use cultural development to improve the national image of Oklahoma and even provided the first funding support through his office. At the national level, Congress had passed legislation creating the National Endowment for the Arts, making available federal arts funding to states that created state arts agencies and provided state funds to match the federal dollars.

In 1965, the Oklahoma Arts and Humanities Council was created through legislation authored by state senator Denzil Garrison of Bartlesville and state representative Ruth Patterson of Logan County. Governor Bellmon signed the bill into law and appointed a fifteen-member council, whose members required state senate confirmation. Dannie Bea Hightower became chairman, and the group hired its first executive director, Curt Schwartz. Council appointments were established for a three-year term, and a member could be reappointed for one additional term. Appointees were intended to be individuals with a real and active interest in the arts who would provide equitable geographical representation so that no part of the state lacked a voice on the council. Serving without salary, they would meet throughout the year to set policies for arts and arts education programs and to distribute matching grants, which were funded solely with Arts Endowment dollars in the early years.

As the Oklahoma Arts and Humanities Council was beginning its work in the 1960s, a talented young woman trained as an artist and musician, Betty Price, came to Oklahoma's capitol. She taught music in the public schools until Senator John Garrett asked her to come to work for him. A native of Muskogee, Oklahoma, she had fallen in love with the capitol on a high school field trip. She was impressed with this building, the largest she'd ever seen at that time, and doubly impressed with its spacious chambers, marble staircases, and the Great Rotunda. But even at that young age, she realized the building lacked color and vibrancy, qualities she invested in her paintings.

Like most senate offices, Senator Garrett's lacked art, and Price was asked to bring her work to enliven it. Other Oklahoma artists joined her in loaning paintings for display in legislative offices. With her boundless energy and artistic talents, Price exuded an enthusiasm for the arts that became contagious. She joined forces with the Oklahoma Arts and Humanities Council to help convince the legislature that more needed to be done to support the arts in the state. She was asked to work for the council as its public information director, later as its assistant director and, in 1983, as its executive director. Price was the first woman to hold the position. She followed five men who had directed the agency since its inception—Schwartz, Dr. Donald W. Dillon, William McKenzie Andres, Bill Jamison, and Benedict J. DiSalvo. Price and the early directors worked with prominent citizens such as Katie Westby of Tulsa, John Kirkpatrick of Oklahoma City, Martha Griffin of Muskogee, and Carol Daube Sutton of Ardmore, who as council members became active supporters of programs to promote the appreciation of the arts in all sections of the state. They also began to think about art that should hang in "The People's Capitol."

Early on, Betty Price had blended history and art for exhibits in the capitol. Lieutenant Governor George Nigh had asked her to research and paint the state emblems—the state

flower, flag, song, and others—which most people knew little about, for a display outside his office. Guides used it as an educational tool for thousands of visitors, especially school children, who came to the capitol each year.

When David Boren was elected governor in 1974, Price was invited to be a member of his inaugural committee because of his wish to have the arts as an inaugural theme. She helped organize a spectacular Evening of the Arts that included ballet, opera, symphonic music, and statewide entertainment on both stages of Oklahoma Theatre Center the night before the inauguration. Boren's inaugural balls included nationally known entertainers Hoyt Axton, who was Boren's cousin, and his friend Arlo Guthrie. Boren asked Price to

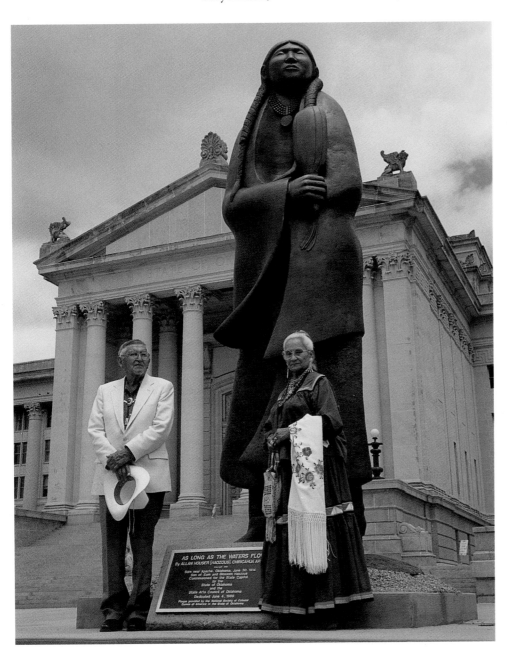

develop his idea of featuring the works of Oklahoma artists in the governor's office. Price organized an "Artist of the Month" program for the governor's reception area. With the help of arts volunteers such as Minnie Lou Jessup of Okarche and Aileen Frank of Oklahoma City, almost one hundred artists, including Beth McAninch of Oklahoma City, Woody Crumbo of Checotah, and the governor's cousin, noted southwestern artist James Boren, were honored with shows. In 1975, after years of limited Arts Endowment funding for grants, Boren proposed the first state funding for community arts and artists-in-residence programs, which was approved by the legislature. During his administration, he joined the Oklahoma Arts and Humanities Council in helping Oklahoma become one of the first states to implement Governor's Arts Awards. He helped found the Oklahoma Arts Institute, directed by Mary Y. Frates. Boren's wife, Molly, later served

as chairman of the board. He led the first statewide Governor's Conference on the Arts. Boren has said, "Betty Price deserves a large part of the credit for all forms of art in Oklahoma." Mary Frates concurred, and spoke specifically about the art in the capitol: "The magnificent art which has been placed in the capitol would not, could not have been possible without the tireless work and unerring eye of Betty Price."

In 1979, the name Oklahoma Arts and Humanities Council was changed by legislation to State Arts Council of Oklahoma. George Nigh, who became governor in that year, included Price as a member of his inaugural committee. Nigh and First Lady Donna Nigh demonstrated their interest in and support of the arts by asking Price to convert the entry room leading to the Blue Room, East Wing, into the Governor's Gallery. This elegant space exhibits works of fine art by individual artists as well as paintings and sculpture from Oklahoma's world-class museums. During Nigh's administration, with strong legislative support, funding to the Oklahoma Arts Council almost doubled. In addition, Nigh was instrumental in the decision that a sculpture of a Native American woman be placed in the oval opposite *Tribute to the Range Riders* on the south plaza of the capitol. The East and North Galleries were established for changing art and photographic exhibits on the first floor of the capitol. All three galleries are still managed by the Oklahoma Arts Council. The quality and diversity of the works shown in them makes them popular destinations for state officials and employees as well as for tourists visiting the building.

When Henry Bellmon came to his second term as governor, he again demonstrated his interest in the arts. Although line-item vetoing some of his own programs in the last day of session, he supported a line item for funding of the sculpture *As Long As the Waters Flow* by Allan Houser. Urging his action were United States senator David Boren and state senator Penny Williams.

Governor David Walters presided over the 1991 dedication of a mural entitled *Flight of Spirit* in the presence of the five world-renowned Oklahoma ballerinas it honored and more than 1,000 people. Governor David and First Lady Rhonda Walters' interest in the arts is also reflected in the bronze sculpture by Lena Beth Frazier on the mansion grounds, commissioned in honor of their late son Shaun and honoring all children of Oklahoma governors. Governor Frank Keating and First Lady Cathy Keating made enormous contributions to the beautification of the capitol, including the addition of the dome and transformation of the plaza, surrounding grounds, and permanent art collection of the Governor's Mansion.

Cathy Keating collaborated on a number of books during the Keating administration. When approached by Sandy Meyers about a book featuring the beautiful works of art in the state capitol and giving recognition to the work of Betty Price, she enthusiastically endorsed the idea. Senator Charles Ford, who had a vigorous program of adding original art to the legislative halls, was brought into the project, which led to the publication of *Art Treasures of the Oklahoma State Capitol*.

At the inauguration of Governor Henry, love for the arts was demonstrated by including an original poem read by Pulitzer Prize–winning poet N. Scott Momaday, an

Oklahoma Cultural Treasure. Famed opera star Leona Mitchell, a native of Enid, Oklahoma, sang during the ceremony, and Oklahoma Cultural Treasures ballerina Yvonne Chouteau and artist Charles Banks Wilson were special guests. The Henrys enlisted the help of Betty Price, along with Karen Sharp and Scott Cowan of the Oklahoma Arts Council, to place original works of art in the office of the governor. Master Oklahoma artists' works that now adorn the governor's office include paintings, bronzes, and carved wood sculpture, continuing the rich tradition of Oklahoma governors supporting the arts.

In 1996, the State Arts Council of Oklahoma was renamed the Oklahoma Arts Council. Today's council continues as an energetic state agency whose mission is to nurture and support a thriving arts environment in the state of Oklahoma. It is honored for its long history of stimulating awareness of the importance of the arts to quality of life, education, and economic development. The council's mandate is to make the arts available to all Oklahomans through matching grants to non-profit arts organizations, schools, sovereign Indian nations, and local governments. Its active role in bringing the magnificent works of Oklahoma's master artists to public spaces inside and outside the capitol is ongoing. This is accomplished in partnership with visionary Oklahoma governors, legislators, Capitol Preservation Commission members, state government agency heads, artists, business and arts leaders, state employees, and the general public.

As a devoted arts leader and the Oklahoma Arts Council's far-sighted executive director since 1983, Betty Price has now served under eight governors, leading dedicated members and staff of the Oklahoma Arts Council in their quest to promote the arts in the Sooner State through distribution of financial assistance for programs serving more than four million people annually. The Oklahoma Arts Council now supports 800 organizations with arts and arts education programs.

The work of Price on behalf of the Capitol Preservation Commission and the Oklahoma Arts Council, assisted by panels of Oklahoma arts professionals, has added lasting art treasures to the rotunda and public spaces of the capitol in the past three decades. Lou Kerr, chair of the Capitol Preservation Commission, observed that "Betty and her tireless efforts to beautify the capitol have proved to be an endless source of inspiration to those of us who are privileged to work with her. Through her knowledge, energy, and tireless efforts, Betty's light will shine on for generations to come."

Through the talent of master artists, exquisite paintings and sculptures tell the story of Oklahoma, its unforgettable places and people, and of the events that make the state's history the boldest and exciting of any state in the Union. With the addition of superb art, the capitol has gained the ambience of a great museum.

THE MURALS

Ten years after the end of World War I, the tragedies and triumphs of that period were still so strongly impressed upon the American people that more than 1,500 Oklahomans thronged to the capitol on Armistice Day, November 11, 1928, for the dedication of the three memorial murals, a gift to the state from Bartlesville oilman Frank Phillips. The impressive murals, called collectively *Pro Patria,* were done by Thomas Gilbert White, an esteemed American painter who had been decorated for service in World War I as a member of the United States Army Reserve. General Roy Hoffman of Oklahoma City and Mrs. Patrick Hurley of Tulsa, the mother of famous Oklahoma painter Wilson Hurley, made up a committee to approve the paintings produced during a two-year period in a Paris studio provided by the French government.

Massed battle flags carried by Oklahoma troops in the world war provided the backdrop for the dedication ceremony at which Governor Henry S. Johnston and Lieutenant Governor William J. Holloway spoke. Johnston said, "Let our hearts be filled with love for our soldiers dead and our soldiers living. The blighted health, the broken forms, the absent faces, the mould of the tomb, in pensive eloquence raise a prayer to heaven, a plea to humanity that the sacrifices which they have made shall prove fruitful in the regeneration of the martial spirit and warlike heart of man."

The unveiling of the White paintings and their acceptance by the state may have been the first direct official recognition that art was an interest of Oklahomans. Reporter A. C. Scott wrote in *The Daily Oklahoman* in 1928, "Everyone who recognizes the place of art in life will rejoice in this first step and will hope that the state will lead the way in the recognition of art and place its favorable stamp upon the ever-enduring value of beauty." In fact, the White murals were so well received that a permanent committee, headed by School Land Commission secretary W. A. Durant and historian Anna Korn, was formed to aid leaders in decorating the capitol. Early plans called for a series of fifteen murals for empty panels on the fourth floor of the building. The committee wanted the series to tell the story of Oklahoma, beginning with the time of early Spanish explorers. But funds were not appropriated and the dream would have to wait for decades.

Nearly seventy-five years later, Wilson Hurley painted the Centennial murals for the second floor rotunda, with Oklahoma Arts Council executive director Betty Price essentially assuming the role Hurley's mother had played in the *Pro Patria* murals.

FACING: CENTRAL PANEL.

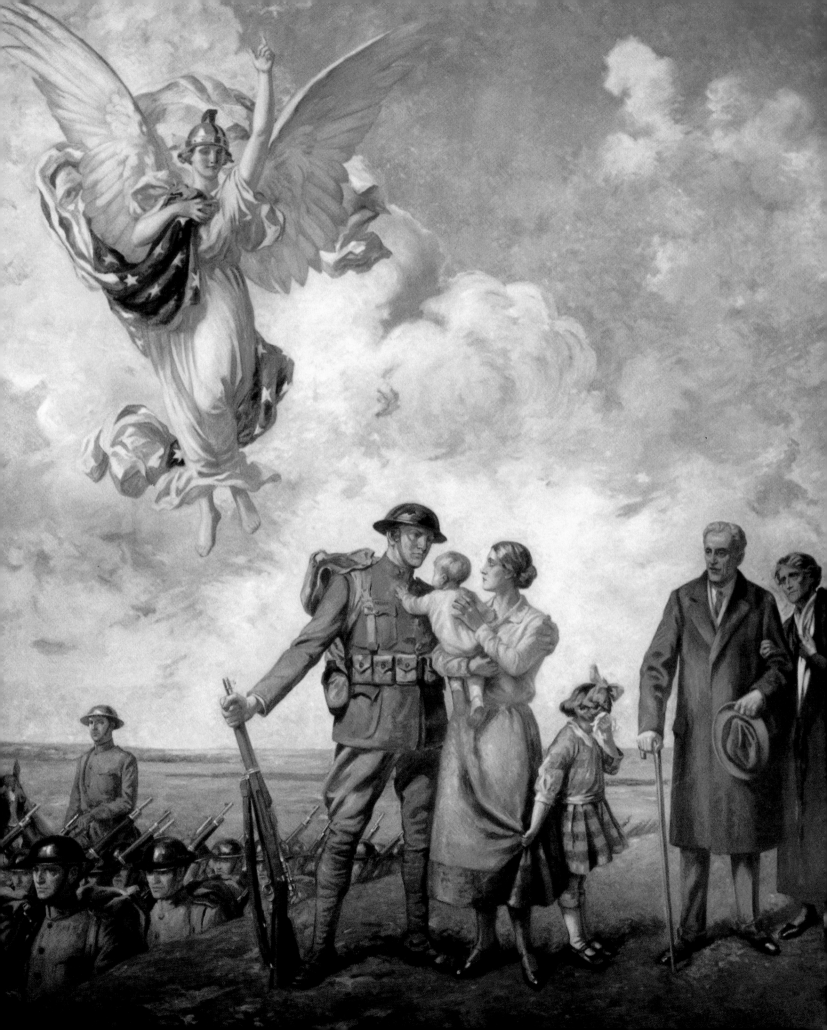

In the central panel of *Pro Patria,* the winged female figure of the State of Oklahoma gives the call to arms. A soldier embraces his wife and says farewell to his family, heeding the call to sacrifice family for country. At the right, the soldier's father and mother recognize the possibility that their son may not return. Artist Thomas Gilbert White explained, "The father, although he hears the country's call, is too old to respond and is obliged to stay behind to care for those who remain. He turns his head and gazes at the departing troops below." At the 1928 dedication of the panels, White said, "Through these canvasses, may the muffled voices from the grave speak to the generations to come of a day when men were not too proud to fight and held life less than their country's honor."

The *Pro Patria* murals remain as permanent indications of Oklahoma's early awareness of fine art. They have been joined by other artworks illustrating the history of Oklahoma.

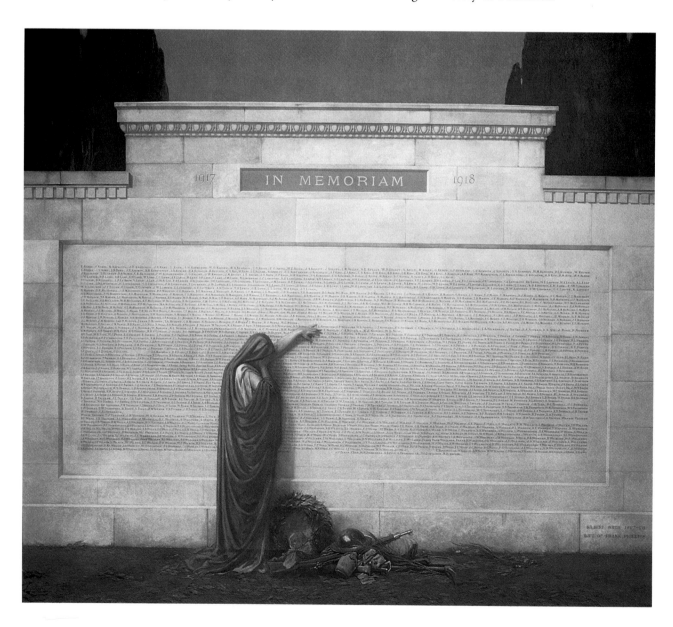

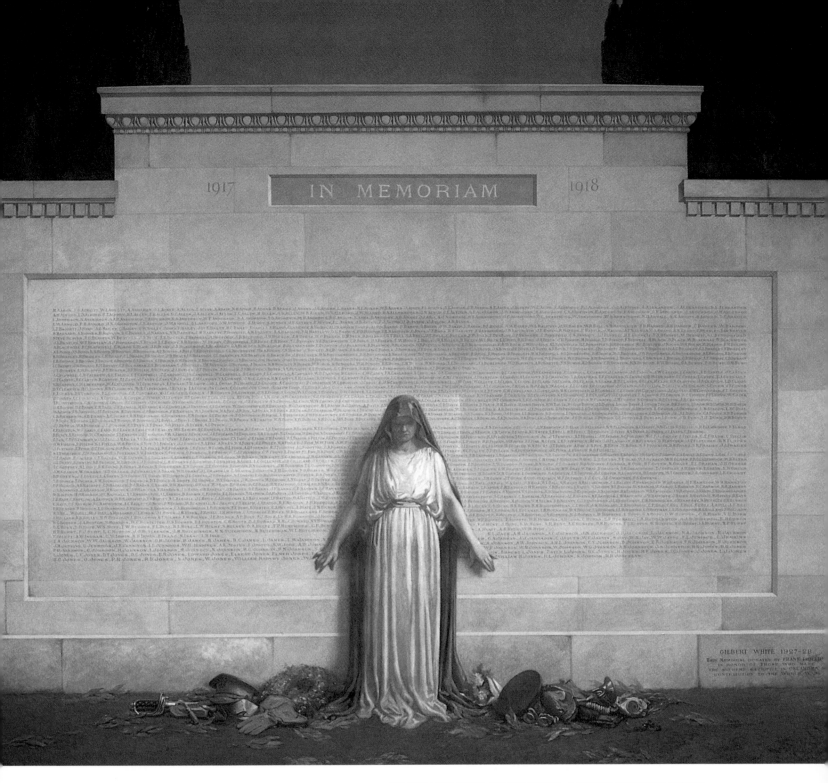

IN MEMORIAM

1917 1918

GILBERT WHITE 1927-28
THIS MEMORIAL DONATED BY FRANK PHILLIPS
IN HONOR OF THOSE WHO GAVE
THE SUPREME SACRIFICE IN OKLAHOMA'S
CONTRIBUTION TO THE WORLD WAR

FACING: ON THE RIGHT PANEL OF
PRO PATRIA, A FEMALE FIGURE
GRIEVES. VEILED, HER HEAD ON ONE
ARM, SHE STANDS AMID FLOWERS,
LAURELS, AND EMBLEMS OF WAR.

ON THE LEFT PANEL OF PRO PATRIA, A SIMPLE MATERNAL FIGURE
STANDS BEFORE A MARBLE TOMB, ARMS OUTSTRETCHED IN A
GESTURE EXPRESSING OKLAHOMA'S PROUD PROTECTION OF HER
DEAD. THE ACCOUTREMENTS OF WAR LIE AT HER FEET. BEHIND HER,
AND ON THE RIGHT PANEL, APPEAR THE NAMES OF THE 2,735
OKLAHOMANS WHO DIED IN WORLD WAR I.

THE SCULPTURE

TRIBUTE TO RANGE RIDERS
BY CONSTANCE WHITNEY WARREN

The first statue to grace the lawn of Oklahoma's state capitol was that of a cowboy riding a bucking bronco, and for nearly two-thirds of a century it has been referred to as "a bronze tribute to the romantic riders of the range." It was created by Constance Whitney Warren in Paris, France, in 1929. The sculpture was a gift from Warren and her father, George Henry Warren of New York City, although the state legislature appropriated $7,000 for the statue's base.

The sculpture was scheduled to be dedicated by humorist and Oklahoma favorite son Will Rogers in 1930. Governor William J. Holloway planned a gala affair made possible through the efforts of Oklahoma Supreme Court justice Albert C. Hunt. However, when Rogers was unable to attend the ceremony, the dedication was postponed and Holloway soon left office.

Oklahoma's next governor was William H. "Alfalfa Bill" Murray who, legend has it, was not overly fond of Rogers because he supported Democratic presidential nominee Franklin D. Roosevelt, whom Murray despised. Murray was not about to invite Rogers to dedicate the statue, so he ordered a tarpaulin to cover it. When the tarp disappeared, Murray had a sign installed that read, "A $500 reward will be paid for arrest of anyone unveiling this statue, except Will Rogers." One day when the tarpaulin was again missing, Rogers quipped, "It musta' been a cyclone that did it cause that tarp was blown clean to Governor Murray's back yard." When asked when the statue would be dedicated, Murray replied, "Oh, it's already unveiled."

The statue was officially dedicated twenty-seven years later, on November 14, 1957, by Governor Raymond Gary, even though the bronze plaque attached to the statue says that Will Rogers was present, creating a mystery of sorts. In 2002, the Smithsonian Institution provided a Save Our Sculpture grant to the Oklahoma Department of Central Services, enabling it to clean the green-corroded cowboy in time for the dedication of *The Guardian* atop the new capitol dome.

The sculptor of *Tribute to the Range Riders,* Constance Whitney Warren, was a New York native who made her way to France and established a worldwide reputation for sculptures of the American West. Equestrian works by Warren are on display in other states, including Texas. Her career was short-lived. Four years after creating Oklahoma's statue, Warren was committed to an institution, where she remained until her death in 1948.

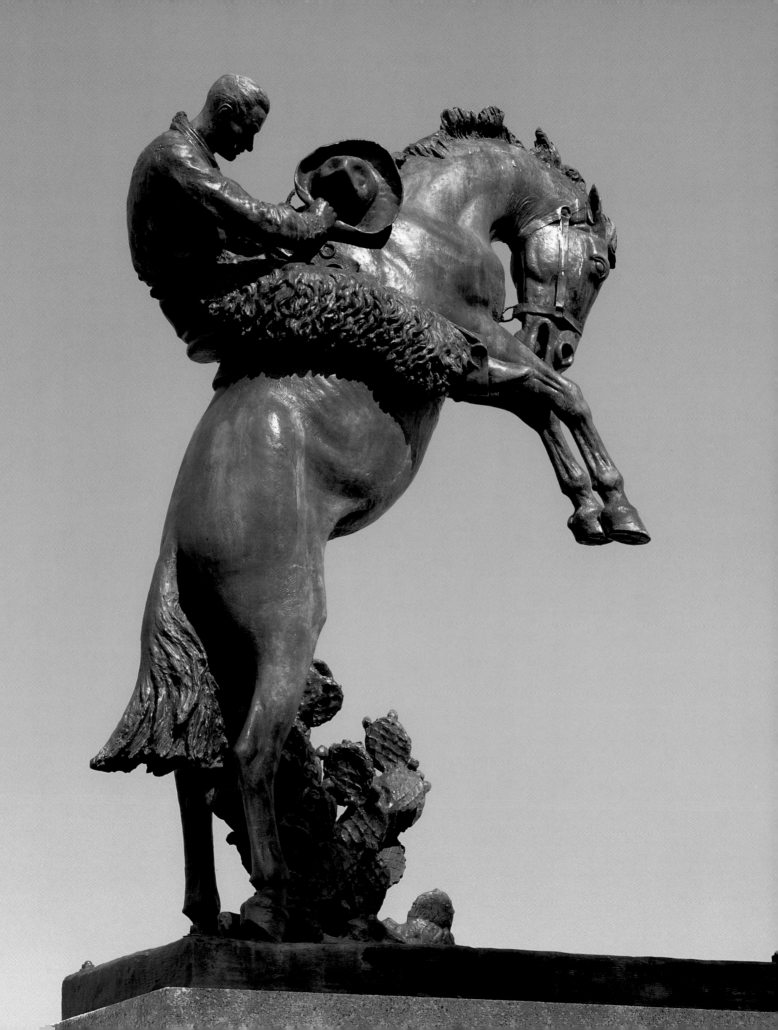

As Long As the Waters Flow, a tribute to Native Americans, was unveiled on June 4, 1989. The fifteen-foot monumental bronze was created by Native American sculptor Allan Houser, a Chiricahua Apache born in Apache, Oklahoma, whom many consider the patriarch of American Indian sculptors. Houser's natural talent was recognized when he was a young lad in southwest Oklahoma. He was persuaded to attend the United States Indian School in Santa Fe, New Mexico, where his works gained national attention.

Houser's Indian name, Ha-oz-ous, means "Pulling Roots." The sculptor's great uncle was Geronimo, the legendary Apache chief. Houser's father was a prisoner of war at Fort Sill with Geronimo and served as his interpreter. Never far from Houser's mind were his ancestors, his state, and the national Indian community. The sculptor often stated his intent to present Indian people in a manner that expressed respect and admiration. Many of his experiences and those of his ancestors are portrayed in his artwork. The Oklahoma Arts Council named Houser its first cultural ambassador in 1984. President George Bush honored him in 1992 as the first American Indian to receive the National Medal for the Arts, the nation's highest honor for artists. The artist's *Offering of the Sacred Pipe* stands at the U.S. Mission to the United Nations in New York City.

As Long As the Waters Flow depicts a woman of the red earth with an eagle feather fan. Its name is derived from terminology common to many treaties between the United States government and the Indian nations. During the administration of President Andrew Jackson, government negotiators first promised that tribes would own their land "as long as the grass grows and the rivers run."

Indian flute players Doc Tate Nevaquaya and Woodrow Haney joined Governor Henry Bellmon, Betty Price, former governor George Nigh, United States senator David Boren, state senator Penny Williams, Supreme Court justice Yvonne Kauger, and other state government and art leaders at the ceremony dedicating the statue. The well known Comanche medicine man George Woogee Watchetaker conducted a traditional ritual that included a prayer of dedication of the sculpture and artist, using smoke from cedar chips and sage. Prayers were offered and fanned upward by Watchetaker while the audience participated in private prayers and watched in reverence. Dr. Mary Jo Watson, curator of Native American art at the Fred Jones, Jr., Museum of Art at the University of Oklahoma, said, "The inclusion of all the traditional elements proved to be very moving and spiritual."

Watson explained Houser's vision. "In many of his figurative pieces, either carved stone or bronze, there is little intent to define or articulate representative details, rather he provides massive surface planes which form the idea of the shape—in this sculpture, the woman, her blanket, shirt, and boots. Only one hand is visible which holds the fan pointing straight up, complementing the verticality of the female form. It is in the face, however, that we see the essence that Houser strives for. This woman is bound to exist!"

ALLAN HOUSER
1914-1994, AT HIS
STUDIO IN SANTA
FE, NEW MEXICO
WINTER OF 1994

A VISION FOR OKLAHOMA

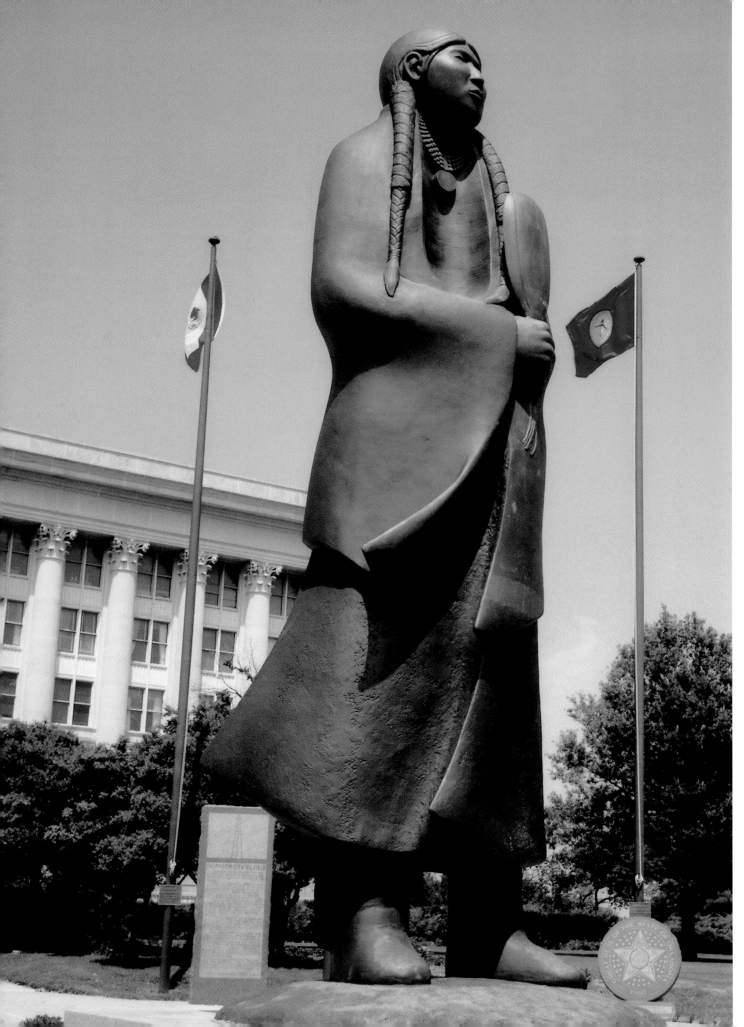

THE GUARDIAN

BY ENOCH KELLY HANEY

Enoch Kelly Haney's sculpture of an American Indian warrior, *The Guardian,* was selected to adorn the top of the new state capitol dome in 2002. Haney is a longtime member of the Oklahoma State Senate and House of Representatives of Seminole/Creek descent whose ancestors came to Oklahoma on the Trail of Tears. The sculpture stands seventeen feet tall, and its subject holds a staff more than twenty-two feet in length. The statute took ten months to complete, required 4,000 pounds of bronze, and was cast in fifty sections. Haney's sons and grandchildren served as its models, his son, William, providing inspiration for the eyes and his grandson, Enoch, for the cheeks. On June 7, 2002, a huge crane lifted the 5,980 pound statue into Oklahoma's blue sky and placed it atop the newly constructed dome facing east—significant to Indian tradition—wtih the warrior's head facing south.

Senator Haney spoke in the voice of *The Guardian* at the dedication in these words: "I am the Guardian… my journey began in the 1830s with the passage of the Indian Removal Act. Thousands and thousands marched halfway

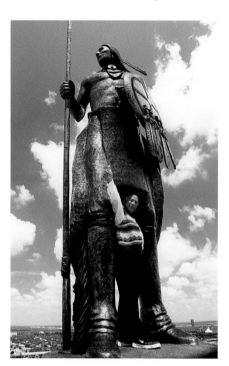

ENOCH KELLY HANEY WITH *THE GUARDIAN* ON THE DAY IT WAS INSTALLED ATOP THE CAPITOL. HANEY WAS THE LAST PERSON TO TOUCH THE SCULPTURE AFTER IT WAS LIFTED TO ITS PERMANENT LOCATION.

DETAIL OF A NINE-FOOT BRONZE EDITION OF *THE GUARDIAN,* A GIFT TO THE PEOPLE OF OKLAHOMA ON STATEHOOD DAY, NOVEMBER 16, 2002, FROM NANCY PAYNE ELLIS AND HER CHILDREN IN MEMORY OF HER FATHER-IN-LAW, WILLIAM T. PAYNE, A NATIVE AMERICAN AND PIONEER OKLAHOMAN. PAYNE FOUNDED BIG CHIEF DRILLING COMPANY AND WAS CO-FOUNDER OF HELMERICH & PAYNE.

across this country; thousands died along the way. But we rebuilt our lives, our families and our nations here. Through the years we were joined by others; their ancestors came from every corner of the world . . . to build a new life in this land of red earth.

The years to come were not easy; there were wars pitting brother against brother, tribe against tribe, and ultimately nations against nations. Throughout the years, thousands of Oklahomans have given their lives defending this country. . . I will guard their memory always. Our young state has faced many adversities; for some it was too much, and they moved on. But for most of us, this red earth was now our home, even when the very earth itself seemed to turn against us. We refused to be moved; we survived the Dust Bowl . . . floods and storms and we reached out our hands and helped one another. . . . When hate and evil struck our state in 1995 at the Murrah Federal Building, we proved to the world how strong our spirit was; and we showed that good is always stronger than evil. We stood our ground.

Soon I will be raised to the top of this capitol building. Inside are many guardians of this state. Our Governor, our legislators, our judges—they are charged with a very sacred task I will stand guard here, over our great state, over our majestic land, over our values. My lance pierces my legging and is planted in the ground. I will not be moved from my duty, from my love of Oklahoma and all of its people. . . I will stand my ground, and I will not be moved. From this day on, I will stand guard. I will stand strong and be proud of Oklahoma, our home."

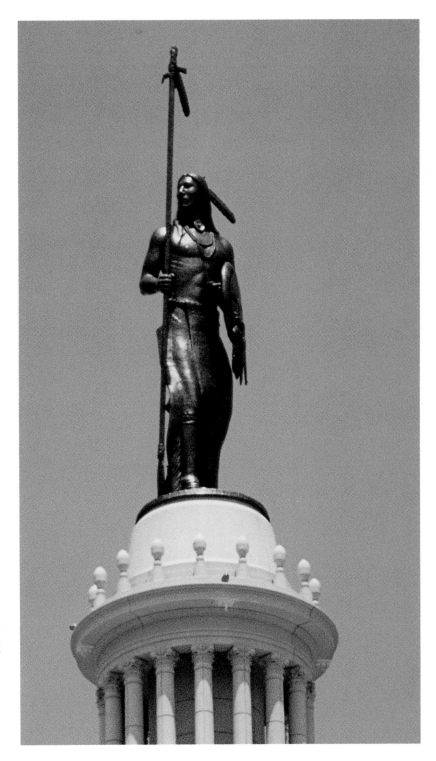

CENTENNIAL MEMORIAL PLAZA

Two state agencies joined forces in 2002 to construct the Centennial Memorial Plaza of the Oklahomans near the south steps of the state capitol.

The Oklahoma Department of Transportation and the Department of Central Services provided planning and funds to replace uninteresting gray concrete with red, pink, and black granite. The plaza features twenty-eight granite rosettes designed after the state seal. They commemorate historical events in Oklahoma such as the Land Run of 1889, statehood in 1907, and the moving of the capital from Guthrie to Oklahoma City. The Centennial Plaza was designed by Meyer Architects, Paul B. Meyer, principal architect, and is surrounded by granite benches. The project was one of nearly 200 planned by the Centennial Commission in anticipation of Oklahoma's one hundredth birthday in 2007.

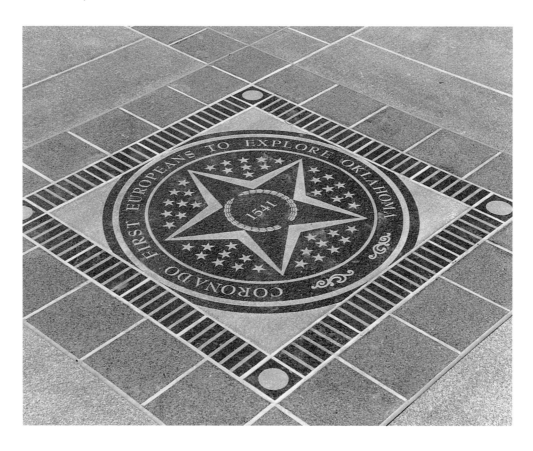

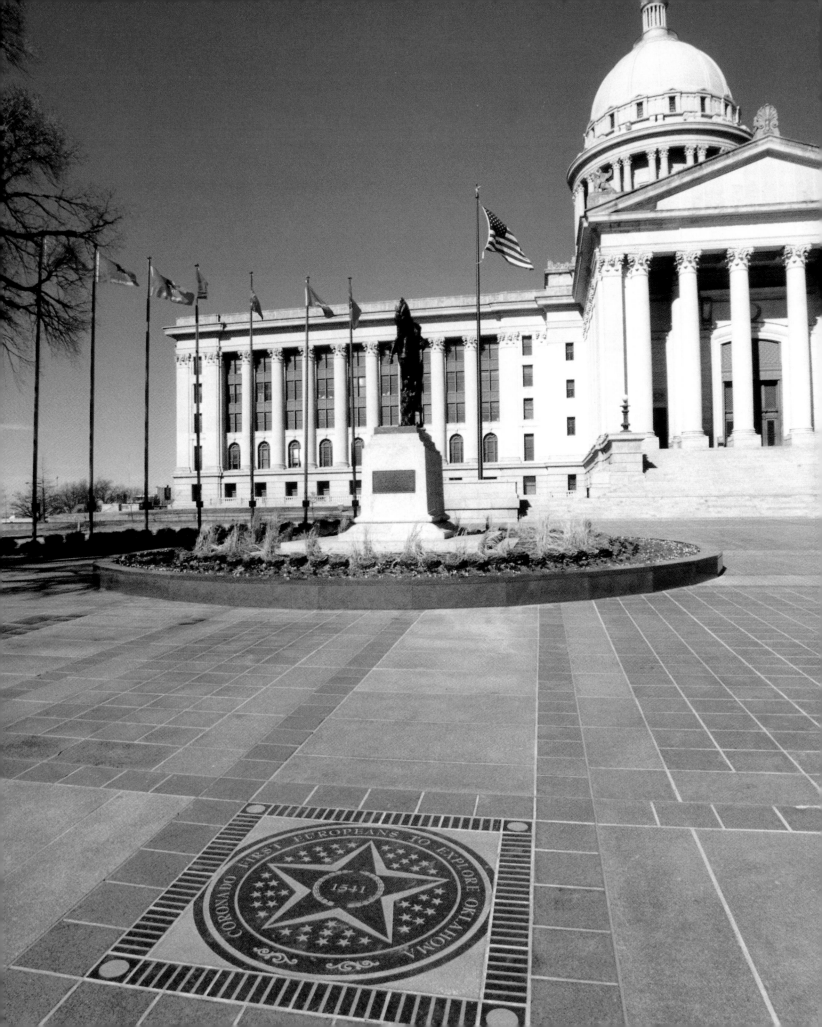

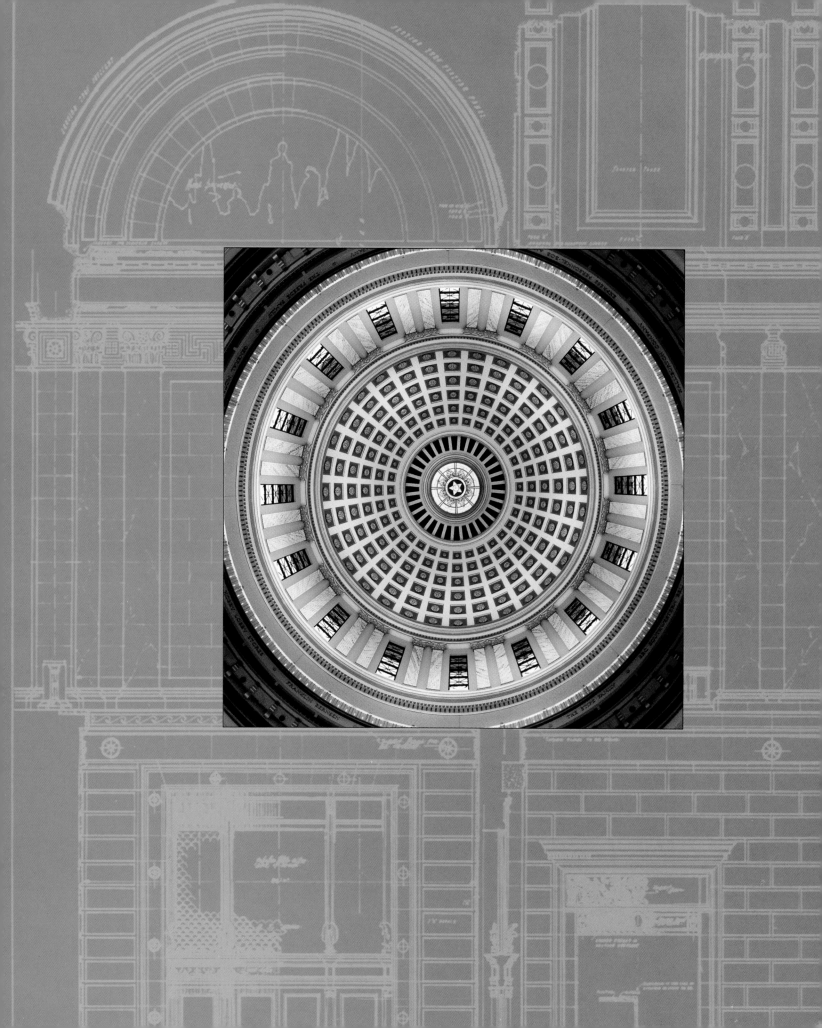

2

ASSURING THE BEST:
THE CAPITOL PRESERVATION
COMMISSION
AND THE CAPITOL ARCHITECT

ART *in* PUBLIC *spaces*

ART IN THE ROTUNDA

THE PORTRAITS

THE PAINTINGS

In 1983, the Oklahoma legislature created the Capitol Preservation

Commission to assure that only art of museum quality would be considered

for permanent display in the capitol. The legislation was the brainchild of

state senators Frank Keating, Penny Williams, and Rodger Randle of Tulsa,

state representatives Cleta Deatherage of Norman and Robert Henry of

Shawnee, architect Paul B. Meyer, chief clerk of the House of

Representatives Richard Huddleston, Oklahoma Arts Council

director Betty Price, and Colonel Martin Hagerstrand, who

became the first chair of the commission.

LOU KERR, CHAIR OF THE CAPITOL
PRESERVATION COMMISSION.

The commission has authority over the display of art objects in the
public areas of the capitol and the first floor of the Governor's Mansion.
The commission's executive committee is made up of elected officers of
the body, the state capitol architect, and the director of the Department of
Central Services, the state government agency that oversees the day-to-day
operations of the capitol.

The Art Standards Committee of the Commission sets standards for
art objects that are acquired and commissioned for display in the capitol.

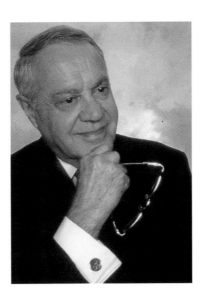

The Architecture and Grounds Committee oversees any proposed restoration, reconstruction, or renovation of the capitol, landscaping and maintenance of the building exterior, and it has power of final approval of all monuments and sculptures surrounding the building. The Long Range Planning Committee is responsible for looking into the future in order to devise programs and recommend funding for projects to enhance the artistic beauty of the capitol.

The law that governs the work of the Capitol Preservation Commission mandates that all works of art in the capitol be directly related to the history and culture of the state. The commission must approve both the subject matter of a proposed artwork, and the artist. The law limits portraits of Oklahomans who can become part of the permanent capitol collection to those "whose achievements and contributions to the history of Oklahoma and the nation are of such transcending importance as to place the individual in a status clearly and generally acknowledged to be of paramount significance to the enduring history of the state." No portrait of any person may be permanently displayed in the capitol unless he or she has been dead for at least ten years.

The commission has fifteen members—three appointed by the governor, three by the Senate president pro tempore, three by the Speaker of the House, and one by the chief justice of the Oklahoma Supreme Court. The five ex-officio members are the chair of the Oklahoma Arts Council, director of the Department of Central Services, president of the Oklahoma Historical Society, the capitol architect and curator, and the capitol building superintendent.

Since the inception of the law that created the Capitol Preservation Commission, Paul Meyer has served as capitol architect and curator. Before 1983, there was no organized plan for preserving or remodeling the capitol. When money was appropriated for changes, there was generally no effort made to follow the architectural design of the building. Meyer believes the major benefit of the commission is that a system is now in place to develop long-range plans for projects in the capitol. There now exists a "wish list" of changes or additions, such as a visitor center, which are well thought out in advance. In the future, when money is appropriated by the legislature for capitol renovation, the plans will already exist to assure that the architectural style of the capitol is enhanced. Meyer has completed the extensive long range planning for the capitol without charge to the taxpayers.

Commission chair Lou Kerr, wife of Robert S. Kerr, Jr. and daughter-in-law of former governor and United States senator Robert S. Kerr, is a long-time volunteer with a love for protecting Oklahoma's capitol. "Having standards is very important," she said. "We are the caretakers who must preserve our history for the benefit of future Oklahomans." Without

BETTY PRICE WITH THE SCULPTURE OF
KATE BARNARD ON HER BRONZE BENCH.

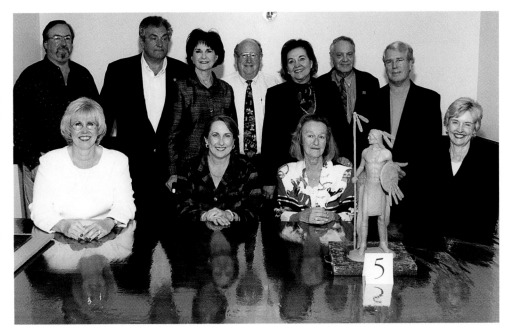

special volunteers, the hidden stairwell at the capitol would have never been uncovered and restored and other projects to preserve the originality of the capitol would have never gotten off the ground. "We have walked through many minefields," Kerr remembered, "but it's all worth it. Through the results of many, Oklahoma's state capitol is among the most beautiful in the land."

Doubtless, many visitors to the capitol who have lingered over the great range of beautiful, interesting, and publicly approachable artworks would agree.

AN ESPECIALLY APPEALING SCULPTURE IN THE PUBLIC SPACE commemorates a ninety-pound dynamo affectionately known to Oklahomans as "Miss Kate," who is memorialized with a sculpture by Sandra Van Zandt of Oologah. This long overdue tribute to one of Oklahoma's greatest leaders was created in 2001.

Kate Barnard was the first woman in America elected to a statewide office. She led the ticket as the state's first commissioner of charities and corrections in 1907. Even though she could not vote for herself—the Women's Suffrage movement was in its infancy—she received more votes than even the first governor, Charles Haskell. Earlier, she was the only woman allowed to address the Oklahoma Constitutional Convention and was responsible for several planks in the Constitution relating to child labor and mine safety.

Miss Kate was best known for protecting the rights of prisoners. Her investigations of Oklahoma prisoners being housed in Kansas resulted in the state legislature appropriating funds to build the first state penitentiary at McAlester. She was also a champion of underprivileged children, especially the state's Native American orphans whose fortunes were often plundered by greedy lawyers and judges. Miss Kate suffered from a variety of illnesses in her later years. The frail heart of Oklahoma's angel of mercy finally gave out. She was

found dead in the bathtub of her room in the Egbert Hotel in Oklahoma City on February 23, 1930. After her death, Miss Kate was largely forgotten by the state she served. Her grave in Oklahoma City's Fairlawn Cemetery was unmarked for forty years until a group of interested women purchased a headstone.

Miss Kate sits on one of two turn-of-the-century bronze benches, where she is a favorite of visitors, especially children, who sit beside her for souvenir photographs.

ALSO POPULAR WITH VISITORS is a striking 1986 depiction of Oklahoma's official state wildflower, the Indian Blanket (*Gaillardia pulchella*). The textile, titled *Indian Blanket Quilt*, incorporates nearly 3,000 fabric pieces and is based on a traditional Seminole Indian pumpkin blossom patchwork design. It hangs beneath the majestic grand staircase of the capitol. *Indian Blanket Quilt* is the work of Nettie Wallace of Konawa,

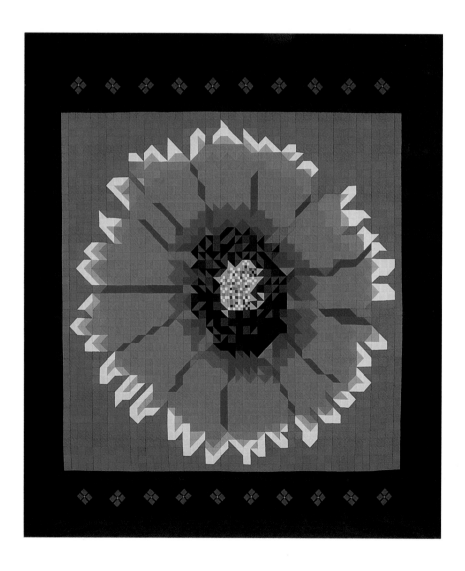

INDIAN BLANKET QUILT, BY NETTIE WALLACE.

Oklahoma. The piece was commissioned and donated by Senator Enoch Kelly Haney, who had sponsored legislation that designated the Indian Blanket as the state wildflower, legislation that Haney said might be his most important contribution as a legislator because the flower was used as the theme for the beautiful inner design of the capitol dome.

AS PART OF OKLAHOMA'S DIAMOND JUBILEE celebration in 1982, Oklahoma City sculptor Leonard D. McMurray was commissioned to sculpt the busts of twenty-one of Oklahoma's governors. McMurray, born to a prominent cotton family in Texas, moved to Oklahoma in 1955. He lived in both Stilwell and Oklahoma City. McMurray studied under famous sculptors Carl Mose and Ivan Mestrovic. His works include a number of public sculptures including the '89er statue on Couch Drive in downtown Oklahoma City, the statues of Wiley Post and Stanley Draper at the Oklahoma City Civic Center, the Praying Hands on the campus of Oral Roberts University in Tulsa, and busts of Cherokee educator Sequoyah and humorist Will Rogers in the state office buildings that bear their names. A McMurray monument began with a vision. He once said,

THE HALL OF GOVERNORS.

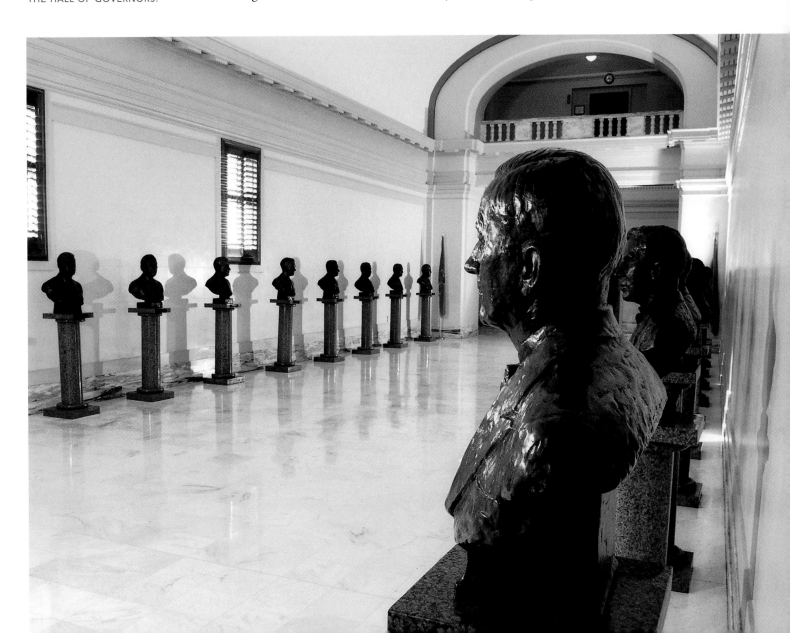

"It is best not to immediately grab clay and start working on the first impulse. It is better to think it out. An idea improves in the mind with time." Of his works, McMurray mused, "Each piece must have a soul, a living quality that's far more important than just physical representation. A piece has to have guts; the strength, power, and dignity that makes it a monument."

In 2002, the bust of Governor David Walters, by Harold T. Holden of Kremlin, Oklahoma, was unveiled. Born in Enid, "H," as he is known by his friends, has major works on display throughout the world. His artwork was used by the United States Postal Service for the 1993 Cherokee Strip commemorative postage stamp.

Longtime Ponca City artist Jo Saylors, a native of Tennessee, created the bronze bust of Governor Frank Keating that was unveiled in January, 2003. The dedication of Keating's commemorative bust brought together the artist, Governor Keating, Oklahoma Arts Council executive director Bettty Price and three former Oklahoma governors, George Nigh, Henry Bellmon, and David Walters.

Saylors was asked by First Lady Laura Bush to sculpt an ornament of Oklahoma's state bird, the scissor-tailed flycatcher, for display on the 2002 White House Christmas tree. Saylors' statues can be found in many public places, including libraries and museums throughout the United States. Her *Lady of Justice* stands inside the Oklahoma Bar Center in Oklahoma City, south of the capitol.

AT THE DEDICATION OF THE BUST OF GOVERNOR FRANK KEATING, LEFT TO RIGHT: FORMER GOVERNOR DAVID WALTERS, LIEUTENANT GOVERNOR MARY FALLIN, SCULPTOR JO SAYLORS, GOVERNOR KEATING, FORMER GOVERNOR GEORGE NIGH, FORMER GOVERNOR HENRY BELLMON, AND BETTY PRICE.

ART IN THE ROTUNDA

THE CENTENNIAL SUITE

BY WILSON HURLEY

Internationally known artist Wilson Hurley was born in Tulsa but moved to Washington, D.C., when his father, Patrick Hurley, became secretary of war in the administration of President Herbert Hoover. Hurley never forgot his Oklahoma roots. Unfulfilled as a West Point engineer and George Washington University–trained lawyer, he turned to painting, an avocation of which his famous father was not supportive. His two loves are painting and flying.

Hurley's landscapes are some of the most recognized in Oklahoma. In the early 1990s, he was commissioned to paint a set of huge murals, *Windows on the West,* which grace the walls of the Noble Center at the National Cowboy and Western Heritage Museum in Oklahoma City. Hurley was named an Oklahoma Cultural Treasure by Governor Frank Keating in the 2002 Governor's Arts Awards sponsored by the Oklahoma Arts Council.

Four of Hurley's heroically scaled oil paintings created for the second floor rotunda of the capitol represent the four quadrants of Oklahoma. Philanthropist Roger M. Dolese made the Centennial Suite possible.

Spring Morning Along the Muddy Boggy was unveiled in 2001 and *Autumn Woods North of Tahlequah* in 2002. Hurley collected ideas for *Autumn Woods* by visiting the community of Peggs near Tahlequah. When he saw the woods bright with color, he remarked, "This country is just asking to be painted." *Sunset at Roman Nose State Park* interprets northwest Oklahoma. To catch the spirit of an Oklahoma storm in *A Storm Passing Northwest of Anadarko,* Hurley set up his easel on a day when light rain and stormy skies dominated the sky above. However, to catch the "terrible beauty" of an actual storm, he studied tapes of storms prepared by the University of Oklahoma and KWTV in Oklahoma City.

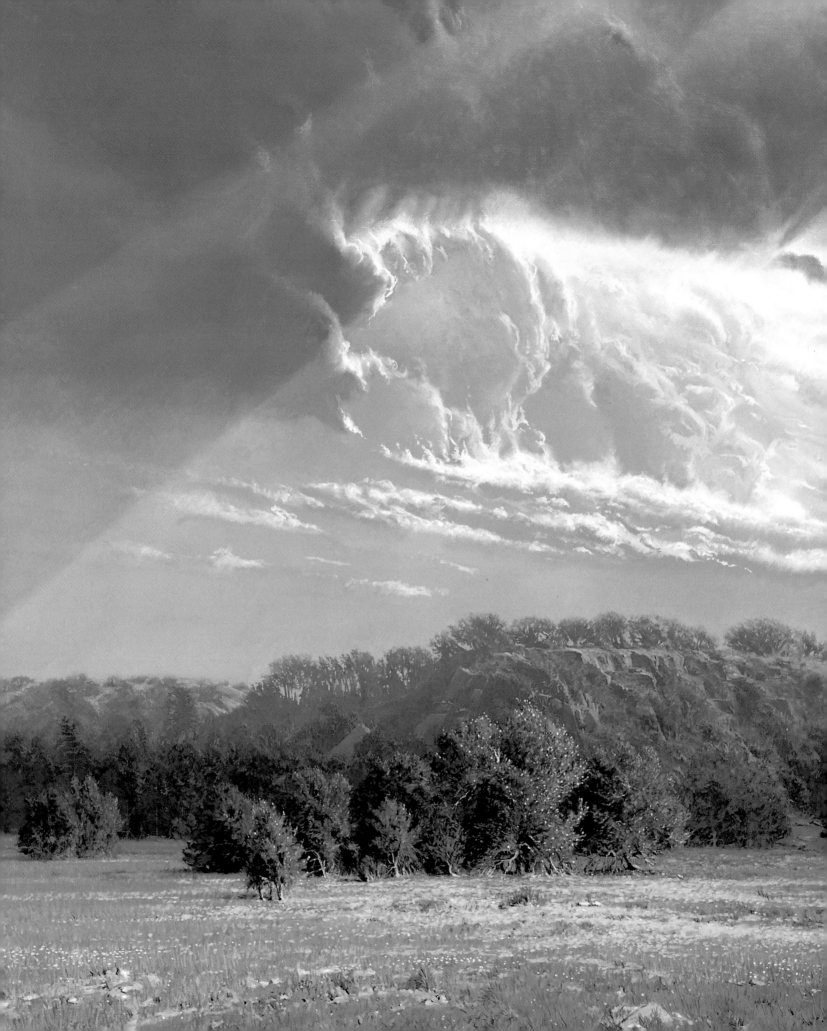

SPRING MORNING ALONG THE MUDDY BOGGY

Wilson Hurley's father was born near the Muddy Boggy in the Old Choctaw Nation in present Coal County. Some of the inspiration for this painting came from Hurley's visits to his grandmother's grave in the Lehigh cemetery. "There in the spring," Hurley said, "the low clouds were racing northeast and the sun was swinging great shafts of light across the shadowed land. One burst of light washed over a field of yellow flowers like an all-forgiving and comforting blessing, an affirmation of how beautiful Oklahoma is."

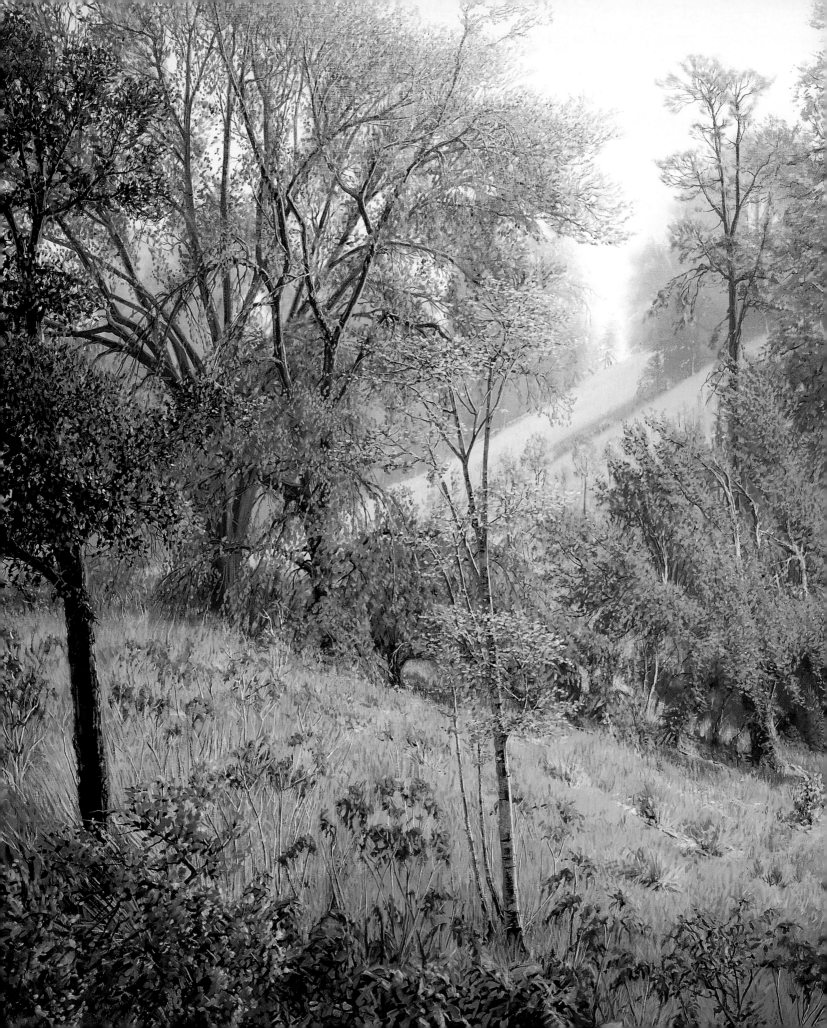

AUTUMN WOODS NORTH
OF TAHLEQUAH

*Hurley saw "an array of sumac, oak,
sycamore, and one old maple bright red
in the quiet, cool sunlight that lingers for
a few days before winter comes."*

SUNSET AT ROMAN NOSE STATE PARK

Hurley recalled that "The sky was bright in the setting sun, the trees were in full leaf, and the evening was calm. The white cap rock lying on the dark red earth slowly sank into the peaceful twilight showing the essential, quiet, everlasting loveliness of Oklahoma."

*Hurley painted in light rain to capture an
Oklahoma storm with its "terrible beauty."*

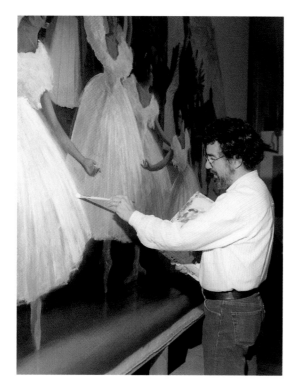

MIKE LARSEN AT
WORK ON *FLIGHT
OF SPIRIT.*

Mike Larsen, a Chickasaw artist who lives in Oklahoma City, created *Flight of Spirit*, dedicated in the Great Rotunda of the capitol on November 17, 1991, to honor five Oklahoma Native American ballerinas. Yvonne Chouteau, a Cherokee born in Vinita, was the youngest American to ever become a member of the Ballet Russe de Monte Carlo. Rosella Hightower, born in Ardmore and of Choctaw descent, performed with the major ballet companies of Europe. Moscelyne Larkin, of Shawnee-Peoria descent and a native of Miami, Oklahoma, was a member of the Original Ballet Russe in 1941. Maria and Marjorie Tallchief, Osage sisters born at Fairfax, assumed superstar status on the ballet stages of the world.

Larsen does not portray the ballerinas individually but the five are symbolized by ballerinas in white with a background that includes tribal ancestors, young dancers, and five flying geese symbolic of each ballerina's grace and spirit. The background depicts the Trail of Tears, the forced removal of several of Oklahoma's Indian tribes from the southeastern United States to Indian Territory in the 1830s.

The artist studied at the University of Houston and the Art Students League in New York City. Versatile in oil, watercolor, and pastel, Larsen began by painting landscapes and western scenes, but his Native American heritage led him to explore Indian images. He depicts Native American figures with strong faces full of character and exaggerated hands and feet that seem to leap from the canvas.

In 1998, Larsen was commissioned by the Oklahoma Arts Institute to paint the *Quartz Mountain: Sacred Ground* series of paintings. The eight paintings in the series reflect the history of the Kiowa tribe of southwestern Oklahoma.

The beautiful and joyous presence of *Flight of Spirit* in the capitol rotunda was described by Dr. Mary Jo Watson: "The luminescence of the dancers' dress is reminiscent of the goals of French Impressionism, yet it is mingled with Oklahoma Native American ideology. Light showers the ballerinas and their tutus. The effervescent qualities of the mural and the recognition of both the visual and dance artists, signifies an

important aspect of Native art. Importantly, Larsen gives respect to traditional values and ideals. . . . The art of the Indian ballerinas and the art of Mike Larsen stand as a gateway between the past and the future. This work indicates that Indian painting, music, dance, and all Native Arts continue with a brilliant ability to absorb contemporary life and yet maintain a grounding in tradition."

State senator Jerry Smith, Tulsa, approached Betty Price in 1988 to commission the mural of the five Indian ballerinas for the rotunda. They worked with legislative leaders and Governor Henry Bellmon to appropriate state funds which were matched by major donors including Texaco, the Kirkpatrick Foundation, Phillips Petroleum Company, and Public Service Company of Oklahoma. Other contributors to the project were Ann Simmons Alspaugh; Allen E. Coles; Stifel, Nicolaus & Company, Inc.; Sun Company, Inc.; Center of the American Indian, Inc.; Red Earth, Inc.; Pratt Foods; and Jim Vallion.

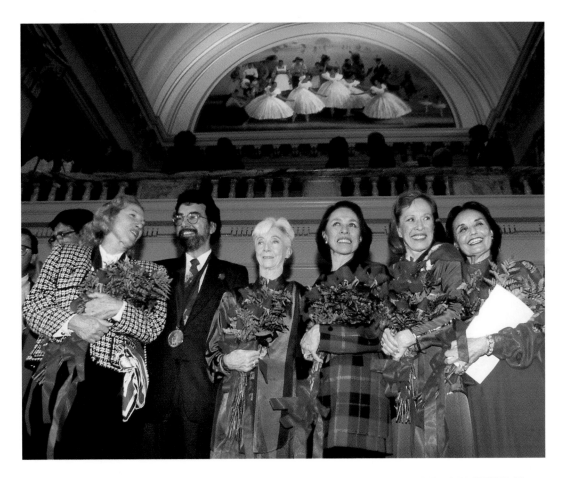

FOR THE FIRST TIME IN HISTORY, ALL FIVE OKLAHOMA BALLERINAS APPEARED IN PUBLIC TOGETHER AT THE 1991 DEDICATION CEREMONY. LEFT TO RIGHT, YVONNE CHOUTEAU, ARTIST MIKE LARSEN, ROSELLA HIGHTOWER, MARIA TALLCHIEF, MARJORIE TALLCHIEF, AND MOSCELYNE LARKIN.

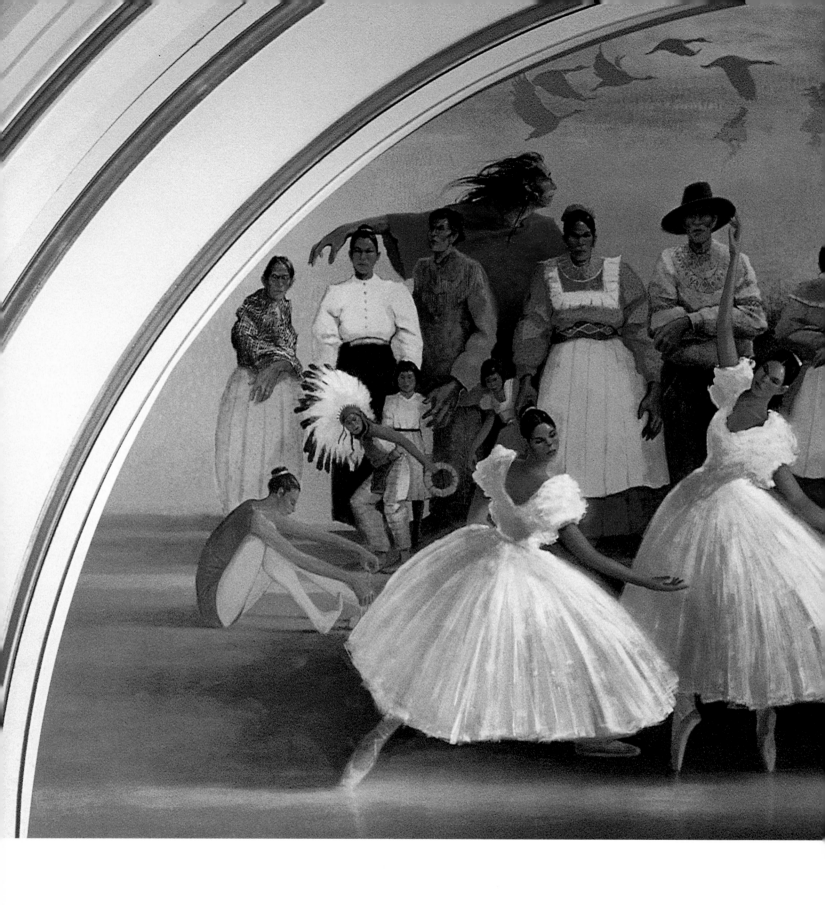

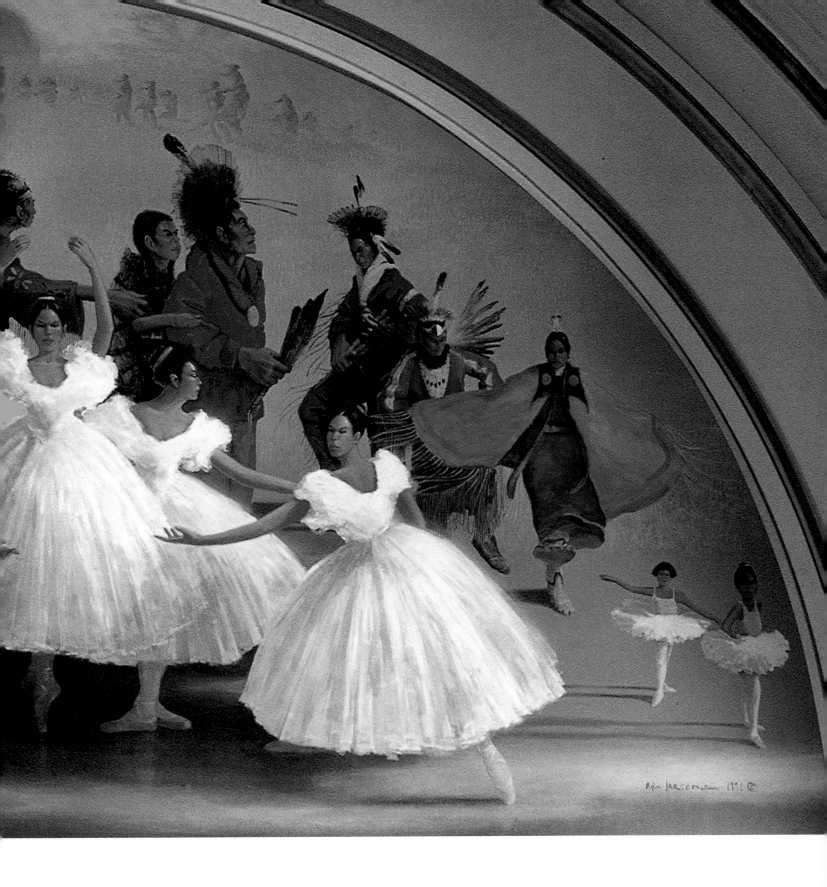

The one hundredth anniversary of Oklahoma's oil and gas industry was celebrated in November, 1996, with the dedication of *Oklahoma Black Gold,* a mural by Jeff Dodd, native of Kingfisher, Oklahoma, now living in Enid. Dodd, in his thirties at the time the piece was commissioned, conceived the idea after spending three days in an oil field taking photographs and observing workers. The mural was funded by private donors from the oil and gas industry and was a result of the University of Central Oklahoma's 1995 salute to the centennial of the state's oil and gas industry. Donors included the Oklahoma Independent Petroleum Association, Koch Industries, Phillips Petroleum Company, Conoco Inc., Coastal Corporation, Apache Corporation, Oklahoma Natural Gas Company, Mike Cantrell, Samson Resources, Mobil Oil Corporation, Chesapeake Energy Corporation, and Kerr-McGee Corporation.

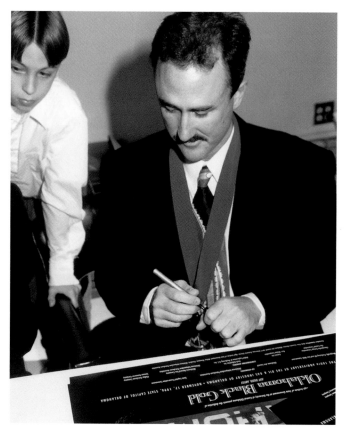

MURAL ARTIST JEFF DODD SIGNS A POSTER FOR CHANCE CAMMACK, OKLAHOMA CITY, FOLLOWING THE DEDICATION OF *OKLAHOMA BLACK GOLD,* NOVEMBER 17, 1996.

Dodd, a graduate of Southwestern Oklahoma State University, depicts both the past and the future of petroleum production in the state.

On the left side of the mural is an antique wooden structure that represents Oklahoma's first attempts at tapping vast oil reserves. The segment on the right side of the work represents the future and the infinite. Dodd used the state flag, with its striking blue and gold, as the background. In the center of the mural, an oil well worker represents a consistent pushing and pulling toward the goal of drawing energy from the earth. The mural's base is twenty-two feet across with a radius of eleven feet. It was completed in a rented warehouse because it was too large to paint in Dodd's studio. It was then rolled and transported to the capitol where workers from Pirate's Alley constructed its frame. Employees of an engineering firm meticulously placed the mural on the high wall, as Dodd looked on.

Dodd's epic *We Belong to the Land* celebrates the contributions of agriculture to the history and future of Oklahoma. Dodd, a product of rural Oklahoma, uses several scenes to create the mural, including cattle with blazing eyes and glistening muscles, a pioneer woman wiping the sweat from her brow, and a tractor and plow breaking ground. *We Belong to the Land* was the first official project of the Oklahoma Centennial Commission to celebrate Oklahoma's first century as a state.

The mural, dedicated March 16, 1999, was sponsored by the Bank of Western Oklahoma; Farmland Industries, Inc.; J-M Farms, Inc.; John Deere Corporation; Kerr Center; Noble Foundation; Oklahoma Cattlemen's Association; Oklahoma Association of Electric Cooperatives; Oklahoma Farm Bureau; Oklahoma Pork Council; Oklahoma Farmers Union; Oklahoma Fertilizer and Chemical Association; Oklahoma Grain and Feed Association; Oklahoma State University; Oklahoma Telephone Association; Shawnee Milling Company; and Weyerhaeuser Company.

Carl Reherman, director, Nigh Institute of State Government, University of Central Oklahoma, worked with Betty Price and the Capitol Preservation Commission on the management of the projects and named both murals.

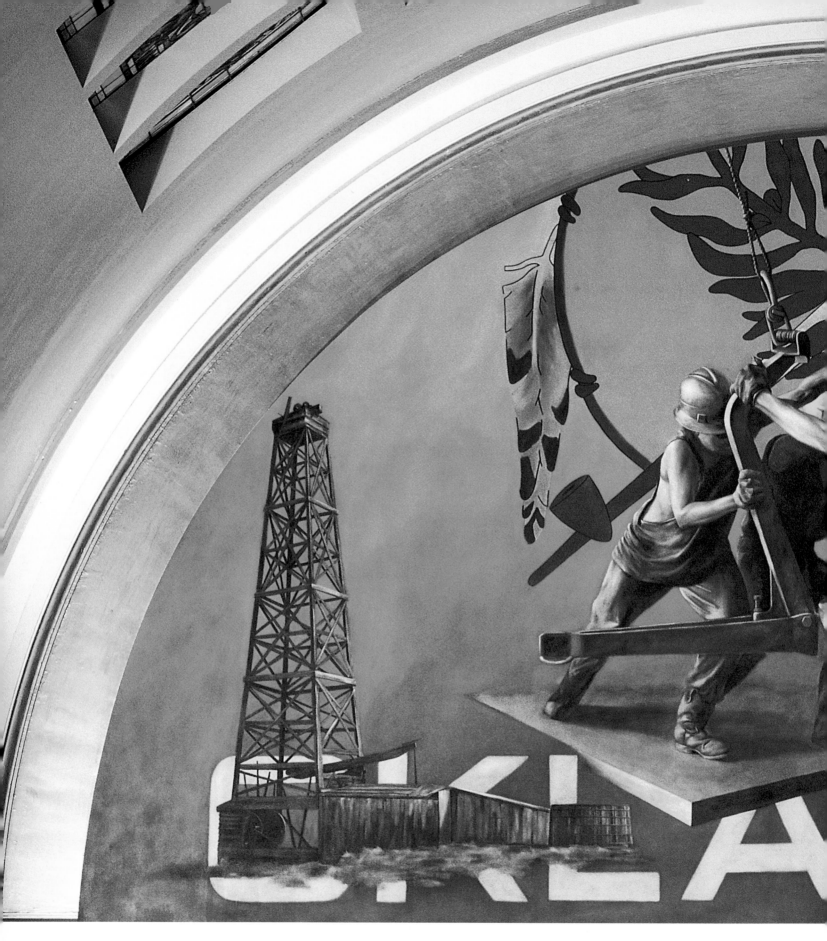

OKLAHOMA BLACK GOLD

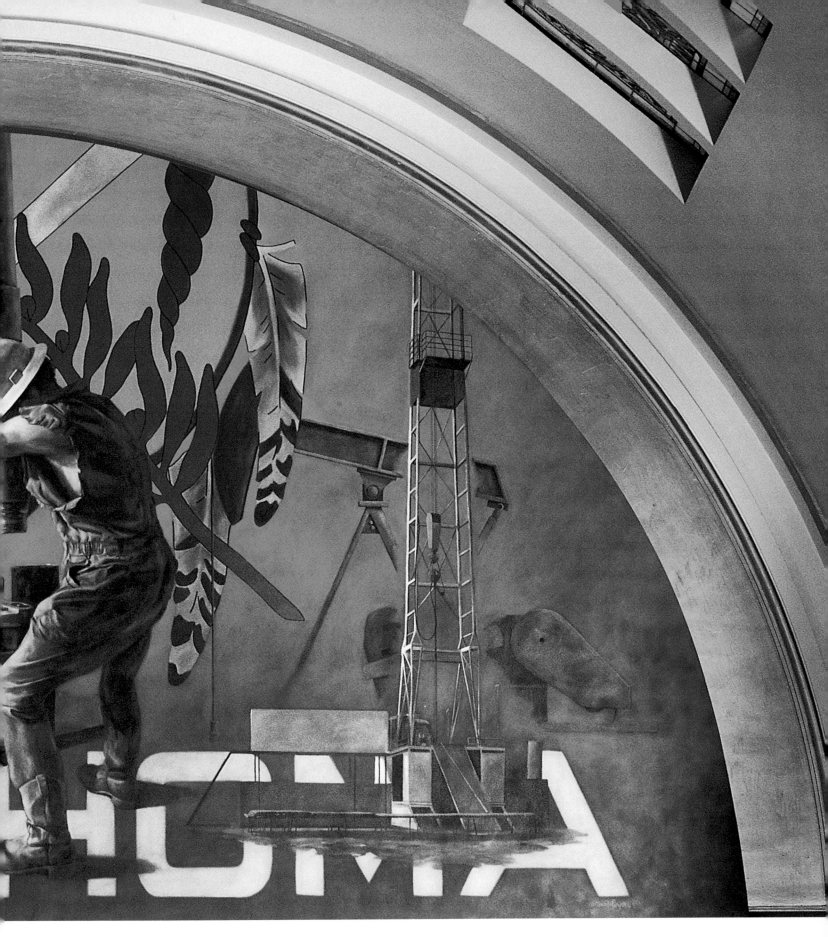

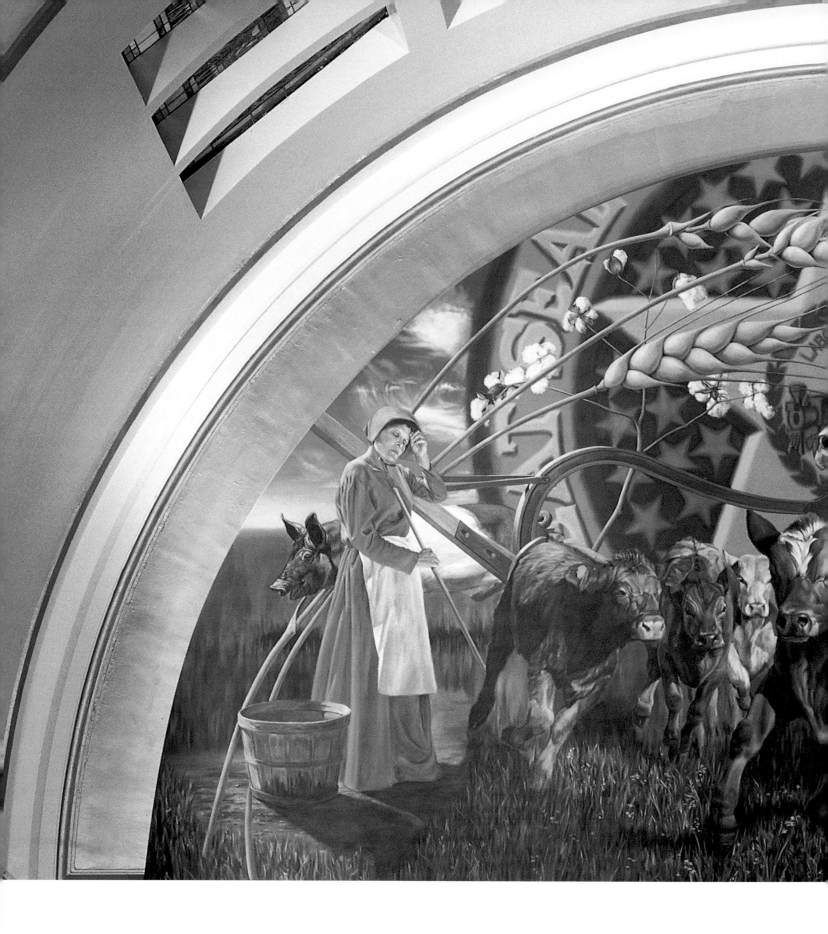

WE BELONG TO THE LAND

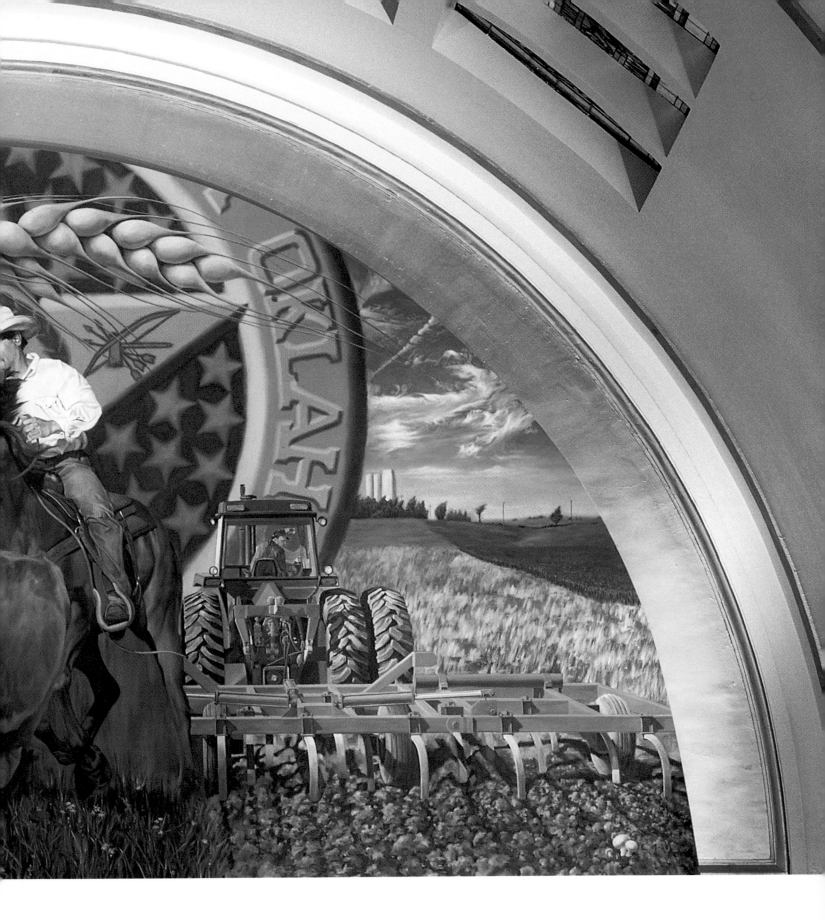

The popularity of Charles Banks Wilson's portraits of Robert S. Kerr, Sequoyah, Jim Thorpe, and Will Rogers brought about a renewed interest in acquiring art for the state capitol. In 1970, the state legislature commissioned Wilson to paint four murals depicting the history of Oklahoma from 1541 to 1900.

CHARLES BANKS
WILSON WITH
JOE BENNY
MASON, OSAGE.

Wilson, named an Oklahoma Cultural Treasure in 2001, worked four years researching and visiting each of the sites to be pictured and drawing every person to be shown in the murals from life. He built clay models before transferring each scene to thirteen-by-twenty-seven-foot linen canvases woven in Belgium and coated with polymer acrylic gesso. Wilson used polymer acrylic paint for its permanence and flexibility. Marian Mickelenberg and Anton Konrad used a hot wax resin adhesive to mount the murals on Fiberglas supports built by Newman Industries of Miami, Oklahoma. Wynn Construction Company of Oklahoma City placed the murals—a complicated engineering feat as the murals were to hang on a concave surface thirty-six feet above the floor. The unique installation used stacks of scaffolding.

The four murals were dedicated on Statehood Day in 1976. Carl Clark and Betty Price co-chaired the dedication committee. Historian Dr. A. M. Gibson delivered the dedicatory address.

In *Discovery and Exploration,* Wilson depicts the Spanish explorer Francisco Vasquez de Coronado, Oklahoma's "first tourist." He crossed the Oklahoma Panhandle seeking gold in 1541. Capsulizing Oklahoma's history from 1541 to 1820, the mural shows Coronado and French explorers exploring the land coveted by many as a key for control of the region. Wichita Indians represent some of the more peaceful Native American tribes who lived in the area in the 16th century. Wilson shows the Antelope Hills, important to travelers who followed the many major trails across what would become Oklahoma. Large deposits of salt on the Cimarron River were written of in early accounts of the first travelers to Oklahoma.

Wilson's second mural, *Frontier Trade,* shows Oklahoma history from 1790 to 1830, when many people showed an interest in the land. Boats were built along the Arkansas River and fur trading posts and salt exporting businesses rose up in the wilderness. Forts were built to protect the settlers from Native Americans who believed the land was theirs forever. *Indian Immigration,* the third mural, captures how much of Oklahoma's future was forged in the years 1820 to 1885 when members of sixty-seven

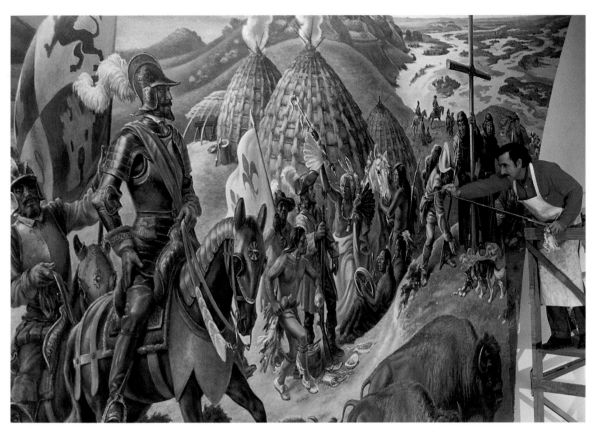

different Native American tribes were brought to the region. Oklahoma had been home for centuries to nomadic hunters following buffalo herds. The location of the Five Civilized Tribes in Indian Territory opened the way for the settlement of other tribes in the future state. Charles Banks Wilson shows federal troops who were used to keep the peace to prevent constant tribal warfare.

The fourth era of Oklahoma history is depicted in *Non-Indian Settlement.* During this period, from 1870 to 1906, the federal government opened the Unassigned Lands in the Land Run of 1889. Wilson shows Boomers, in the foreground, preparing to enter the "promised land." Other land openings set the stage for the admission of Oklahoma as the forty-sixth state of the Union on November 16, 1907.

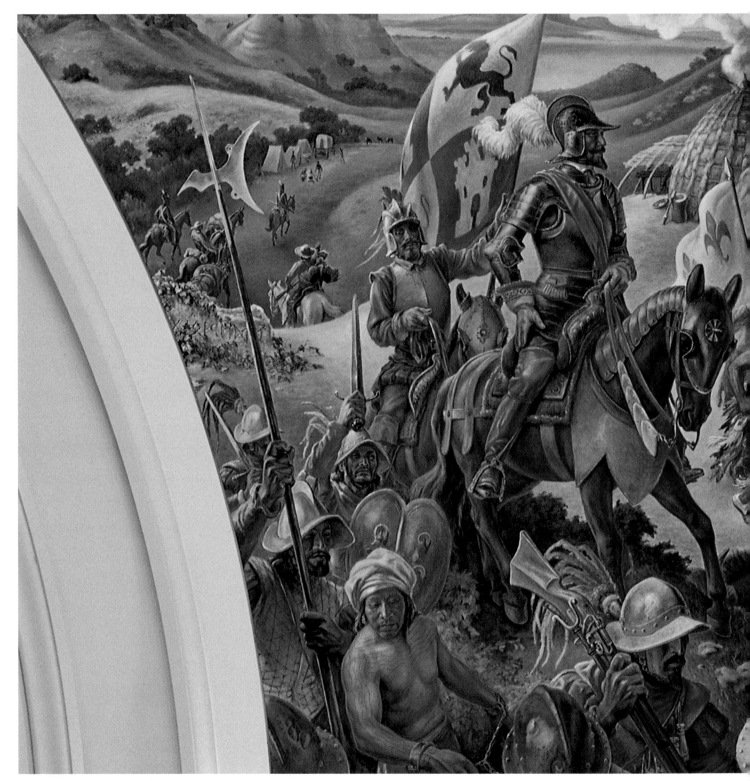

DISCOVERY AND EXPLORATION — 1541–1820

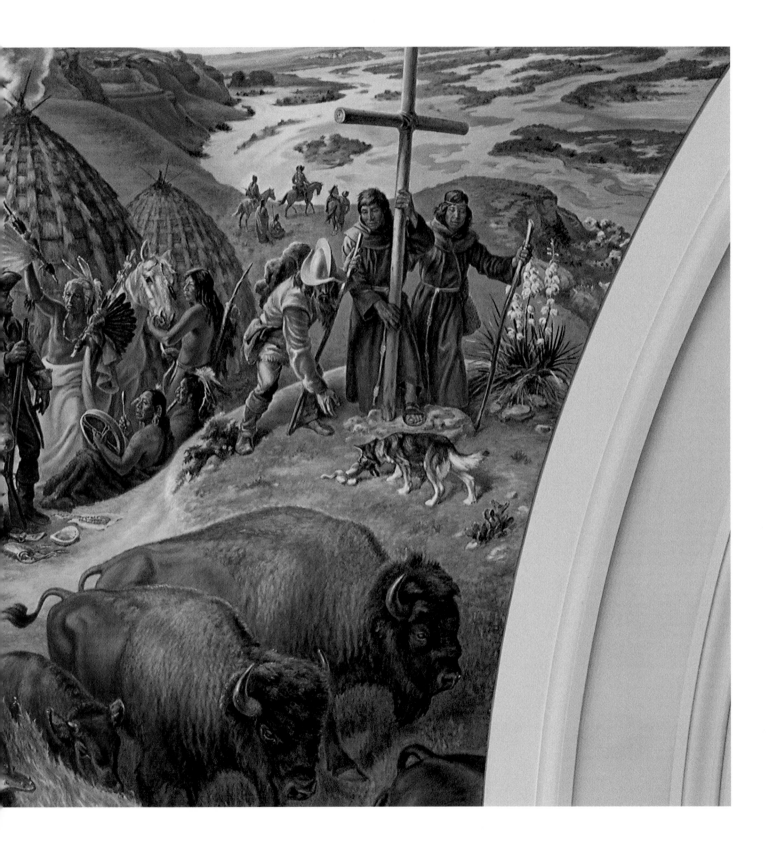

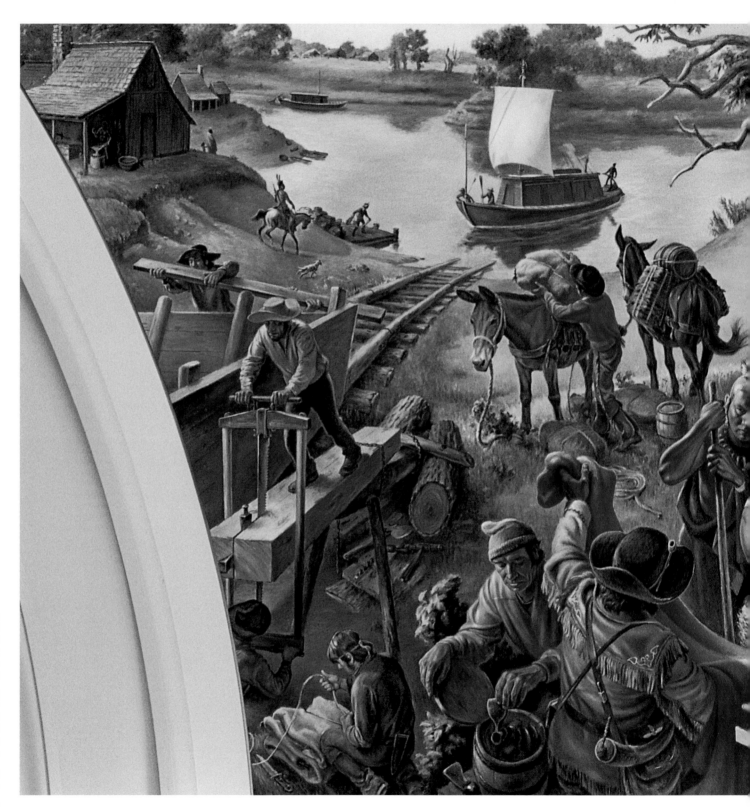

FRONTIER TRADE — 1790-1830

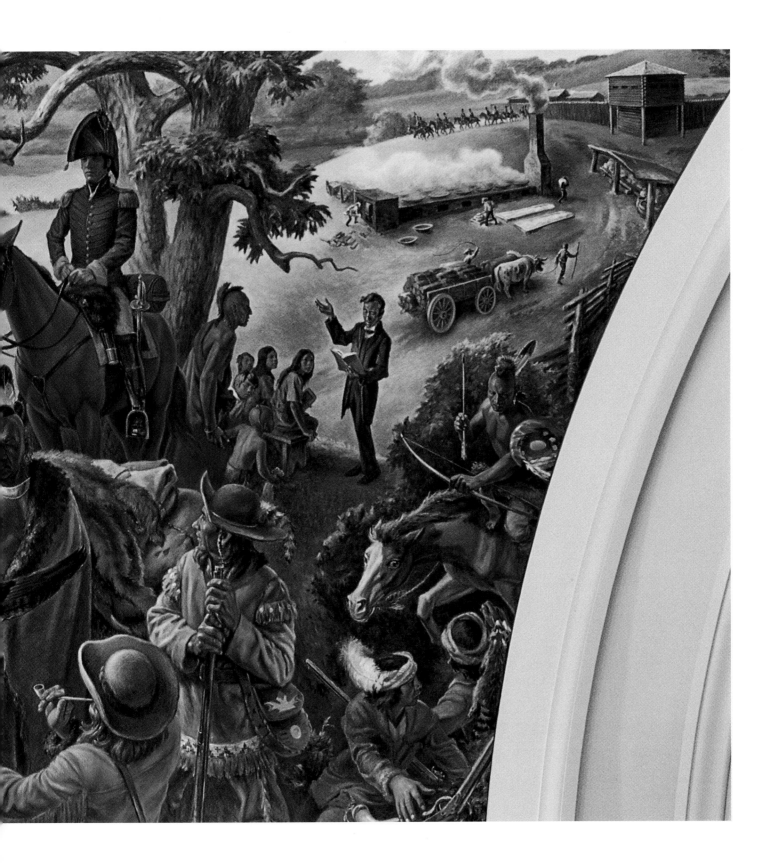

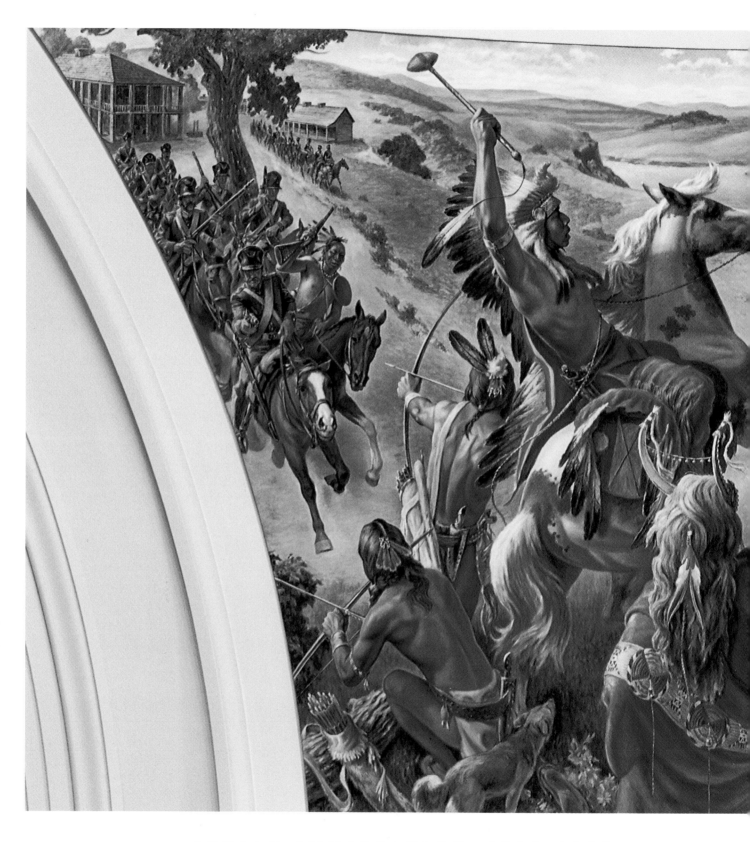

INDIAN IMMIGRATION — 1820-1885

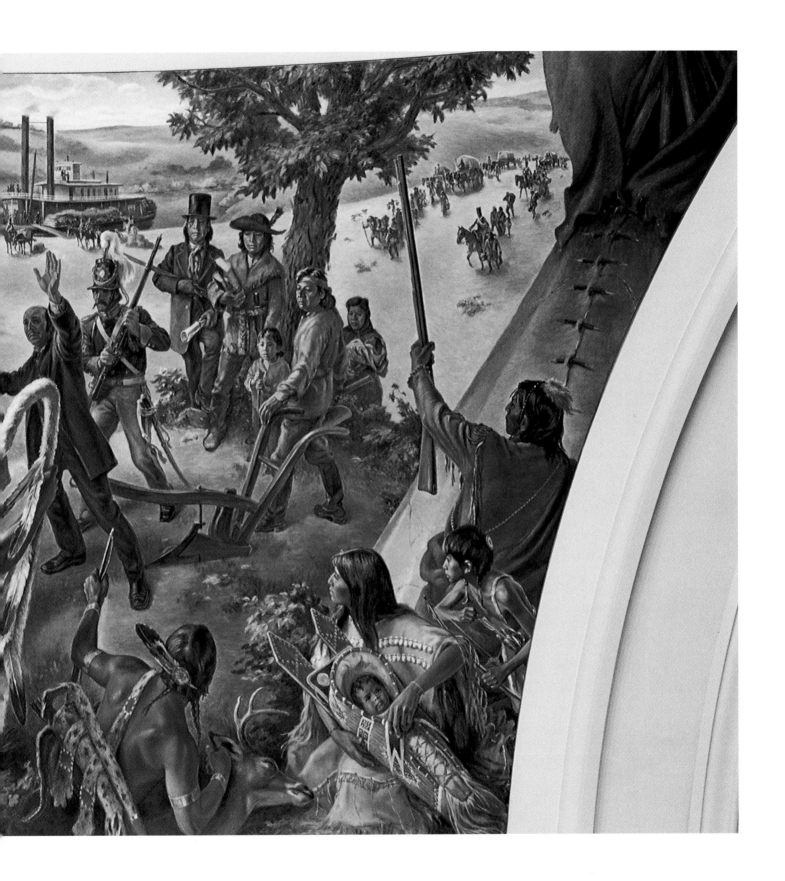

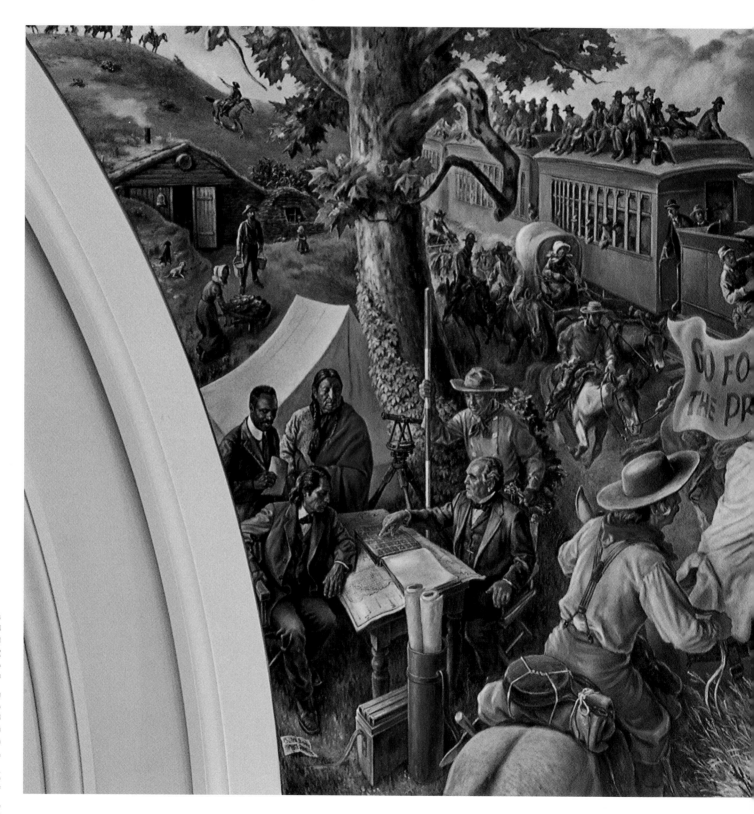

NON·INDIAN SETTLEMENT—1870·1906

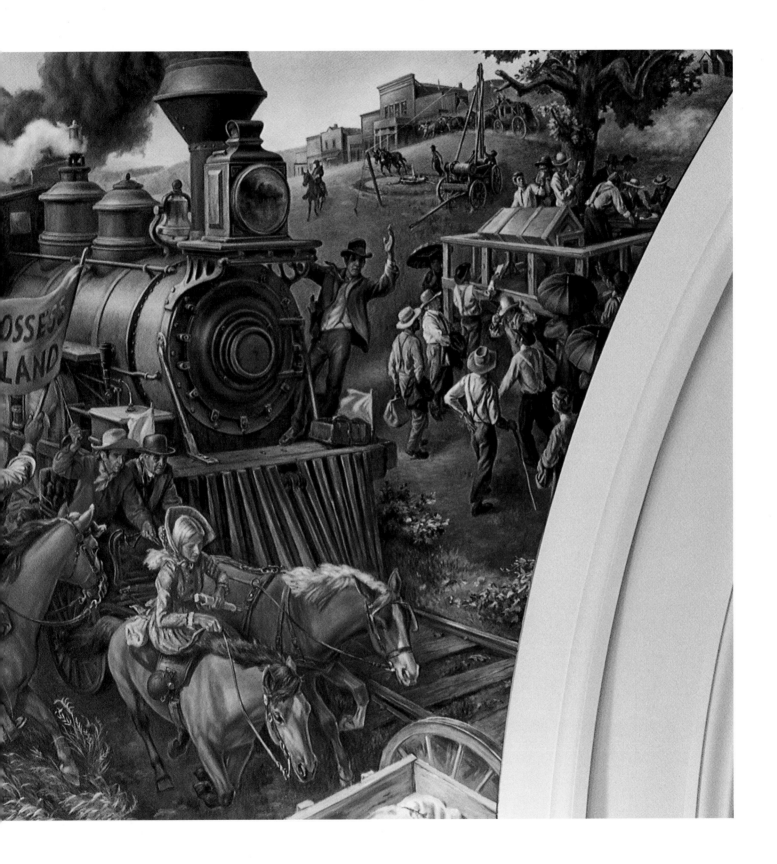

A final group of murals adorning Oklahoma's capitol are of etched-glass done in bas-relief by Marrilynn and Gary Adams of Edmond. The artists decided in the late 1970s to follow their dream of building a stained glass studio, which they named Dragon's Gate. Fascinated by the beauty and timelessness of glass, they ventured beyond stained glass into glass sculpture. Hours in the blasting booth, a dusty and physically demanding job, have resulted in many ethereal and beautiful glass sculptures. The third member of the Adams team is Danny Newsome, a master carpenter who designed unique methods to produce etched glass masterpieces. The team's work at the state capitol includes a series of four panels for the state treasurer's office that depict early settlers and the Trail of Tears. Oklahoma farmland scenes, called *Waves of Grain,* were created as part of the remodeling of the governor's office during the second term of Governor Henry Bellmon.

In 1989, Carl Reherman, director of the Nigh Institute of State Government at the University of Central Oklahoma, commissioned Marrilynn and Gary Adams to produce the 45th Infantry Memorial mural. The project was sponsored by Edmond publisher Ed Livermore, Jr. The 45th Infantry Division is Oklahoma's famous national guard unit, which saw active duty in World War II and the Korean War. In the mural, the Adamses show a small boy and his grandfather looking back on scenes from the European front of World War II, including a concentration camp. The thunderbird, the symbol of the 45th Division and a symbol for rain, is visible in the clouds. One of the 45th's most famous military actions was the occupation of Sicily, an operation made exceptionally difficult because of heavy rains. On the right of the sculpture is a soldier in a foxhole reading a newspaper commemorating the 45th's own cartoonist, Bill Mauldin, who made Army cartoons famous during World War II. The Adamses completed the 45th mural only thirty minutes before its official dedication in 1989.

Lieutenant Governor Robert S. Kerr, III commissioned the creation of another Adams mural, *The Patriots,* during a remodeling of the lieutenant governor's office on the capitol's second floor. For this work, the Adamses chose many Oklahoma heroes, including representatives of all branches of the military, astronauts, and Indian warriors.

THE PORTRAITS

FOURTH FLOOR PORTRAITS
BY CHARLES BANKS WILSON

More than thirty-six years after the commissioning of Gilbert White's war memorial murals, *Pro Patria,* the state legislature decided for the first time to spend tax money on art for the capitol. In 1963, Charles Banks Wilson of Miami, Oklahoma, was commissioned to paint portraits of four great Oklahomans—Will Rogers, Sequoyah, Robert S. Kerr, and Jim Thorpe. Wilson was once introduced to President Harry S. Truman by Thomas Hart Benton as "America's greatest artist-historian." In the 1960s, he was already known around the world for his well-researched lithographs of Native Americans, and he had illustrated a new Oklahoma history textbook for the public school system in 1955. Initially, he was approved to paint the life-size portraits of only Rogers, Sequoyah, and Kerr, whose recent deaths had stirred the hearts of legislators to honor native sons of Oklahoma. Wilson had Jim Thorpe in mind for the fourth portrait but the idea was opposed by some legislators. Eventually, Governor Henry Bellmon backed Wilson's choice of Thorpe, and debate on the subject ended. The painting of the four portraits was difficult because all four men were dead. Sequoyah was a legend, and most Oklahomans recognized the likenesses of Rogers, Kerr, and Thorpe.

Wilson's portraits were placed in spaces in the capitol that architect Solomon Layton had reserved for "statuary." The masterpieces received national attention and were reproduced throughout the state and region. Their acceptance brought a new call for more art to be placed in the capitol.

The first of the portraits completed by Wilson for the fourth floor rotunda was that of Will Rogers. Capturing the image of Rogers was not new for Wilson, who had painted the great Oklahoma humorist in person in 1934, just a year before his death and that of aviator Wiley Post in a plane crash in Alaska. However, recreating the face of an American icon was difficult. The movies had shown Rogers as a slouching, shuffling character in contrast to the Rogers that Wilson knew—the proud Cherokee Kid who carried himself like the athlete he was. Rogers was the most beloved man of his time—movie star, newspaper columnist, philosopher, and humorist. By 1963, more than two dozen books had been written about him, and his life was documented by hundreds of photographs and motion pictures. Wilson studied them all, with the goal of capturing the "easy dignity" of Rogers. The eight-foot-tall painting (page 81) shows Rogers on an airstrip in a pasture, a man on the go with his coat over his arm and his hat in his hand. The scene was an accurate historical setting for Rogers, who was the most air-traveled person of his time and was commonly called the

"Patron Saint of Aviation." Rogers did much to introduce passenger air travel to the world. For Rogers' head, Wilson used a series of photos rather than a single one. He wished to create the expressions and characteristics of Rogers as he matured from a young man into an older gentleman.

Wilson began his research of Sequoyah, whose real name was George Guess, with an old crayon portrait redrawn from a painting by Charles Bird King that had burned in a fire at the Smithsonian Institution. The artist took the drawing around Tahlequah, Oklahoma, asking if anyone knew someone who resembled Sequoyah, the inventor of the Cherokee alphabet. Eventually six men and one woman became models for the second fourth floor rotunda portrait (page 80)—all contributing some physical characteristic similar to that of the great Sequoyah.

For days, Wilson walked the hills around Sequoyah's cabin home near Sallisaw "hoping to get their rhythm in me and into the portrait." He carefully recorded timber and wild plants. He studied coats and leggings that came over the Trail of Tears. He read the ancient description of the shawl that appears on Sequoyah's head as a turban. In the portrait, Sequoyah holds the ingenius syllabary which made the Cherokees among the most literate people in the world. Sequoyah was depicted writing his name. He is writing in the soil with a stick, as was the educator's practice when drawing his word pictures for inquiring Cherokees. Even though Sequoyah was a myth to most modern Oklahomans, Wilson hoped that people would see in the portrait a very mortal man to be admired and honored.

"King of the Senate" and "The Modern Father of Oklahoma" were how Robert S. "Bob" Kerr was remembered when he died on January 1, 1963. Kerr was Oklahoma's senior United States senator, and he wielded immense power at the top levels of government. He was a former governor of Oklahoma—the first native son to be governor—as well as an oil executive and philanthropist. More than once, Wilson had "fallen under the spell of his oratory," and he had discussed painting the senator before his death.

In forty feet of canvas (page 84), Wilson includes a number of symbols of Kerr's life. The Black Angus bookend represents the breed of cattle Kerr loved and raised on his ranch. The bookend supports a Bible, filled with scraps of paper marking scriptures that Kerr surely referred to for inclusion in his speeches. These items rest on the top of a maple desk from Kerr's Oklahoma office. The senator wears a blue chambray shirt, his trademark, monogrammed R.S.K. by the fashionable company that made it. His pockets are stuffed with note pads and pencils. After the painting was completed, Wilson was amused by Kerr's friends who recognized items such as hand lotion and lip balm that caused pocket bulges. Wilson said, "Many old friends smile when they notice his tie is typically uneven." The background of the portrait is a large map, symbolizing Kerr's dream for the development of the Arkansas River and its tributaries. He holds his glasses, emphasizing a point about legislation involving land, wood, and water, the three natural resources that became the title to Kerr's book of which a replica is worn as a tie clasp in the portrait.

The last of the Charles Banks Wilson portraits commissioned in 1963 was that of Jim Thorpe (page 85), voted by the Associated Press the greatest American athlete of the first half of the 20th century. Thorpe was the star of the 1912 Olympics and was recognized by the King of Sweden as the greatest athlete in the world. He was stripped of his medals a year later, however, when it was discovered that he had violated Olympic rules by playing a few games of professional baseball. Thorpe later played major league baseball and professional football and was the first president of what became the National Football League.

Wilson used doctors' measurements of Thorpe—"the most perfectly developed man. . . the nearest thing to a Greek god." Only a few photographs were in existence and no one model could duplicate Thorpe's physique. Wilson said, "It was difficult to find a man powerful enough in legs, arms, and shoulders to put the shot and throw the discus, yet built for speed to excel in the sprint, hurdles, high jump, and broad jump." The artist found Thorpe's forearm on a man who worked as a bricklayer and a Thorpe-like deltoid on a young farm worker. Other athletes served as models for ankles and the neck but Wilson had to use his imagination to create the muscles above Thorpe's knees. Wilson meticulously documented the details of the discus, track shoes, Olympic emblems, hurdles, suits, and the national flags of 1912, as Thorpe stands ready to woo the world with his athletic prowess.

Carl Albert was known as the "Little Giant from Little Dixie" as he represented Oklahoma's Third Congressional District and became Speaker of the United States House of Representatives. A Rhodes Scholar from McAlester, he was diminutive in size but large in spirit and leadership. In his post as house speaker, the highest office ever occupied by an Oklahoman, he twice was in line for the American presidency between 1971 and 1976 because of vacancies in the vice president's office. Wilson's portrait (page 82) juxtaposes the one-room schoolhouse Albert attended in Bugtussle, Oklahoma, with the dome of the Capitol in Washington, D.C., where Albert served Oklahoma and the nation for decades. The artist spent many hours with Albert over more than a year, studying him and reviewing hundreds of photographs. Wilson called the Albert painting one of his finest works. Governor David Boren presided over the dedication of the Carl Albert portrait on May 18, 1977. Boren called Albert "one of the greatest Americans of his generation."

The only portrait of a woman to hang in the public area of the capitol is that of historian and author Angie Debo (page 83). Commissioned by State Representative Robert Henry of Shawnee and state senator Penny Williams of Tulsa, the portrait was unveiled in 1985 by Governor George Nigh. Debo was ninety-five years old when Wilson sketched her in her Marshall, Oklahoma, home. The aging historian could only sit for an hour at a time so Wilson made a half dozen trips to observe her.

Debo is arguably Oklahoma's greatest historian. She bravely wrote of wrongs inflicted upon Oklahoma Indian tribes by white government leaders. Some of her most important works had to be published outside Oklahoma because of political pressures. In this oil on canvas, Wilson shows Debo sitting on a sofa with some of her books on the shelf behind her, including a biography of Geronimo, *A History of the Rise and Fall of the Choctaw Republic, And Still The Waters Run,* and *The Road to Disappearance.*

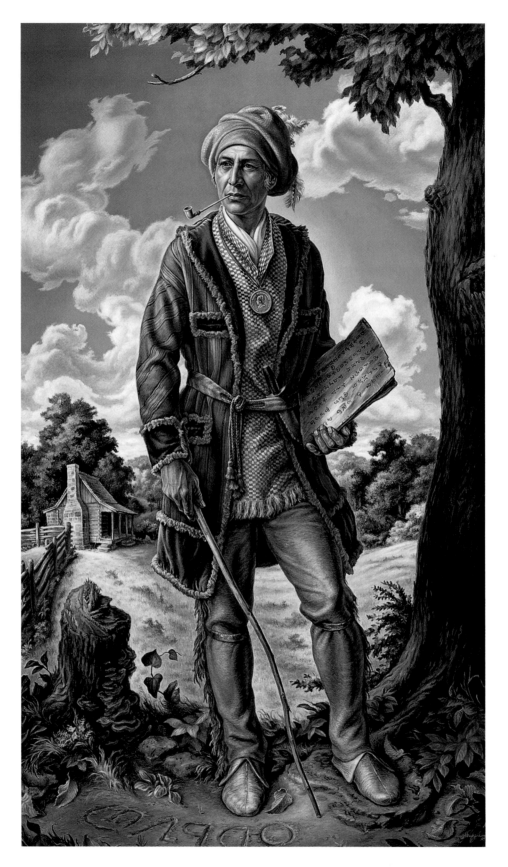

SEQUOYAH

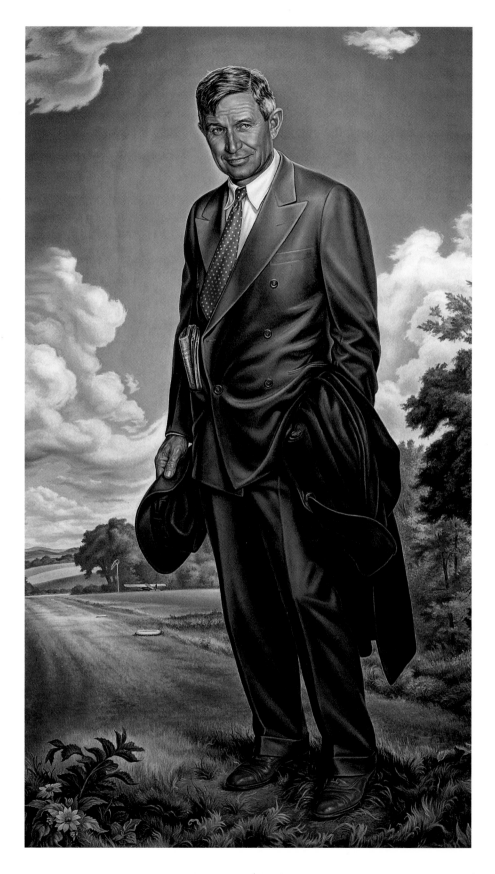

WILL ROGERS

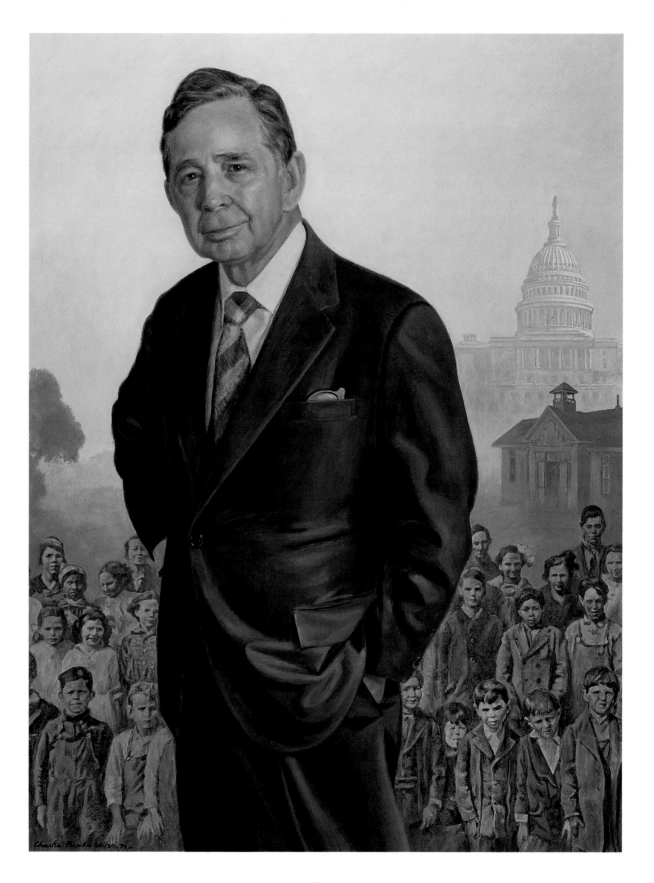

CARL ALBERT

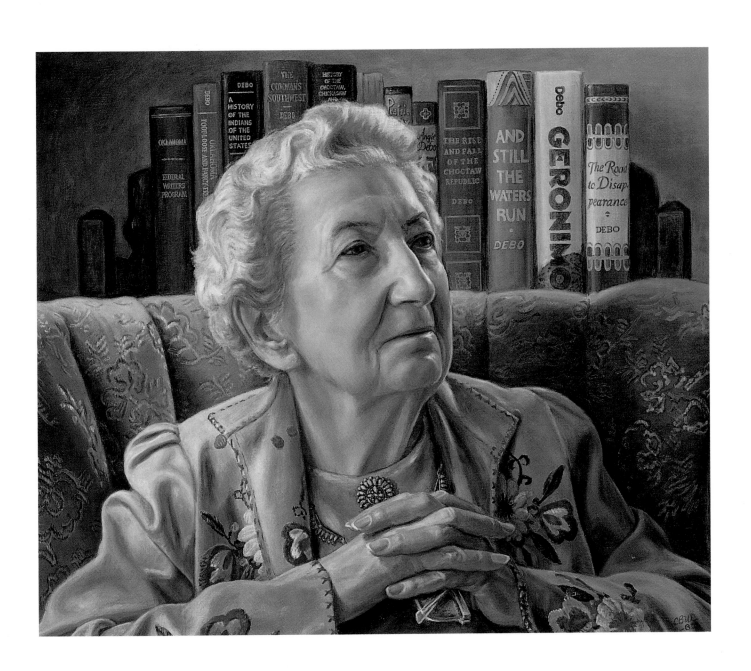

ANGIE DEBO

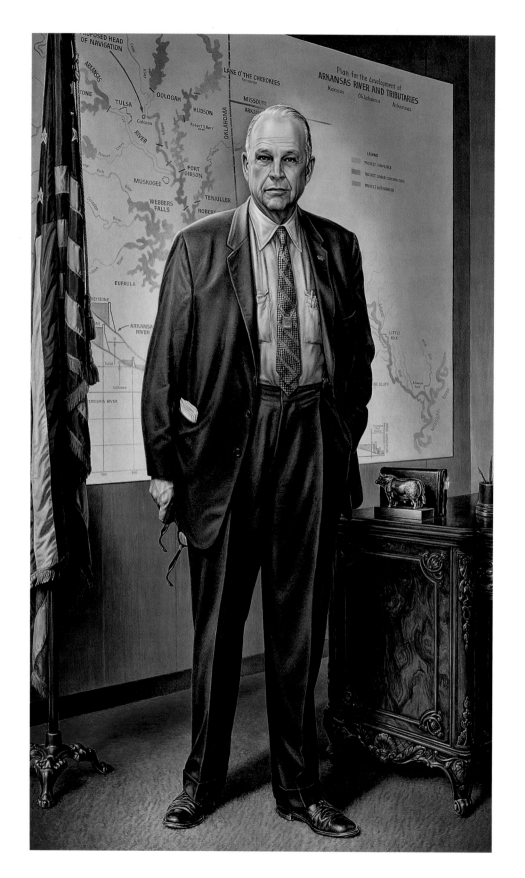

ROBERT S. KERR

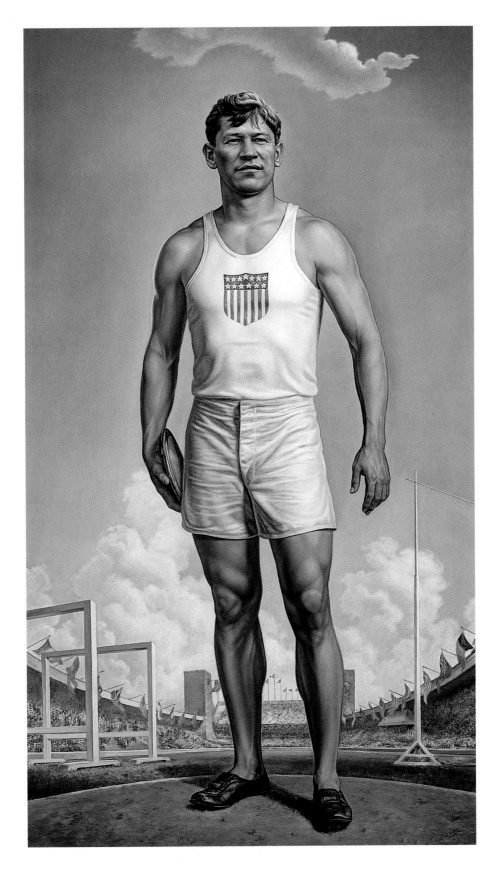

JIM THORPE

In 1983, legislation sponsored by the Oklahoma Legislative Black Caucus provided sufficient funds to the State Capitol Preservation Commission to commission portraits of four prominent African Americans who had made significant contributions to the history and culture of Oklahoma. On February 7, 1984, the four portraits were unveiled in an elaborate ceremony presided over by Governor George Nigh; Legislative Black Caucus chairman, Representative Don Ross of Tulsa; Miss America, Vanessa Williams, and Betty Price. The four Oklahomans honored were Roscoe Dunjee, Edward P. McCabe, Benjamin Harrison Hill, and Albert Comstock Hamlin.

Norman artist Mitsuno Ishil Reedy, a native of Japan, painted the portrait of Roscoe Dunjee, who played a major role in the struggle for civil rights in Oklahoma during the first half of the 20th century. Dunjee was the longtime editor of *The Black Dispatch* in Oklahoma City, a nationally known newspaper he founded in 1915. His lucid and timely editorials helped shape Oklahoma's future.

Dunjee was an early leader of the National Association for the Advancement of Colored People (NAACP) and personally sought out plaintiffs for lawsuits which the United States Supreme Court would use to change discriminatory laws and practices for the entire nation. Dunjee worked with young NAACP lawyer Thurgood Marshall to maneuver cases through the court system to outlaw all-white juries in America and to make it possible for African Americans to attend formerly all-white institutions of higher education. Poet Melvin B. Tolson once said that Dunjee did more for the cause of human dignity than any other Oklahoman of any race.

Reedy began painting portraits, still lifes, and landscapes in the 1970s. She has studied with notable pastel artists Albert Handell and Daniel Greene and oil painters John Howard Sanden and David Leffel. Her commissioned portraits include corporate and civic leaders, college deans, doctors, military officers, federal judges, and children. Her works are on display in several public buildings in Oklahoma.

For the Dunjee painting, Reedy was provided with a few black and white photographs of Dunjee, whom she painted in color. She had to use her imagination to depict the newspaper publisher. At the unveiling of the portrait, close friends of Dunjee applauded the artist for "capturing his essence."

DAVID L. PAYNE

BY JOE R. TAYLOR

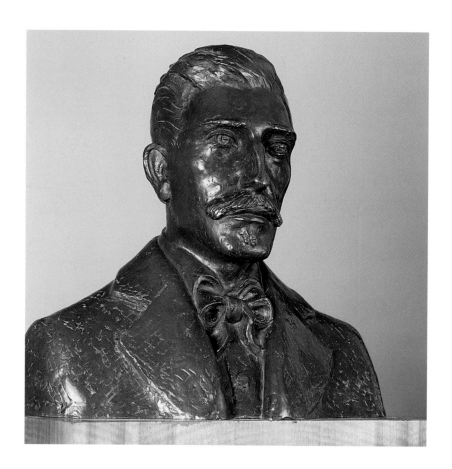

Taylor's bronze sculpture of David L. Payne, "Oklahoma's Original Boomer," was a gift of George E. Massey, who came to Oklahoma in the Land Run of 1889. Captain Payne, a native of Indiana who was named after his cousin Davy Crockett, led the "Oklahoma Boomer" movement in the 1880s in an attempt to settle the Unassigned Lands that would ultimately be opened to public settlement by lottery and land runs.

Payne organized hundreds of pioneers into colonies with the idea of leading them into the unsettled lands that he considered to be public domain and open to homestead. He was detained by federal troops and forcefully removed from the Unassigned Lands six times, but continued to lead the fight to open the lands of central Oklahoma to homesteaders. He died in 1884—witnessing the Land Run of 1889 for which he had so valiantly fought. For his efforts to settle what became Oklahoma, Payne has been called the "Father of Oklahoma."

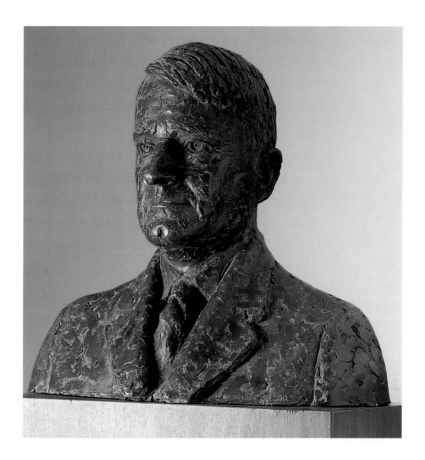

Robert L. Williams is possibly the one man most responsible for the completion of Oklahoma's domeless capitol, which occurred during his governorship. During the building's construction, Williams oversaw even the smallest detail, declaring that Oklahoma should have a capitol "built honestly and efficiently." Williams was a strong proponent of removing the dome from the capitol's plan because of his desire to stay within the construction budget and because he believed the dome would be "useless ornamentation."

World-renowned sculptor Joe R. Taylor created the bronze sculpture of Williams, a gift to the capitol from the Robert L. Williams Estate. Taylor was professor of art and sculpture at the University of Oklahoma for nearly four decades. His sculptures are among the most prominent in the state, including the sculpture of Dr. William Bennett Bizzell in front of the library that bears his name on the University of Oklahoma campus in Norman.

Mike Wimmer studied scores of photos of Oklahoma aviator Wiley Post before completing this oil on canvas, dedicated in November, 1998, the one hundredth anniversary of Post's birth. Post was the first pilot to fly solo around the world, invented the pressurized flight suit, discovered the jet stream, and was one of the most popular men on the planet when he and Will Rogers died in a plane crash at Point Barrow, Alaska, August 15, 1935.

The Post story is a saga of accomplishment against great odds. The Maysville, Oklahoma, resident became the world's most famous pilot in the 1930s despite the fact that he had only a sixth grade education, had a prison record, was haunted by a severe depression problem, and had only one eye. The artist said, "Although Wiley stood only a few inches above five feet, his achievements marked him as a giant with few peers."

The Wiley Post portrait was a project of the Wiley Post Centennial Commission and was made possible by grants from Southwestern Bell Telephone Company, Bob Burke, and Kerr-McGee Corporation. The portrait was Wimmer's first commission for the capitol. Before and after the Post portrait commission, he has published several award-winning children's books such as *Homerun: The Story of Babe Ruth* and *Flight: The Journey of Charles Lindbergh.* In 2002, he joined Oklahoma Governor Frank Keating to produce children's book about Oklahoma's favorite son, Will Rogers.

Wimmer grew up in Muskogee, Oklahoma, where he began painting in the seventh grade. He was a high school football star who gave up his dream of being middle linebacker for the Chicago Bears when he arrived at the All-State football game to find that he was smaller than most players. He earned a bachelor of fine arts degree from the University of Oklahoma and has worked as an illustrator since. Wimmer's theory of his work—"Words are the wings of our imagination, but pictures are the final destination."

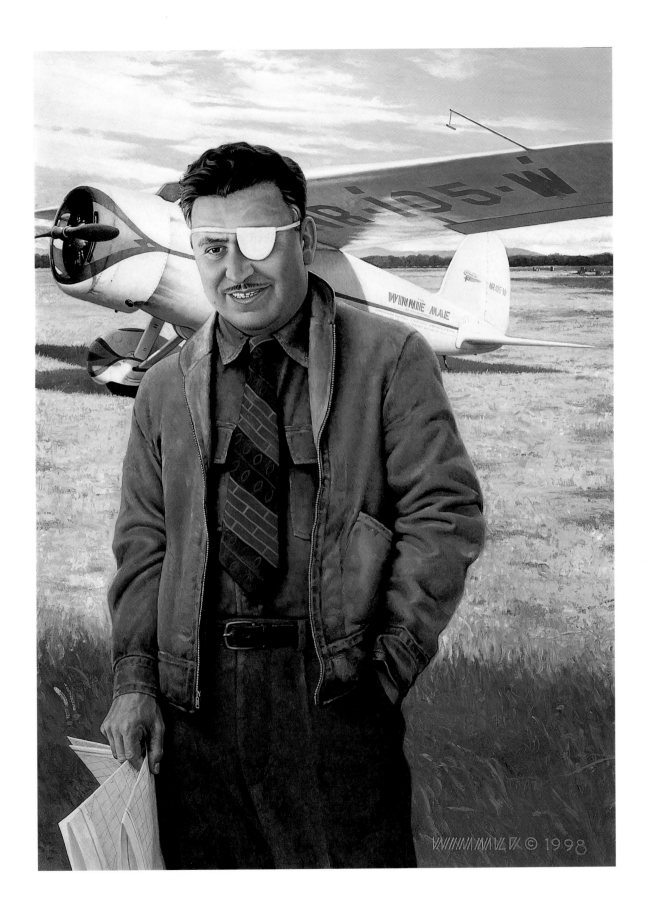

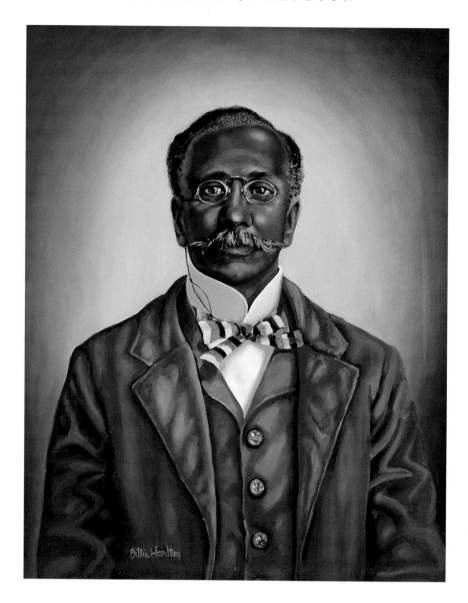

The portrait of Edward P. McCabe was painted by Billie J. Harlton of Tulsa. McCabe was one of the most powerful African Americans in the Southwest; he founded the all-black town of Langston and advanced the idea of Indian Territory becoming an all-black state. He was state auditor of Kansas before moving to Oklahoma. When Oklahoma was opened to settlers, McCabe was appointed assistant territorial auditor, one of the highest government posts in the U. S. held by an African American. He was nearly appointed governor of Oklahoma Territory but objections to his race defeated his dream of governing the territory without regard to race or color. McCabe used his power to seek equality for his people and fought for their civil rights during territorial years.

Hamlin's portrait was painted by artist Lorelei Chowning Welch of Sallisaw. Hamlin, the first African American to serve in the Oklahoma legislature, was born in Kansas but moved to Oklahoma Territory with his family in 1890. Elected in 1908 to the legislature, Hamlin worked for the passage of legislation on a variety of subjects. However, he is best known for authoring the bill that established the Taft School for deaf, blind, and orphaned children.

Oklahoma City artist Felix Cole, a native of Tulsa, painted the portrait of Benjamin Harrison Hill, a longtime Tulsa civic leader, minister, journalist, and state legislator. At the ceremony at which Hill's portrait was unveiled, his widow, Fannie Hill, looked out over the hundreds of Reverend Hill's former parishioners who had trekked from Tulsa and said, "It looks like the whole congregation is here."

Hill, a native of Canada, served as pastor of the Vernon AME Church in Tulsa and was an elementary school teacher and principal. He was elected to the Oklahoma House of Representatives in 1968.

THE PAINTINGS

THE EARTH AND I ARE ONE
BY ENOCH KELLY HANEY

Dedicated on Earth Day, 1990, *The Earth and I are One* was sponsored by Kerr-McGee in cooperation with the office of Attorney General Robert Henry and the State Arts Council of Oklahoma.

Governor Jack Walton was impeached by the Oklahoma House of Representative and ousted from office by the state senate in 1923 after serving as governor for less than a year. Walton's administration had begun in fine style with 75,000 people attending a free barbecue at the state fair grounds. Buffalo, bear, venison, antelope, and beef were barbecued in pits dug in the ground.

In 1976, artist Jean Richardson of Oklahoma City was commissioned by the Oklahoma House of Representatives to portray the great and historic debate that took place during the proceedings against Governor Walton. The governor was charged with general incompetence and corruption in office although most historians believe that his struggle began when he declared all-out war against the powerful forces of the Ku Klux Klan in Oklahoma.

Richardson was born in Hollis, Oklahoma, and is internationally known for her contemporary paintings of horses and and Native American dancers with a southwestern flavor. She was educated at Wesleyan College in Georgia and the Art Students League in New York City. Her highly textured canvasses range from the purely abstract to a suggestion of figuration. *The Debate* is an acrylic on canvas whose blacks, greens, and brown tones are reminiscent of the tones of old photographs of the event and the people who witnessed the debate. Because the painting was too large for her studio, Richardson borrowed a basement room at the Oklahoma Museum of Art in which to work. After research was completed, she worked four months to complete the work, sitting on the floor with the canvas leaning against the wall.

Last Address was commissioned by the Oklahoma House of Representatives in 1976. It depicts Speaker of the House and later governor William H. "Alfalfa Bill" Murray addressing a session of the House. The artist used old photographs of the House chamber and legislative gatherings to capture the mood of both Murray and fellow House members. Murray, certainly Oklahoma's most colorful political figure, was the first Speaker of the Oklahoma House of Representatives, a member of Congress, and served as governor from 1931 to 1935. He also was a serious contender for the Democratic presidential nomination in 1932. Stories of his eccentricity are legendary. During the Great Depression, he plowed the lawn of the governor's mansion and allowed neighbors to plant vegetable gardens. On more than one occasion, he called out the National Guard to enforce his edicts.

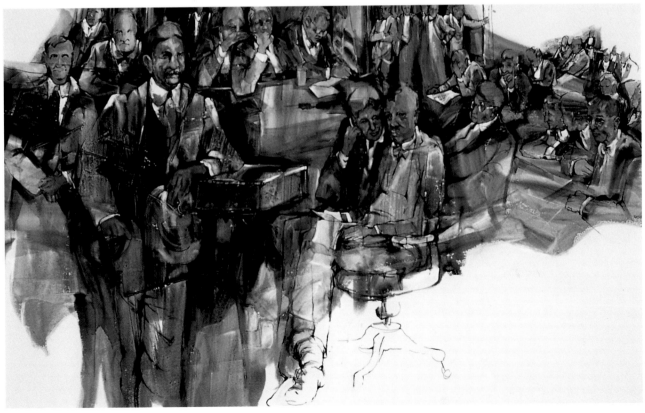

Joan Marron-LaRue is a native of Clinton, Oklahoma, graduate of the University of Oklahoma, and successful Southwest artist who now lives in Tucson, Arizona. She painted *City Towers* in 1981. The "city towers" are oil derricks which stood near the capitol in the 1930s; the capitol is shown in the background. The painting was the result of the artist's assignment from the state senate to produce something "historically significant." Marron-LaRue looked through hundreds of photographs and talked with state officials about lakes, wheat fields, and politics. Even though her research led her to paint a montage, she changed her mind and came up with the theme for *City Towers* and its companion piece, *Prairie Castles.*

Oklahoma's capitol is the only one in the world with an oil well drilled beneath it. Drilling on Capitol Site Number 1, nicknamed "Petunia," began in the middle of a flower bed on November 10, 1941. At one time, there were twenty-four oil wells pumping simultaneously from beneath the capitol grounds. The state of Oklahoma owned one-fourth of the royalty of the more than a million barrels of oil pumped from beneath the capitol.

Because of the size of *City Towers,* the canvas had to be specially stretched. The artist's home studio was too small, so she moved her paints and easel into her dining room. Marron-LaRue's works hang in many permanent collections and the State Art Collection. She is an accomplished plein-air, or outdoor painter. She is a member of American Women Artists, Plein Air Painters of America, and Northwest Rendezvous Group, Inc. She has taught art at the Oklahoma Museum of Art and fashion art at the University of Oklahoma.

Prairie Castles, the companion to *City Towers,* is also painted in acrylic on canvas and was also completed in 1981 as part of a project sponsored by the state senate. The artist visited a tepee village and came away with the idea of reflecting Oklahoma's rich Native American heritage by depicting five Cheyenne-Arapaho tepees in a small village in the autumn.

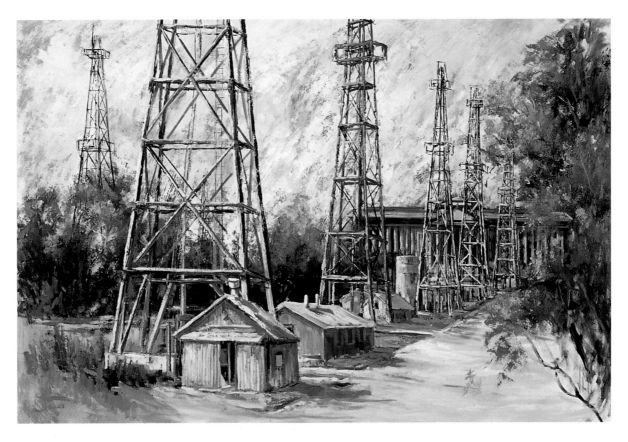

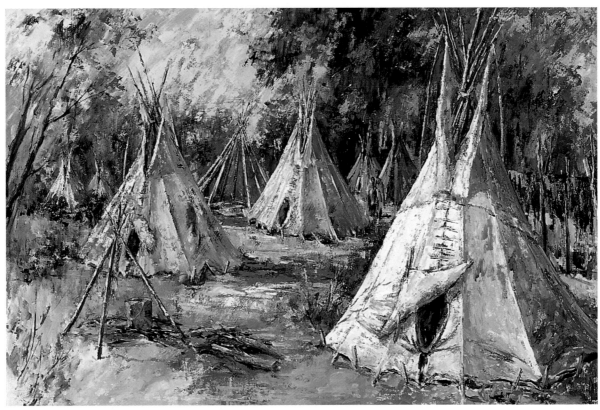

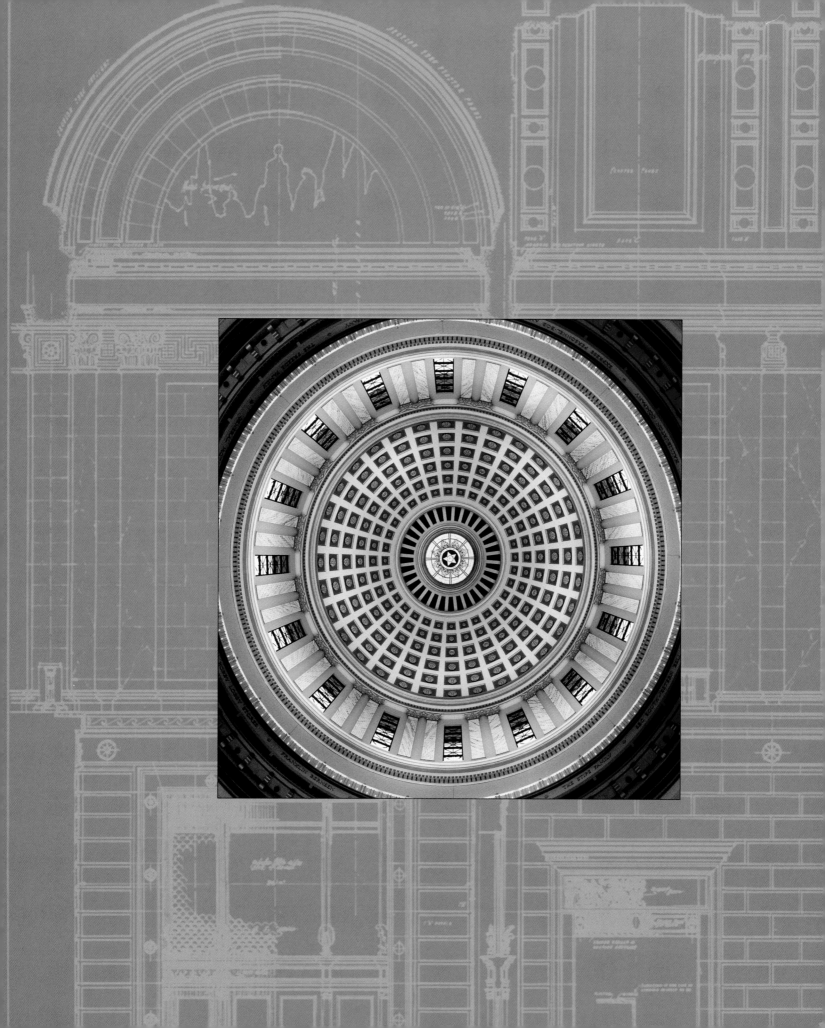

THE WORK OF THE
OKLAHOMA STATE
SENATE HISTORICAL
PRESERVATION FUND, INC.

3

Senate, House, and Courts

ART IN THE

LEGISLATIVE HALLS

THE WORK OF THE OKLAHOMA STATE SENATE HISTORICAL PRESERVATION FUND, INC.

Tulsa state senator Charles R. Ford has been an important force in adding fine art to the space occupied by the state legislature. When Ford arrived as a new member of the legislature in 1966, there was little legislative interest in commissioning paintings for the capitol, and, Ford remembered, "A great deal of architectural integrity had been destroyed by so-called modernization."

Fine art had never been a priority of the legislature. "As a poor agrarian state," Senator Ford recalled, "we had never spent public money to buy fine art for the capitol. Instead, Oklahoma began recording its important people with photography in a series of photographs of governors, legislative leaders, and judges."

As Ford gained seniority, the native Tulsan and real estate investment broker supported the work of the Arts and Humanities Council and Chief Clerk Richard

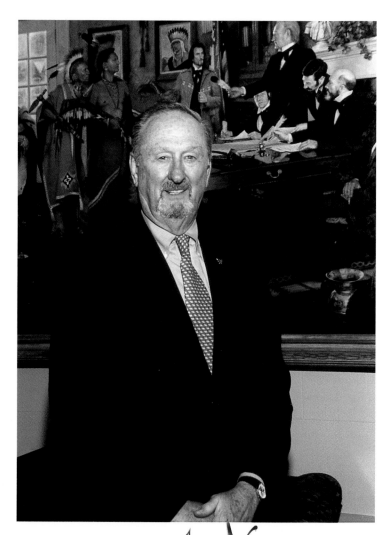

SENATOR CHARLES FORD

Huddleston's hiring of architect Paul B. Meyer to help the House of Representatives make major renovations in its chamber as well as adding new conference rooms. The senate also began renovations and added four new conference rooms. Ford recalled, "Momentum to change the look of the capitol picked up when Paul Meyer was named capitol architect and the Capitol Preservation Commission was formed." Significant changes to the legislative halls came in 1994 when the senate chamber was restored to its original grandeur. The senate lounge and the house lounge and chamber were also restored.

In 1997, Ford initiated a program to replace prints in the senate lounge with permanent fine art. He used personal funds to commission Oklahoma artist Wayne Cooper to create an oil painting based upon a vignette from Washington Irving's book *Tour on the Prairies,* depicting his meeting with Osage Indians at an encampment near present-day Tulsa.

The idea of adding original art to the legislative halls caught on. After the Cooper painting was dedicated in 1998, other senators wanted to commission art commemorating famous events and people from their areas of the state. Ford, an art and antique collector in private life, formed a 501(c)(3) tax-exempt corporation, the Oklahoma State Senate Historical Preservation Fund, Inc., to promote contributions to donate art to the state senate. By 2003, Ford had raised more than $700,000 and the preservation fund had provided more than forty-five pieces of fine art for the capitol, including paintings as large as six by ten feet. Many other projects, sponsored by legislators and art patrons in the state, are planned for the future by Ford.

Only the work of Oklahoma artists is sponsored by the Oklahoma State Senate Historical Preservation Fund, Inc., Ford said, "Because we offer them an opportunity to hang their artwork in the capitol of their state, they are excited and willing to work with us. After all, it is public art that everyone gets to see." Ford, whose idea for adding fine art to the capitol has become a passion, believes the public expects the capitol and other important public buildings to be well decorated. He said, "Art, as a method of recording history, is as old as history itself. People and governments of power have used art to honor themselves and others and tell stories of interest."

As Ford sees it, "Adding quality art work to our beautiful capitol is a never-ending work."

ART IN THE
LEGISLATIVE HALLS

WILL ROGERS

BY BORIS B. GORDON

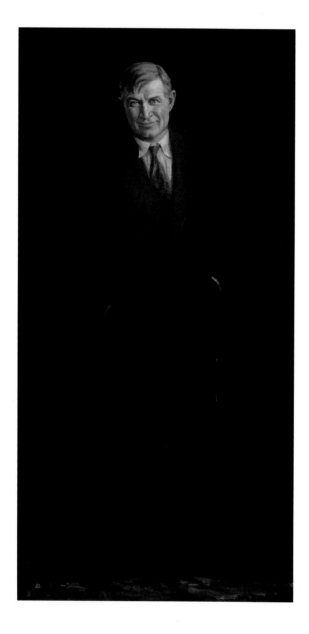

Oklahoma's favorite son posed for this portrait in 1931, at the height of his career as a leading actor, humorist, and newspaper columnist. The painter, Boris B. Gordon, won the right to paint Rogers after impressing the art community with his depictions of Abraham Lincoln and other national leaders in works on display in the Capitol in Washington, D.C. This Will Rogers portrait was exhibited during performances of the Will Rogers Follies in Branson, Missouri, but has been returned to its permanent home in the Oklahoma State Senate through the efforts of state senator Charles Ford.

Fondly known as "Miss Alice," Alice Robertson of Muskogee was the only woman ever elected to the U.S. Congress from Oklahoma. She was a sixty-six-year-old cafeteria owner when she successfully campaigned for Congress in Oklahoma's Second Congressional District in 1920. She was only the second woman ever elected to Congress. Earlier, she had been the first woman postmaster in the nation, appointed postmaster in Muskogee by President Theodore Roosevelt in 1903. The granddaughter of Samuel Worcester, an early missionary to the Indians, Robertson founded Henry Kendall College which later became the University of Tulsa.

Senator Charles Ford of Tulsa sponsored this 2003 oil on canvas by Mike Wimmer.

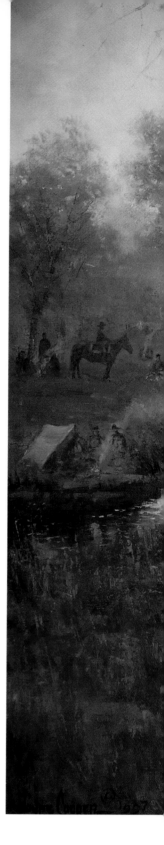

In 1998, Senator Charles Ford of Tulsa made possible this Wayne Cooper oil on canvas that depicts the historic meeting of Washington Irving and the Osage. Irving recorded the visit of an Osage village on the banks of the Arkansas River near present-day Tulsa. Cooper, of Depew, Oklahoma, shows the Irving party camped for the night with the curious Osage mingling around the campfire, no doubt seeking a taste of coffee which intrigued even the Native American tribes of Oklahoma. Irving wrote of the meeting, "Our arrival created quite a sensation. A number of old men came forward and shook hands with us. . . while the women and children huddled together in groups, staring at us wildly."

Cooper is known for his portrayals of western and Indian subjects. He began painting in Chicago in 1964 but returned to Oklahoma in 1981 to sculpt and paint western subjects. Collections of his work are found in a dozen countries around the world. His painting of oilman Frank Phillips hangs in the Woolaroc Museum in Bartlesville. Other works can be found at the Will Rogers Memorial in Claremore.

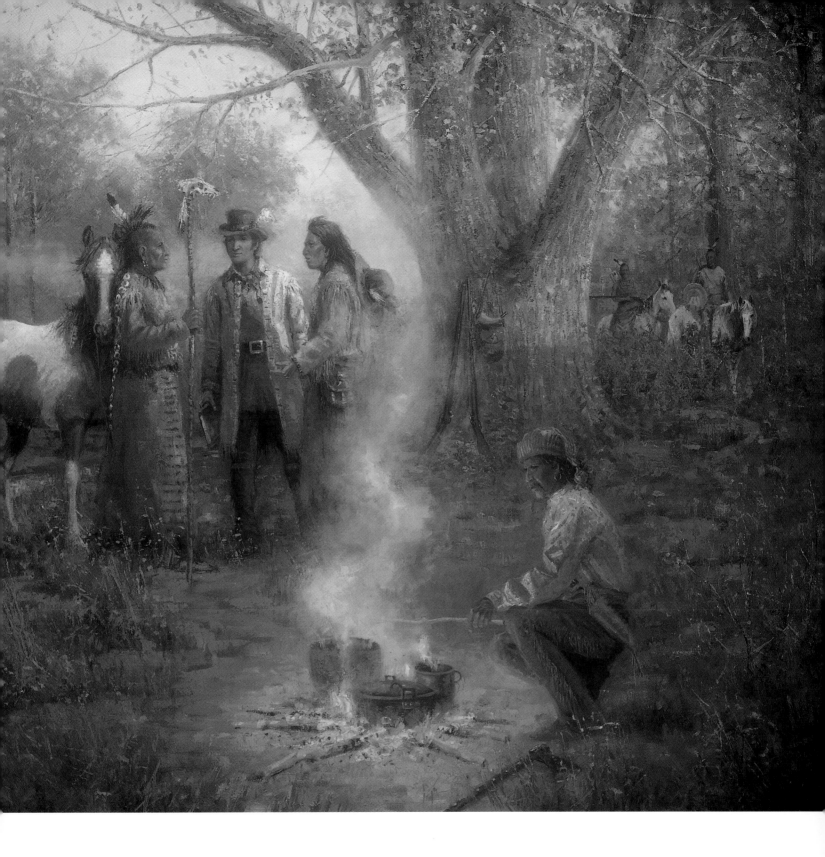

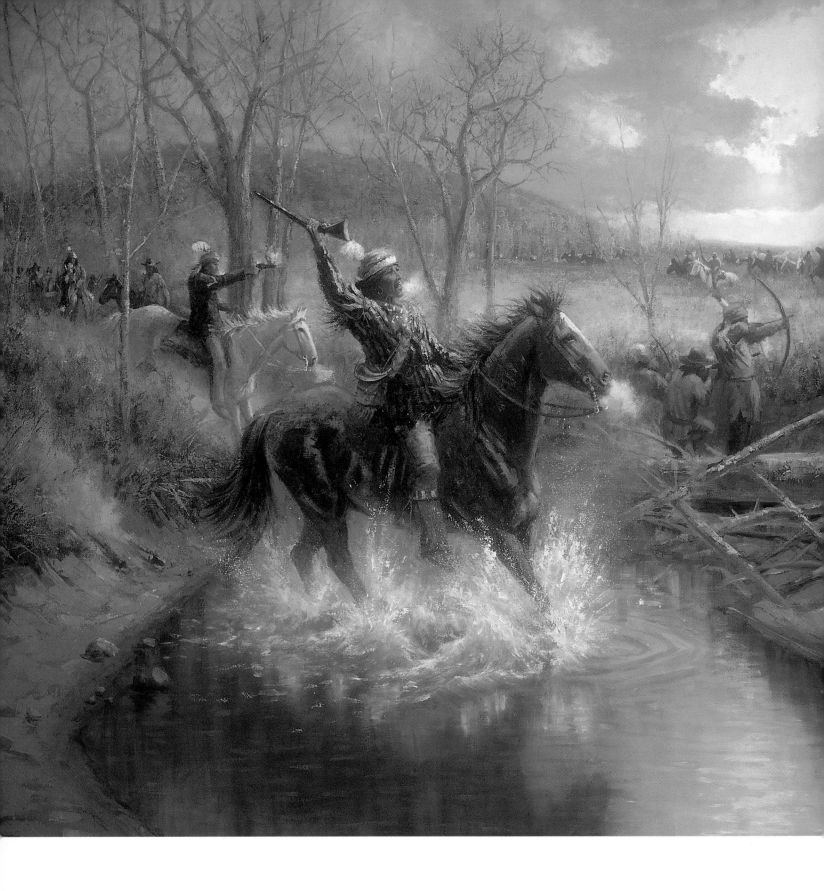

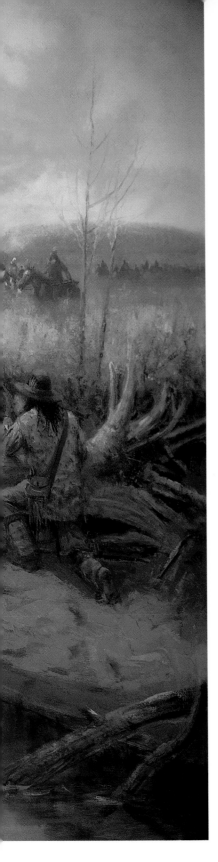

BATTLE OF ROUND MOUNTAIN, NOVEMBER 19, 1861

BY WAYNE COOPER

The first major Civil War battle fought in Oklahoma was the Battle of Round Mountain. Confederate colonel Douglas H. Cooper and troops from the First Choctaw and Chickasaw Regiment were pursuing 9,000 Creeks, under the leadership of Opothle-Yahola, who were heading to Kansas to seek protection of Union forces and avoid being pulled into the alliance with the Confederacy. At the edge of a creek near a hill called Round Mountain, Loyalist scouts turned back Confederates in the battle that lasted into the night. The Battle of Round Mountain took place near the modern town of Yale, Oklahoma. This oil on canvas was a gift in 1998 of state senator Ted V. Fisher of Sapulpa. For the artist, it was a difficult painting to research. He spent a great deal of time at the Oklahoma, Kansas, and Texas historical societies. "What makes the battle unique," Cooper said, "was Indians fighting Indians in the Civil War." Because historians do not agree on the exact location of Round Mountain, Cooper visited two areas that were very similar. In the end, he arrived on a composition that resembled both places. Cooper mused, "That way, each historian will say 'that's exactly where I said it was.'"

State senator Ben Brown of Oklahoma City sponsored another work by Wayne Cooper, the 1998 oil *Friends for a Day*, which depicts the brief friendship of Count Albert-Alexandre de Porutales, a twenty-one-year-old member of Washington Irving's party, and a young Osage boy who brought a stray horse into Irving's camp. The Cherokees believed the horse was stolen and ordered the boy flogged. However, Irving's men rescued him and Count Porutales made the lad his personal squire. In the painting, the Osage boy and Porutales are scouting the countryside on Bald Hill, northeast of present-day Sand Springs. The rock monument marks an Osage hunting trail. Advised by Osage elders that he should not stay with Irving's party, the Osage lad disappeared in the night.

Senator Charles Ford took the artist and his wife to the Bald Hill area to survey the physical setting for the painting. Bad roads prevented access. However, Ford, a pilot, flew the artist over the area several times, allowing the area to be photographed in detail.

TRAFFIC JAM AT LIMESTONE GAP
BY WAYNE COOPER

State senator Gene Stipe of McAlester sponsored this 1999 oil on canvas by Wayne Cooper that shows cattle being driven north to Kansas and commercial goods traveling south to Texas on the Texas Road in northern Atoka County. The Texas Road was a main route between Kansas and Texas, and was the busiest of all the 19th century roads that traversed what would become Oklahoma. The Choctaws built a toll bridge across Limestone Creek, the first toll bridge in Oklahoma. Later, the Missouri, Kansas, and Texas Railroad built a line through the gap. Currently, US-69 passes through the area.

The artist spent time along Limestone Creek near the current highway. He returned with photographs of the limestone formations, several good sketches, and "a load of chiggers."

In 1849, surgeon and naturalist S.W. Woodhouse accompanied government surveyors as they plotted the Creek-Cherokee boundary in Indian Territory. An expert in birds and wildlife, Woodhouse spotted the scissortail flycatcher that would become Oklahoma's official state bird nearly a century later. He also identified several species of wildlife and recorded his observations of frontier life and society and his impressions of the land in a journal. This 2003 painting by Wayne Cooper was sponsored by Senator Nancy Riley of Tulsa. The location of the painting is looking across the Arkansas River from present-day Sand Springs. The region is called Lost City because the huge limestone boulders resemble a village from a distance. Woodhouse is examining the area, taking his daily specimens for study.

SURRENDER OF GENERAL STAND WATIE

BY DENNIS PARKER

As the only Native American to attain the rank of brigadier general during the Civil War, Cherokee Stand Watie led Confederate troops in a rout of Union soldiers in the battle of Cabin Creek. The capture of nearly 300 wagons of supplies allowed the Confederates to continue the war. On June 23, 1865, Watie became the last Confederate general to surrender. This oil on canvas by Dennis Parker of Oklahoma City was a gift of state senator Jeff Rabon of Hugo in 2000 and shows Watie surrendering his command at the home of Robert M. Jones near Fort Towson in present-day Choctaw County, Oklahoma.

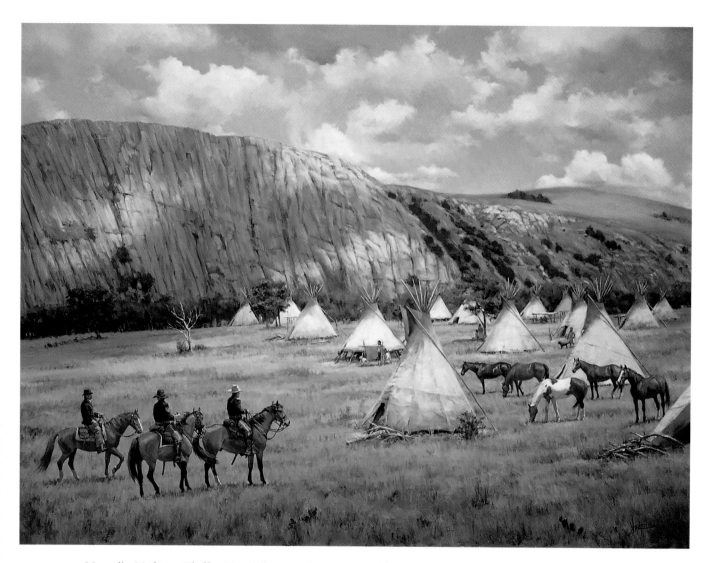

Vaupel's *Medicine Bluff at Fort Sill, 1870s* depicts a peaceful encampment of Kiowas at the base of Medicine Bluff. Kiowas had been moved to Medicine Bluff after the battle at Chief Black Kettle's village on the Washita River. Camp Medicine Bluff later became Fort Sill, Oklahoma. The 1999 oil on canvas was a gift to the capitol from state senators Jim Maddox and Sam Helton of Lawton.

The artist was born in California but now lives in Henryetta, Oklahoma. She taught herself to draw and studied in night school under Floyd Chandler. She began her art career producing advertisements but longed to paint horses, especially quarter horses. She arrived in Oklahoma in 1967 and began painting commissioned portraits of horses and rodeo scenes. Among her early works was a portrait of Wal-Mart founder Sam Walton with his hunting dogs and pheasant.

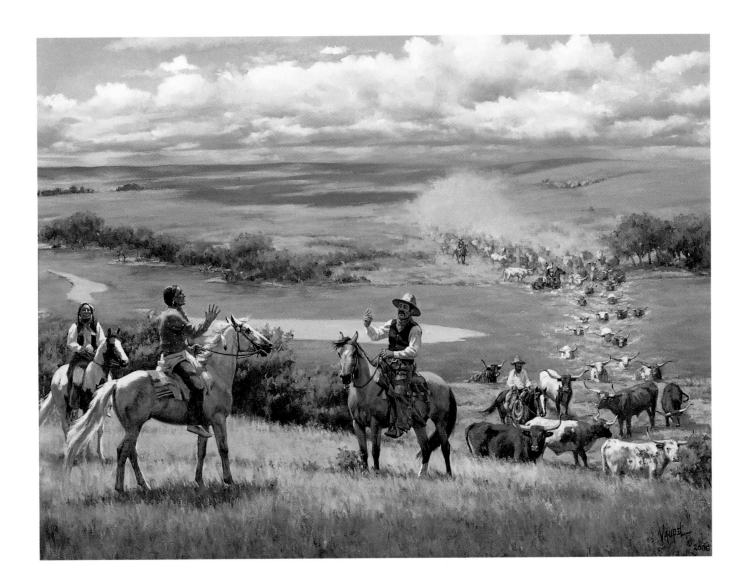

In 2000, state senator Robert M. Kerr of Altus sponsored this oil on canvas by Barbara Vaupel of cattle crossing the Canadian River near Camargo in Dewey County. After the Civil War, four major cattle trails were developed through Oklahoma as Texas-grown longhorns were driven to railheads in Kansas. This scene is on the Great Western Trail blazed by John Lytle in 1874. In the next two decades, more than 300,000 cattle were moved north over the Great Western Trail. After railroads moved into Oklahoma, the famous cattle trails became obsolete.

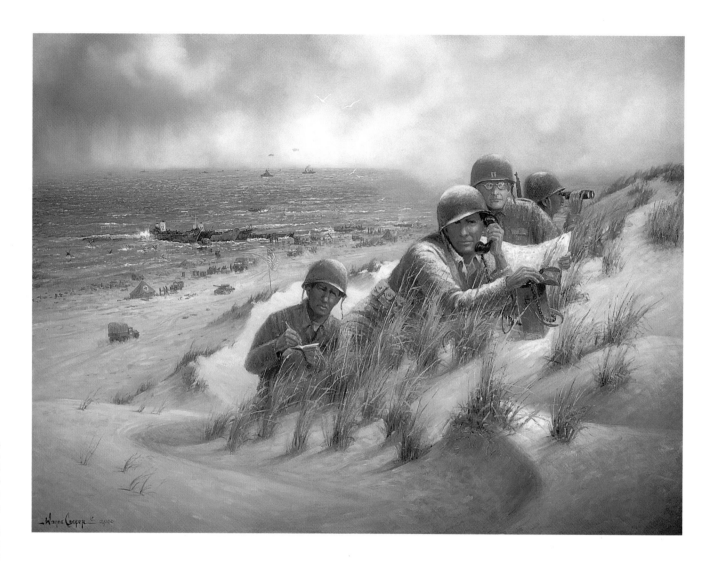

A heroic chapter of World War II is the story of Oklahoma Native Americans who used their Comanche language to provide an unbreakable code for American military forces. Comanches from the Lawton area became the Indian code talkers assigned to the United States Army Signal Corps. Of the original code talkers, only Charles Chibitty was alive in 2003. In this 2000 oil on canvas by Wayne Cooper, Chibitty is shown communicating with other troops on Omaha Beach on D-Day. This painting was sponsored by state senator Jim Dunlap of Bartlesville and Phillips Petroleum Company.

During research for the painting, the artist visited with Chibitty, the last remaining code talker. Cooper said, "As he told the story, his voice became louder and faster. He was sitting there reliving the battle. You could almost smell the gunpowder. Without a doubt Mr. Chibitty is a true American hero."

Lawton's Colonel Robert S. "Bob" Johnson was the state's highest scoring fighter pilot of World War II. This acrylic on canvas by R.T. Foster of Oklahoma City was added to the capitol art collection in 2000 through the generosity of state senator Charles Ford and Tom Clark of Tulsa. The painting depicts Colonel Johnson shooting down one of the twenty-eight German aircraft he downed during the war. Johnson's final two kills allowed him to surpass Captain Eddie Rickenbacker's total of twenty-six enemy planes downed in World War I—making the Oklahoman one of America's greatest wartime aces.

The artist R. T. Foster, a veteran of the Vietnam War, is self-taught. Some of his larger aviation murals are permanently displayed at Tinker Air Force Base, the Oklahoma Air and Space Museum, and major Air Force installations in Georgia and Ohio. His aviation paintings hang in several aviation museums and the Smithsonian Institution in Washington, D.C.

Artist R.T. Foster captured the horrible moments of the Japanese attack on the battleship USS *Oklahoma* at Pearl Harbor, Hawaii, on the morning of December 7, 1941. The acrylic on canvas was a gift to the capitol in 2001 of Admiral and Mrs. William Crowe. Admiral Crowe is the only Oklahoman to have served as chairman of the United States Joint Chiefs of Staff and was the American ambassador to Great Britain.

The *Oklahoma* took three to seven torpedoes in the attack and capsized in less than ten minutes. Only thirty-two sailors were saved from the more than 1,300 crew members on the ship. One of the reasons the ship sank so quickly was its open hatches—in that condition because the *Oklahoma* was preparing for an admiral's inspection the following day. The guns of the ship were silent because they had been broken down to be cleaned in preparation for the inspection. The sunken battleship was blocking the sea channel at Pearl Harbor so the Navy began a massive operation to upright her. Bodies found in the wreckage were interned at the Punchbowl National Cemetery near Honolulu. The once proud ship was stripped and sold for scrap for $46,000. However, the *Oklahoma* developed a list while being towed to the American mainland and plunged to the bottom of the Pacific Ocean between Pearl Harbor and San Francisco, California.

45TH DIVISION AT PORK CHOP HILL, KOREA

BY R. T. FOSTER

R.T. Foster created this acrylic on canvas dedicated in 2003 and sponsored by retired major general Fred Daugherty of Oklahoma City, a former commander of the famed 45th Infantry Division, whose soldiers fought valiantly for the United States in World War II and the Korean War.

The 45th Infantry Division was created as a division of the Oklahoma Army National Guard in 1923. The unit was used extensively to quell civil disturbances in the 1920s and 1930s, but its exploits are best remembered from the bloody battles in Europe during World War II. The 45th was called to federal service even before America entered World War II. After Pearl Harbor and America's active involvement in the conflict, 45th Division soldiers, known as Thunderbirds, participated in the invasion of Sicily and saw intense action in the conquest of Italy. The 45th was also called to active duty in Korea. This painting shows 45th soldiers at Pork Chop Hill where a company-size force of Thunderbirds inflicted heavy casualties on the enemy in a series of attacks throughout the spring and summer of 1952. Soldiers of the 45th resisted a ferocious attack by Chinese Communists to retake Pork Chop Hill in June, 1952.

PRESIDENT THEODORE ROOSEVELT, FREDERICK, OKLAHOMA TERRITORY

BY MIKE WIMMER

President Theodore "Teddy" Roosevelt visited Oklahoma Territory in 1905 as the guest of Burk Burnett, who controlled large tracts of ranchland in Oklahoma Territory and Texas. The purpose of the wolf- and coyote-hunting trip was to convince the president to consider allowing Oklahoma to join the Union. Roosevelt, who loved the outdoors, was impressed with the beauty of southwest Oklahoma.

This 2000 oil on canvas by Mike Wimmer shows a camp scene after a day's hunt with Jack Abernathy and Comanche Chief Quanah Parker. Roosevelt and Abernathy are telling tales around the campfire while enjoying a hot cup of coffee. The greyhounds used in the hunt rest beside many of the hunters who are waiting for dinner prepared by camp cooks on the chuck wagon. The four-6 brand of Burk Burnett's ranch is emblazoned on the chuck wagon. After he returned to Washington, D.C., Roosevelt created the Wichita Mountains Wildlife Refuge and later signed the proclamation which admitted Oklahoma as the forty-sixth state in 1907. The painting was the gift of state senator Gilmer Capps of Snyder.

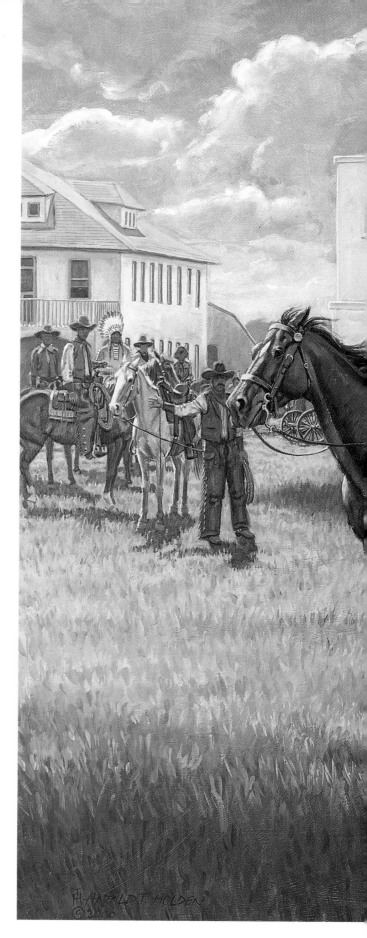

101 RANCH

BY HAROLD T. HOLDEN

The 101 Ranch was a working ranch of 110,000 acres along the Salt Fork River in the Cherokee Outlet and featured the world's greatest Wild West show from 1908 to 1932. The ranch was founded in 1879 by Colonel George Washington Miller. The Wild West show featured famous cowboys and cowgirls and Indian chief Geronimo. It played to large audiences in major cities throughout the United States and Europe. This Harold T. Holden oil on board was sponsored by state senator Paul Muegge of Tonkawa in 2001 and depicts black cowboy Bill Pickett practicing the rodeo sport he invented—steer bulldogging—in front of the 101 Ranch company store.

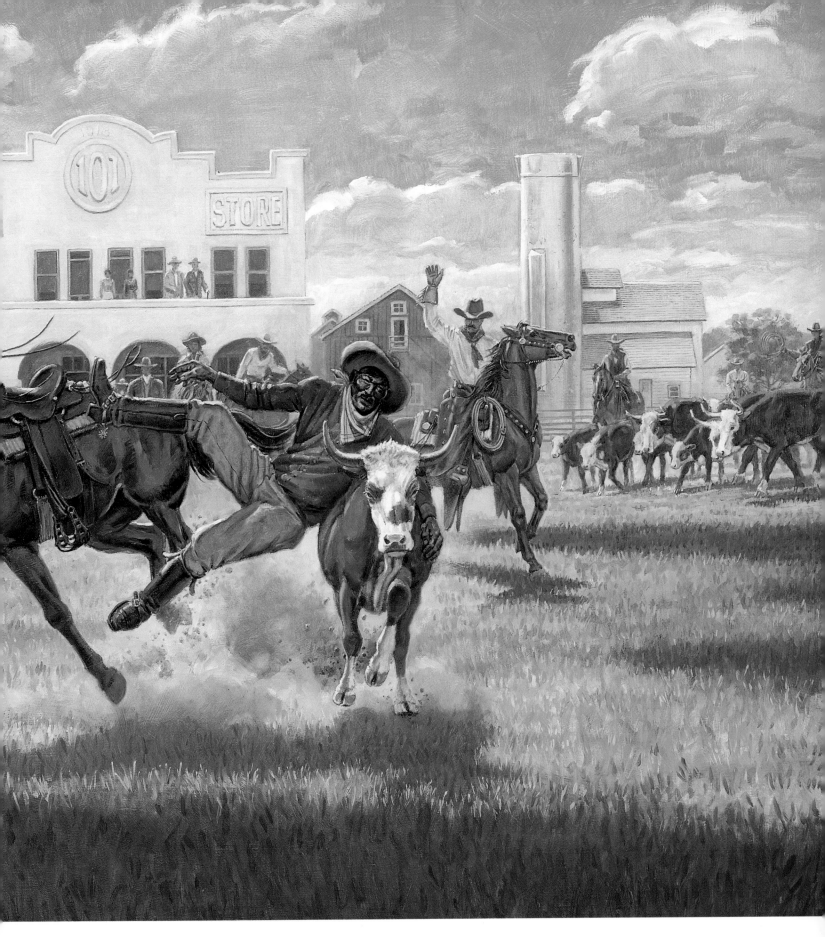

OSAGE TREATY OF 1825

BY MIKE WIMMER

The federal government negotiated a treaty with the Osage in 1825 that basically moved the Osage into Kansas to make room for the Cherokees and Creeks in what would become northeast Oklahoma. This 2001 oil on canvas by Mike Wimmer shows United States Indian commissioner William Clark offering the quill pen to Principal Chief Clairmont of the Osage at the signing of the treaty at Clark's museum in St. Louis, Missouri, on June 2, 1825. Among the witnesses present were sixty great and little chiefs of the Osage, Pierre Chouteau, and Governor Edward Coles of Illinois. This painting was a gift of the Robert and Roxana Lorton family and the *Tulsa World.*

The painting was a particular challenge for the artist because there were no paintings or drawings of the room where the signing took place. The only information available was the description given by the Marquis de Lafayette and recorded in his journal. Wimmer used a number of his friends as models and Senator Charles Ford as the model for William Clark.

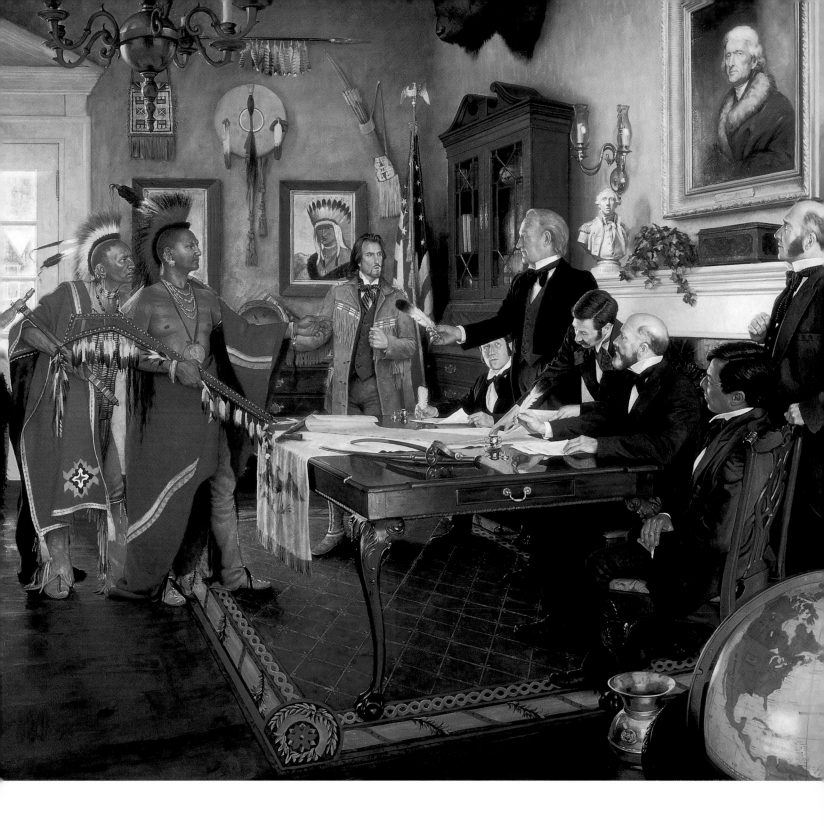

The Tulsa Tribune Foundation sponsored a 2001 series of bronze roundels created by artist Senator Enoch Kelly Haney of Seminole. Roundels on each side of the entrance to the state senate chambers pay tribute to the Native American tribes of Oklahoma.

The Power of Hope shows a mother and child—the mother is strong in the face of adversity that the eastern Tribes endured during their removal from the southeastern United States to Indian Territory. The mother will always protect her child and meet whatever lies ahead with dignity and determination.

The second roundel on the senate side of the capitol's fourth floor is *With the Vision of an Eagle.* The eagle is a symbol of vision, foresight, and leadership, all of which are embodied in the depiction of the tribal leader in the forefront of the relief.

The tribes of Western Oklahoma are depicted in the two bronzes that hang on either side of the entrance to the State House of Representatives. *The Will to Live* shows a young warrior against the background of a buffalo, a native symbol of endurance. At one time, the buffalo was nearly extinct, but ultimately not only survived but is thriving. Likewise, the people of Oklahoma have faced many tragedies and challenges, but have always overcome them all.

The Spirit of Heritage depicts an Indian mother carrying her infant in a cradleboard, imagery that is representative of the rich culture and traditions which strengthen and enrich not just the western tribes but all people of Oklahoma. The rich Native American heritage has influenced and helped shape the lives of many Oklahomans who have enriched our state with incredible success in education, arts, science, government, and athletics.

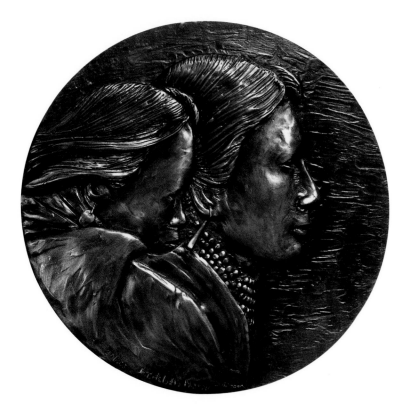

THE POWER OF HOPE

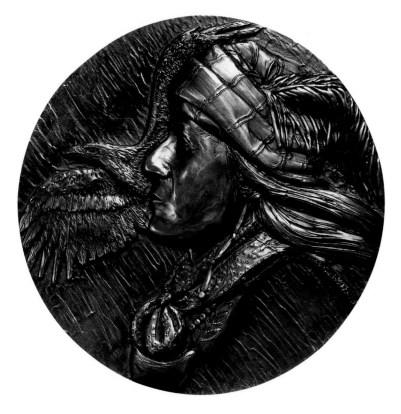

WITH THE VISION OF AN EAGLE

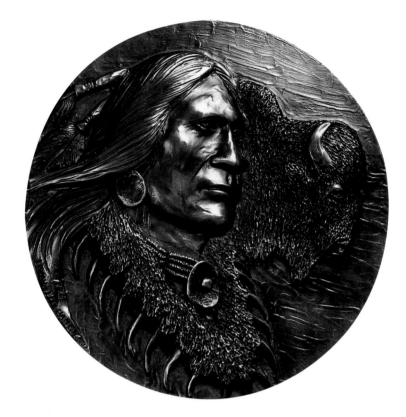

THE WILL TO LIVE

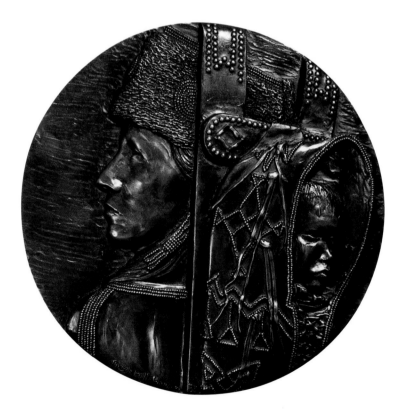

THE SPIRIT OF HERITAGE

COUNCIL OAK TREE

BY MIKE LARSEN

Governor Frank and First Lady Cathy Keating sponsored this Mike Larsen oil on canvas depicting the founding of Tulsa. The bold colors show the mature post oak atop a slight hill along the Arkansas River that marked the first council site for the town established by the Lochapoka, a division of the Creek Nation. Some called the new town Lochapoka, some called it Tallasi, after a Creek town that had existed before the middle of the 16th century. Historians believe the name Tulsa is derived from Tallasi. The painting, dedicated in 2002, shows Creeks celebrating their arrival in their new home by depositing ashes brought over the trail from their last fires in Alabama. The Creek Council Oak Tree still stands in the 21st century between Seventeenth and Eighteenth Streets and Cheyenne and Denver Avenues in Tulsa.

WILLIAM "BILL" TILGHMAN

BY HAROLD T. HOLDEN

Bill Tilghman was a buffalo hunter, frontier scout, peace officer, moviemaker, and state senator. He came to Oklahoma in the land run of 1889 and settled at Guthrie. Two years later he was appointed a deputy U. S. marshal, a position he held for nineteen years. He was described as the "deadliest shot with a six-shooter in the Southwest." State senator, now governor, Brad Henry of Shawnee, sponsored this 2002 oil by Harold T. Holden of Kremlin, Oklahoma. Tilghman had a legendary career as a lawman. He was sheriff of Lincoln County, police chief of Oklahoma City, and tracked down members of the infamous Doolin gang. He came out of retirement in 1924 to clean up the oil boom town of Cromwell, Oklahoma. Unfortunately, he was killed during his first few days on the job.

Frank Eaton won the nickname "Pistol Pete" at fifteen, when he outshot the U. S. Cavalry's best marksmen at Fort Gibson in Indian Territory. At seventeen, he became a deputy U. S. marshal under the tutelage of Isaac C. Parker, the "hanging judge." In 1889, he joined the rush to Oklahoma Territory and settled near Perkins where he was sheriff and later a blacksmith. Eaton lived the life of a true cowboy and was said to be the fastest gun in the Territory. He pleased audiences by tossing a coin in the air and shooting it before it hit ground. In 1923, Oklahoma A & M students saw Eaton in an Armistice Day parade in Stillwater and suggested that "Pistol Pete" be the mascot for their school, symbolizing the Old West and the spirit of Oklahoma. In 1958, Oklahoma State University adopted "Pistol Pete" as mascot, the same year Eaton died in Perkins. This portait was sponsored by state senator Mike Morgan of Stillwater and dedicated in 2002.

ELK HERD IN THE WICHITA MOUNTAINS

BY BARBARA VAUPAL

In 2003, former state representative Don McCorkell of Tulsa sponsored this oil on canvas by Barbara Vaupel, who admittedly prefers painting landscapes because of her love for the Oklahoma countryside. The painting shows elk grazing on a peaceful stretch of grassland bordered by the rising granite mountains of southwest Oklahoma. Elk were indigenous to the Wichita Mountains but were exterminated by the late 1800s. In 1908, a single bull elk was donated to the Wichita Mountains Wildlife Refuge by the city of Wichita, Kansas. Three years later, additional elk were received from the National Elk Refuge herd. The elk population in the refuge is descended from those few animals.

The artist decided to create a spring scene with a rich blanket of wildflowers and the young bull elks' antlers still encased in velvet. However, by the time Vaupel could travel to the Wichita Mountains, it was mid-June and wildflowers had peaked, with only patches of Indian Blanket in full bloom. Vaupel wanted the light and shadows of mid-day but female elk would not come out into the open at that time of the day. She used photographs of elk taken years before to complete the painting, taking artistic license to add rocks in the foreground. However, the collared lizard observing the elk was real.

Dedicated in 2003, this oil by Ross Myers of Tulsa depicts the plentiful deer of southeast Oklahoma's original Choctaw Country, given to Choctaw Indians in the 1830s in exchange for their lands in the southeastern United States. The Choctaws faced many hardships in their travels from Mississippi to their new home. White tail deer became a primary source of meat for them as they carved new homes from the wilderness in what would become Indian Territory and later southeastern Oklahoma.

Myers, a graduate of the University of Tulsa, began the search for the right landscape in the Winding Stair Mountains. He had to use his imagination to paint an autumn scene while observing the beautiful scenery in such places at Cedar Lake, Billy Creek, and Holsom Creek, in the full color of spring. Myers found the perfect junction of mountain forest and flowing water on the banks of a stream called Big Creek that flows into the Black Fork of the Poteau River. Myers' studio was too small for the painting's five- by eight-feet canvas. Ziegler's Art and Frame in Tulsa allowed him to use a large upstairs space where admirers watched the painting slowly come to life. This painting was a gift of the family of the late state senator John R. McCune of Oklahoma City.

Among the natural wonders of northwest Oklahoma are the Glass Mountains, also called the Gloss Mountains, northwest of Fairview. The mountains glisten brilliantly as the sun bounces off the face of the selenite crystal rocks. The unique geological formation was the background for artist Harold T. Holden to place game birds indigenous to northwest Oklahoma onto the canvas. The 2003 project was sponsored by Patty and Joe Cappy of Tulsa.

OKLAHOMA CITY—
APRIL 29, 1889
(SEVEN DAYS
AFTER THE LAND
RUN OF 1889)
BY WAYNE COOPER

Wayne Cooper captures the spirit of Oklahoma City (Oklahoma Station) seven days after the land run that opened the area to settlers. The new city had more than 12,000 inhabitants in the first twelve hours after cannons and rifles announced the beginning of the largest land run in world history. Settlers came from the north, east, and south, by buggy, wagon, train, bicycle, and on foot. Seven days later, Oklahoma Station was a thriving metropolis with permanent buildings rising daily as tent cities gave way to streets and commerce on the prairie. Oklahoma City was truly "born grown." Former Oklahoma attorney general and minority leader of the State House of Representatives G.T. Blankenship and his wife Libby sponsored the painting that was dedicated in 2002. The artist turned to old issues of *Harpers Weekly* which chronicled the first days of the capital city and included sketches of such structures as the chicken house that housed the first post office. This painting is one of Cooper's favorites because his grandmother took part in the Land Run of 1889.

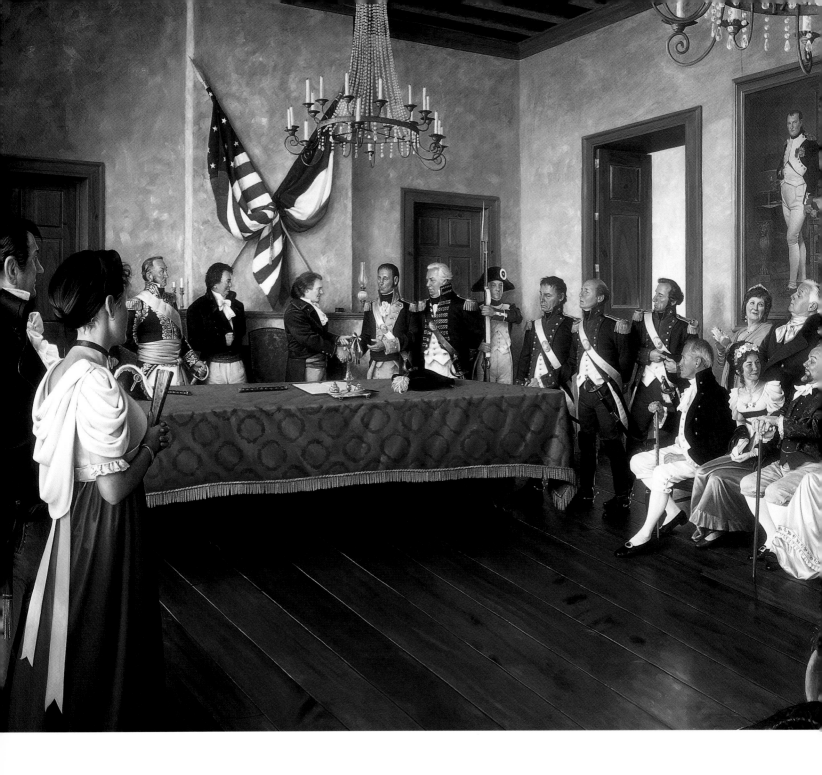

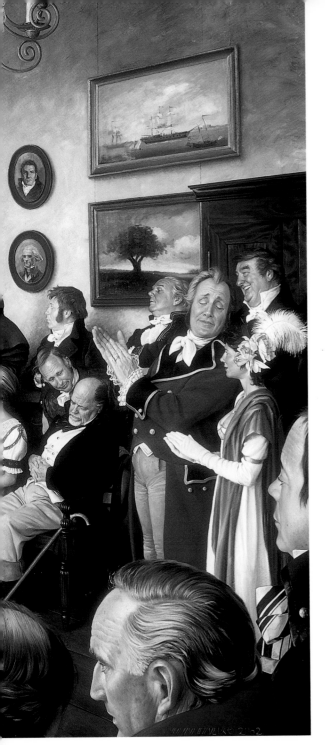

This six- by ten-foot oil on canvas by Mike Wimmer was dedicated in 2003 and was a gift of Henry and Jane Primeaux of Tulsa. The painting depicts the official transfer, the ceremonial "passing of the keys," of the Louisiana Purchase from France to the United States in a ceremony in New Orleans, Louisiana, on December 20, 1803. The acquisition of the vast tract of land of more than 800,000 square miles, including the future Oklahoma, nearly doubled the size of the young American republic and extended its territory westward from the Mississippi River to the Rocky Mountains. The purchase determined the westward orientation of the United States in the 19th century and was basic to its rise as a world power. Oklahoma was the last state carved out of the Louisiana Territory. In the painting, Pierre Clement Laussat, the French prefect, presents the document of transfer to officials of the United States government.

The artist traveled to New Orleans to visit the Cabildo, the building where the signing took place. He photographed the room and recorded its measurements so he could rebuild it virtually in his Norman studio. He reviewed original documents and an inventory of items that were in the room at the time of the ceremony.

Because the American military was in-between uniform changes, Wimmer had to do extensive research to make certain the gold and silver epaulets of the cavalry and artillery officers were correct. Depicted on the back row underneath the Napoleon painting is the dapper couple, Henry and Jane Primeaux, the patrons of the painting.

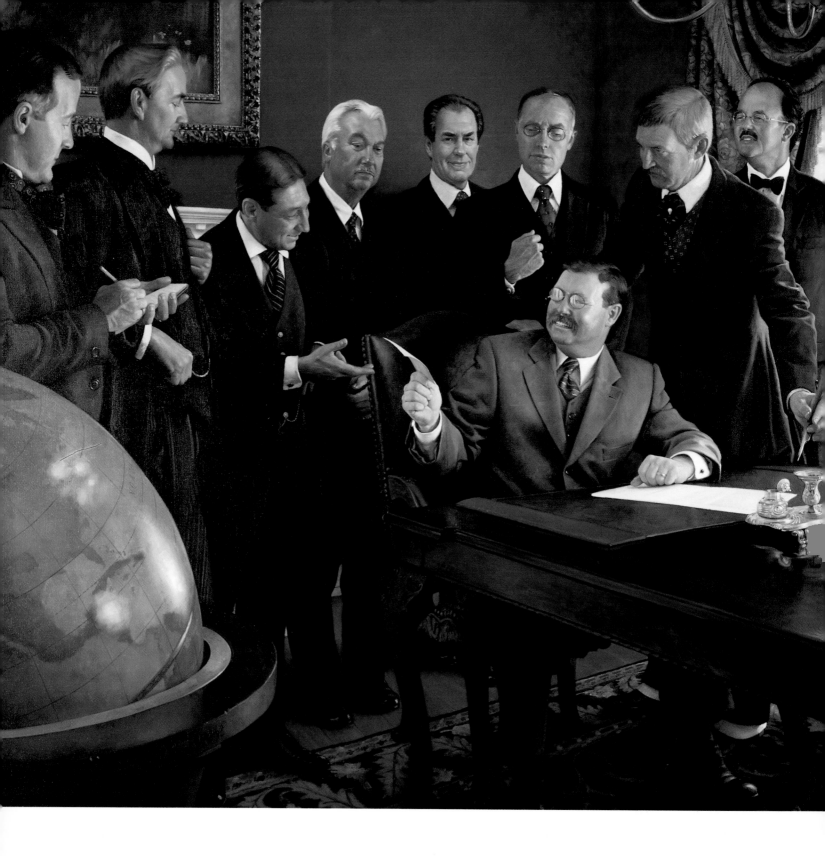

Sponsored by Walt and Peggy Helmerich of Tulsa in 2003, this oil on canvas by Mike Wimmer depicts one of the significant events in the formation of the state of Oklahoma, the moment on November 16, 1907, when President Theodore Roosevelt signed the official proclamation making Oklahoma the forty-sixth state in the Union.

The ceremonies of statehood began shortly after ten o'clock in the morning in the cabinet room of the president. A number of Oklahomans were present when Roosevelt was handed a pen whose quill came from an Oklahoma eagle. The president lifted the lid from the inkstand, dipped the pen, and wrote his name in large letters, the pen making an audible scratch with each wide movement. When he finished his signature, and blotted his name, he looked up and exclaimed, "Oklahoma is a state." The act of signing took just one minute.

After the president blotted his signature, Albert Hammer, a clerk in the general land office in Enid, Oklahoma, cried out, "Mr. President, give me the blotter." With a smile on his face, Roosevelt complied with the request. That scene is depicted in Wimmer's interpretation of the historic event.

As the president retired from the room, those who had witnessed the signing ceremony hastened to communicate the news to the waiting crowds gathered in Guthrie to kick off the daylong celebration of the new state—Oklahoma.

In researching the painting, the artist tried to be as factual as possible. He found old photographs of the room where the signing occurred. He researched the room's décor but took some artistic license with the details of the decorations. He used himself as the model for the reporter depicted in the painting.

143

TALL GRASS PRAIRIE

BY WAYNE COOPER

The tall grass prairie once spanned fourteen states and covered more than 140 million acres. Bison roamed the prairie that was one of the North America's major ecosystems. Artist Wayne Cooper painted this oil on canvas that was sponsored by the Williams Companies of Tulsa in 2001. The vibrant work depicts the rich diversity of plants and animals that made up the tall grass prairie. Today, less than 10 percent of the original tall grass prairie remains—most of it has been converted to farmland. However, in 1989, the Nature Conservancy bought the 29,000-acre Barnard Ranch in northern Oklahoma as the cornerstone of the Tall Grass Prairie Reserve. Three hundred bison were reintroduced into the reserve in 1993 in hopes that the herd would reach 3,200 to freely roam the unique land.

The artist visited the prairie and gathered grasses and flowers to take back to his studio. He used a pet rabbit owned by his neighbor's daughters as the model for the rabbit in the painting.

This Wayne Cooper oil on canvas was sponsored by the Kerr Foundation and dedicated in 2003. It depicts early pioneer family life in the sod houses that dotted the landscape in western Oklahoma after the land run. A pioneer woman tends to her chickens under the watchful supervision of the family milk cow. The wash pot and the wood axe in the foreground symbolize the harshness of life on the windswept prairie.

Sod houses, made from readily available, cheap building material, were cool in summer and easy to heat in winter. The only remaining sod house in the state is located at Aline and is preserved by the Oklahoma Historical Society.

The artist's wife was the model for the pioneer woman in the painting. The grinding wheel belonged to his grandfather. He took several photographs of friends' chickens and borrowed a hen from a neighbor before painting final details. Cooper remembered, "I tethered the chicken in my studio—but will not try that again. All for the sake of art."

As a lad, Will Rogers visited the Boling Springs community in Craig County where Indians, blacks, and whites peacefully coexisted. Artist Sonya Terpening, a graduate of Sequoya High School in Claremore and Oklahoma State University, created this water color in 1998. A project sponsored by state senator Stratton Taylor of Claremore, this painting depicts children from the various ethnic groups playing together on the school ground during recess.

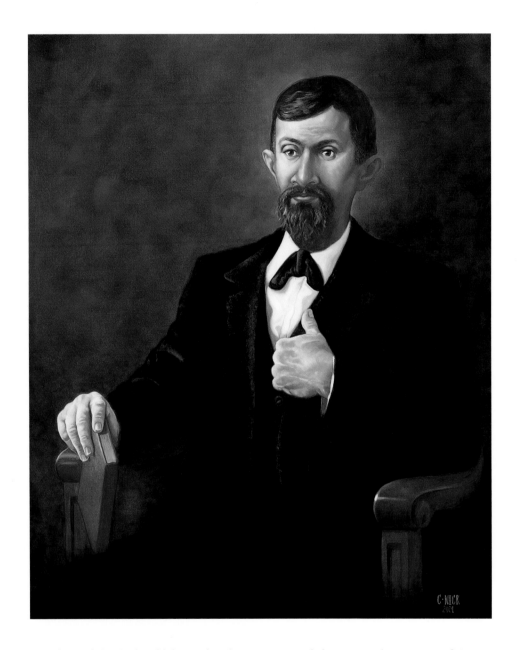

Senate members of the 48th Oklahoma legislature sponsored this 2001 oil on canvas of George W. Gardenhire by Christopher Nick of Oklahoma City. Gardenhire was a Tennessee native who settled in Payne County in April of 1889. As a Populist, he used his negotiation skills to become the compromise choice as the first president of the Oklahoma Territorial Council. His most notable accomplishment was the establishment of Oklahoma Agricultural and Mechanical College, now Oklahoma State University, in Stillwater, even though a political deal had already been made for the Land Grant college to be located elsewhere.

In 1999, state senator Robert Milacek of Waukomis made possible this Mike Wimmer oil on canvas of Henry S. Johnston, the first president pro tempore of the Oklahoma state senate. Johnston, a lawyer in Perry, was elected to the Constitutional Convention and the first legislature. He later served as governor from 1927 until he was impeached and ousted from office in 1929. He was again elected to the senate and served four years with many of the same senators who threw him out of office. Johnston was a popular Oklahoman who lived out his life practicing law in Perry until his death in 1965.

The senate members of the 47th Oklahoma legislature sponsored this 1999 oil on canvas by Mike Wimmer. Taylor, who now lives in Claremore, was the only member of his Alluwe, Oklahoma, high school class of 17 to graduate from college. At 22, he was elected to the Oklahoma House of Representatives. Four years later he advanced to the state senate, where he was unanimously elected to that body's highest position, president pro tempore, in 1995, 1997, 1999, and 2001.

This oil on canvas of Calvin Jackson "Cal" Hobson III by Mike Wimmer was sponsored by senate members of the 48th Oklahoma Legislature. Hobson began serving his first term as president pro tempore of the Oklahoma State Senate in 2003. He graduated from the University of Oklahoma in 1968 and served seven years on active duty in the U.S. Air Force. He is a retired colonel in the Oklahoma Air National Guard.

A real estate broker by profession, Hobson was a member of the Oklahoma House of Representatives from 1978 until he was elected to the state senate in 1990. He and his wife Elaine live in Lexington, Oklahoma.

BY MIKE WIMMER

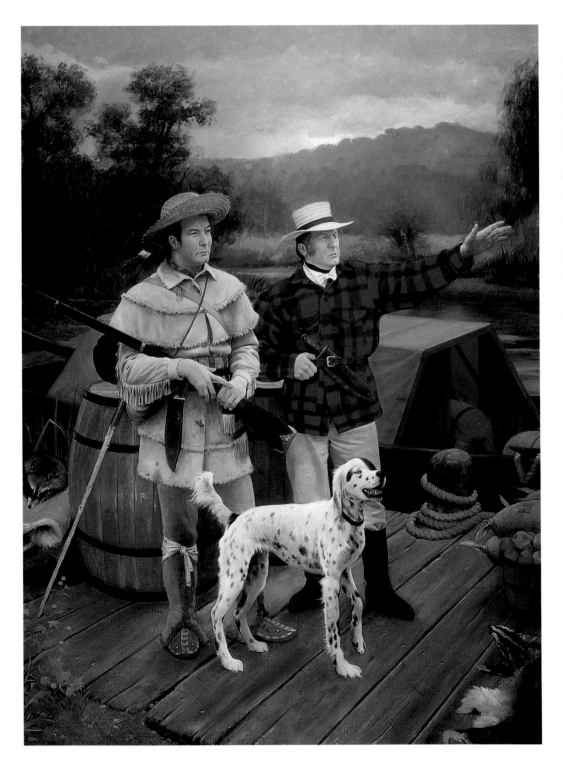

Senator Kevin Easley of Broken Arrow sponsored this portrait of pioneer Oklahoma trader Nathaniel Pryor in 2003. Pryor, a native of Virginia, was a captain in the War of 1812 and a member of the famous Lewis and Clark expedition. After the war, he came to the Three Forks area of northeast Oklahoma where the Arkansas, the Verdigris, and the Grand River merge just north of Muskogee. He opened a small trading post, took an Osage woman as his wife, and won the confidence of the tribe by learning its language. From his trading post, Pryor organized trapping and trading parties to explore New Mexico and to visit Indian tribes. Never a highly successful merchant, he later was appointed as an assistant agent of the Arkansas band of the Osages.

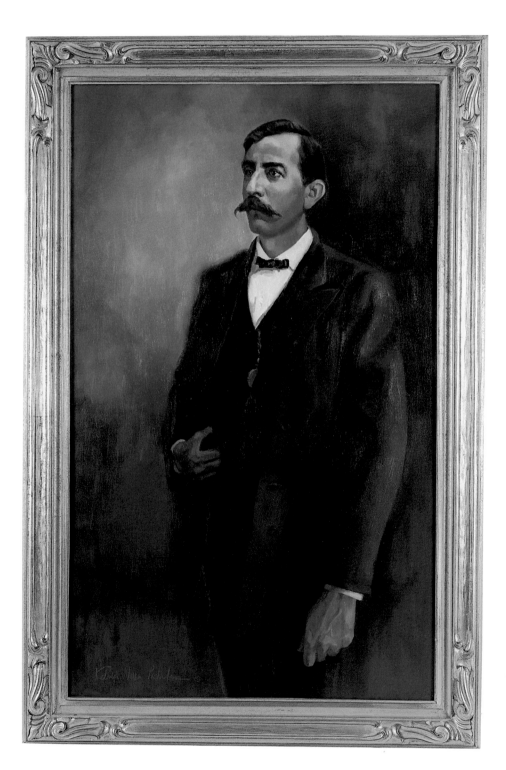

Kathryn Walker Richardson depicts the crusty William H. "Alfalfa Bill" Murray, unquestionably the most colorful political leader in Oklahoma history. Murray was the first Speaker of the Oklahoma House of Representatives, chairman of the state constitutional convention, a member of the U. S. Congress, and Oklahoma governor from 1931 to 1935. His son, Johnston Murray, was also governor.

The artist is a native of Oklahoma and daughter of Oklahoma's premier saddler, W.W. Walker, and Etta Lorene Walker, who imparted her sense of spiritual values while encouraging her pursuit of artistic goals. She studied at Oklahoma State University.

House Speaker Larry Adair of Stilwell sponsored the Murray painting.

The portrait of Arthur Daniels, the first Speaker of the Oklahoma Territory House of Representatives, was sponsored in 2003 by state senator Charles Ford, who served fourteen years in the House, six years as minority floor leader, before being elected to the senate.

Daniels was one of twenty-six members of the House of Representatives elected in the first territorial election on August 5, 1890. The election followed President Benjamin Harrison's signing of the Oklahoma Territory Organic Act, which provided the future state of Oklahoma with its first counties—Payne, Logan, Kingfisher, Oklahoma, Canadian, and Cleveland, organized from the Unassigned Lands, and Beaver County, organized in the present Oklahoma Panhandle. Daniels, of El Reno, was elected Speaker of the first Territorial House of Representatives that convened in Guthrie on August 29, 1890. His election was a surprise because onlookers had expected Republicans to control the House. Fourteen members of the first House were Republican, nine were Democrat, and three were Populists. Two Oklahoma County Republicans joined the Democrats and Populists and elected Daniels.

"A portrait must be a painting first," the artist said, "It must stand on its own merits as a painting with regard to the forms that create its composition, and the technical strength of its execution."

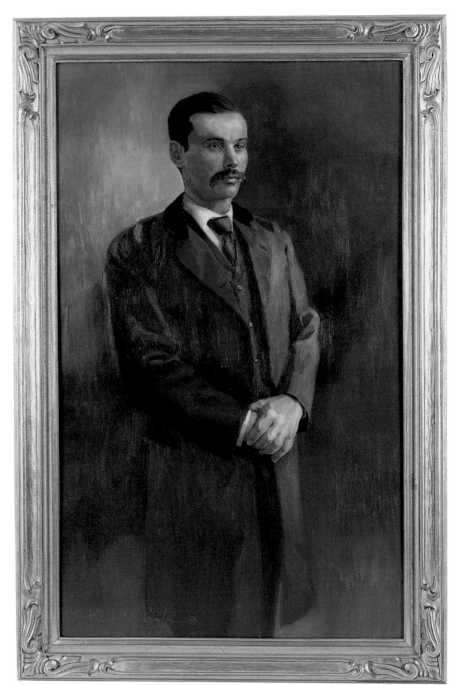

The McKenney-Hall Portrait Gallery of American Indians is an impressive collection of 120 superb color portraits of the most famous Indians in American history. Charles Bird King and other important American artists painted all types of Indians—from noble warriors and important statesmen, to exploited chiefs and downtrodden tribesmen. Responsible for the collection were Thomas Loraine McKenny and James Hall. McKenny was superintendent of Indian trade under Presidents Madison, Monroe, John Quincy Adams, and Jackson. With a keen interest in their customs and traditions, McKenny came to know American Indians well.

James Hall was a frontier lawyer, newspaper editor, author, and judge who assisted McKenny in his collection of the portraits. Together, they produced an unforgettable portfolio of folklore and history of the American Indian. McKenny-Hall lithographs are important because the original paintings were destroyed in a fire while on display at the Smithsonian Institution in 1865.

State senator Charles Ford has traversed the North American continent in search of McKenny-Hall portraits, often bidding thousands of dollars for a single lithograph. Ford bid on a three-volume set of books containing the famous portraits. However, the set eventually sold for more than $100,000.

The stone hand-painted lithograph shown here is of Pushmataha, chief of the Choctaws, for whom Pushmataha County is named.

AMONG THE MCKENNEY-HALL LITHOGRAPHS ON DISPLAY IN THE OKLAHOMA SENATE:

Tshi-Zun-Hau-Kan, a Winnebago warrior

John Ross, a Cherokee chief

Mistippee

Nea-Math-La, a Seminole chief

Sequoyah

Pushmataha, a Choctaw chief

Tustennuge Emathia (or Jim Boy), a Creek chief

Young Mahaskah, an Iowa chief

Le Soldat Du Chene, an Osage chief

Major Ridge, a Cherokee chief

Paddy Carr, a Creek interpreter

Ca Ta He Cas Sa, principal chief of the Shawanese

Mohongo, an Osage woman

Ka Na Pi Ma, an Ottawa chief

Le Da Gie, a Creek chief

Yaha Hajo, a Seminole war chief

Tens Kwan Ta Waw, the prophet

Petalsharro, a Pawnee brave

Oche-Finceco, a Creek

Chittee-Yoholo, a Seminole chief

Foke Luste Hajo, a Seminole chief

Apauly Tustennugge, a Creek

Red Jacket, a Seneca war chief

David Vann, a Cherokee chief

Tshusick, an Ojibway woman

McIntosh, a Creek chief

Wa Baun See, a Pottawatomie chief

Opothaie-Yaholo, a Creek chief

PUSH-MA-TA-HA,
Choctaw Warrior.

Philadelphia Published by F. C. Biddle

Entered according to act of Congress in the year 1837 by E. C. Biddle in the Clerks Office of the District court of the Eastern District of Pennsylvania

Artist Mike Wimmer created this 1999 oil on canvas of the first three members of the Oklahoma Court of Criminal Appeals. With only small and poor quality photographs of the judges to refer to, the artist had to find models to act as stand-ins. Oklahoma's first governor, Charles Haskell, appointed Henry M. Furman of Ada, H.G. Baker of Muskogee, and Thomas H. Doyle of Perry as the first three judges of the Court of Criminal Appeals which the state constitution deemed the court of last resort for appeals of criminal cases in Oklahoma. The painting was sponsored by friends of the Oklahoma Court of Criminal Appeals.

Judge Furman was born in South Carolina and moved to Indian Territory before statehood. Living at Ardmore and Ada, he was one of the most prolific speakers of his day on the issue of statehood for Oklahoma. Furman actually received more votes than Thomas P. Gore in Oklahoma's first United States Senate race in 1907. However, Furman declined the nomination and adhered to a gentlemen's agreement among the Democratic candidates that one of the state's first senators would come from eastern Oklahoma and the other from the western half of the state. Eventually, Gore and Robert Owen, the Democratic nominees, were elected Oklahoma's first United States Senators.

Judge Baker was an oilman and railroad business agent from Muskogee. He served for nine months on the Court of Criminal Appeals, resigning in June, 1909, to run a life insurance company.

Judge Doyle, who once served as president of the Oklahoma Historical Society, was born in Massachusetts but settled in Oklahoma Territory at Perry on the day the town was established. Doyle, a member of the Oklahoma territorial legislature, has been called by one historian "the commanding figure in his devotion for a single statehood." As early as 1904 he presented his ideas of combining Oklahoma and Indian territories into a single state to a committee of the United States House of Representatives.

This painting was a gift of Senator Charles R. Ford and the Oklahoma State Senate Historical Preservation Fund, Inc.

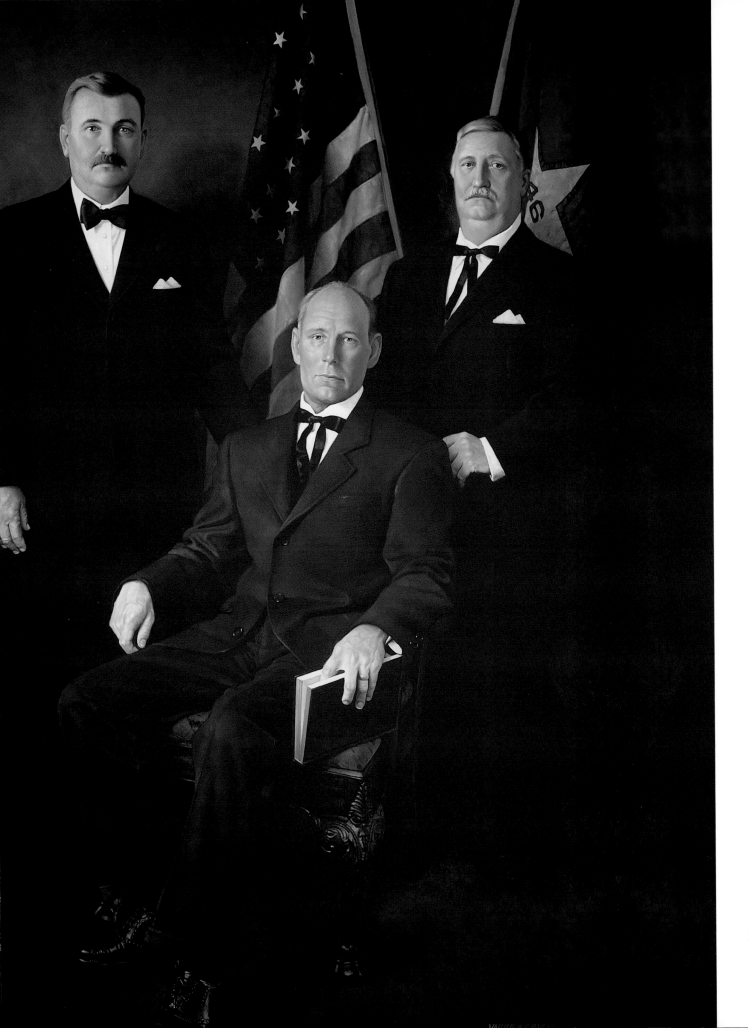

From 1929 to 1933, artist Boris B. Gordon painted oil portraits of the first five justices of the Oklahoma Supreme Court. The portraits hang in the ceremonial courtroom of the Supreme Court on the second floor of the capitol.

This portrait is of Jesse James Dunn, who served on the state's highest civil court from 1907 to 1913 and was chief justice from 1910 to 1911. Dunn was a great-uncle of former first lady Cathy Keating. He was born in Illinois. After reading for the law in Kansas, he made the run at the opening of the Cherokee Outlet in 1893 and settled at Alva. He aggressively fought for Oklahoma statehood and was elected chairman of an Oklahoma delegation that presented the plea for statehood to Congress in 1905.

Other portraits in the collection are of Matthew John Kane, Robert L. Williams, John Bell Turner, and Samuel Walter Hays. Kane was a New York native who settled at Kingfisher shortly after the Land Run of 1889. He was a delegate to the Oklahoma Constitutional Convention, justice from 1907 to 1923, and chief justice from 1909 to 1910. Robert L. Williams, a justice from statehood until he was elected governor in 1914, was the first chief justice. John Bell Turner, a justice from 1904 to 1918 and chief justice from 1911 to 1913, was a native of Tennessee who began practicing law at Vinita, Indian Territory, in 1895. After his retirement, he moved to a home on the Grand River near Chouteau in Mayes County. Samuel Walter Hays, a justice from statehood to 1914 and chief justice from 1913 to 1914, was born in Arkansas. After law school at the University of Virginia, Hays began the practice of law at Ryan, Indian Territory, in 1900. Two years later, he moved to Chickasha. At age thirty-one, in 1906, he was chosen as a delegate to the Oklahoma Constitutional Convention at Guthrie. After his retirement from the high court, Hays moved to Oklahoma City and served as president of the Oklahoma City Chamber of Commerce from 1940 until his death the following year.

Boris B. Gordon was born in 1888 in Switzerland and studied art at the Royal Academy in London and the Academy of Art in Germany. He came to the United States in 1907, served in the United States Marine Corps in World War I, and settled in the Washington, D.C., area, where he painted many political figures. His portraits of Abraham Lincoln and Henry Cabot Lodge hang in the United States Capitol. His works also hang in several state capitols. He painted Shirley Temple at age six and important Americans such as Presidents Dwight Eisenhower, Harry Truman, and Herbert Hoover.

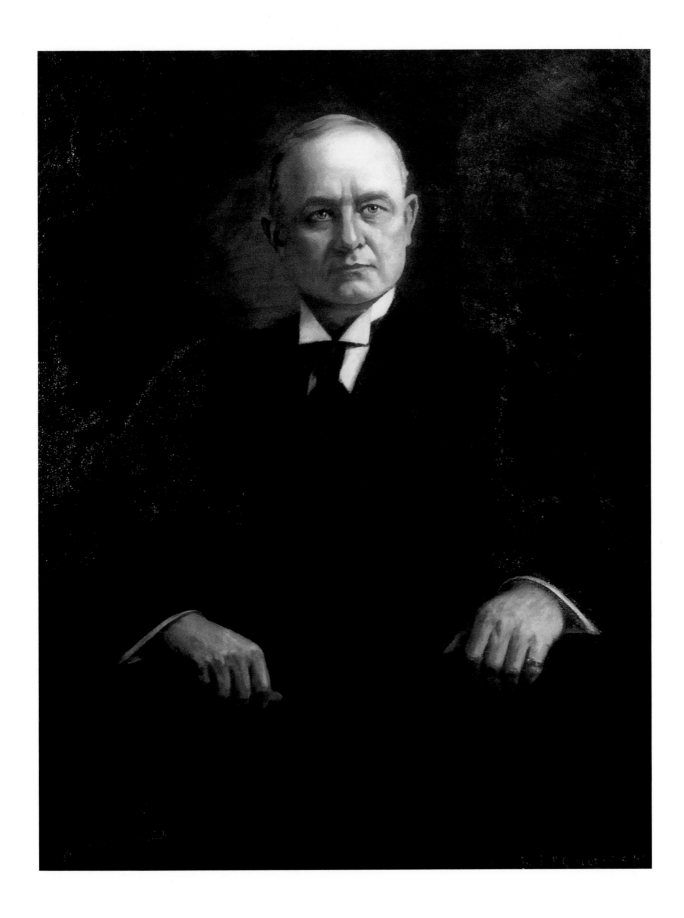

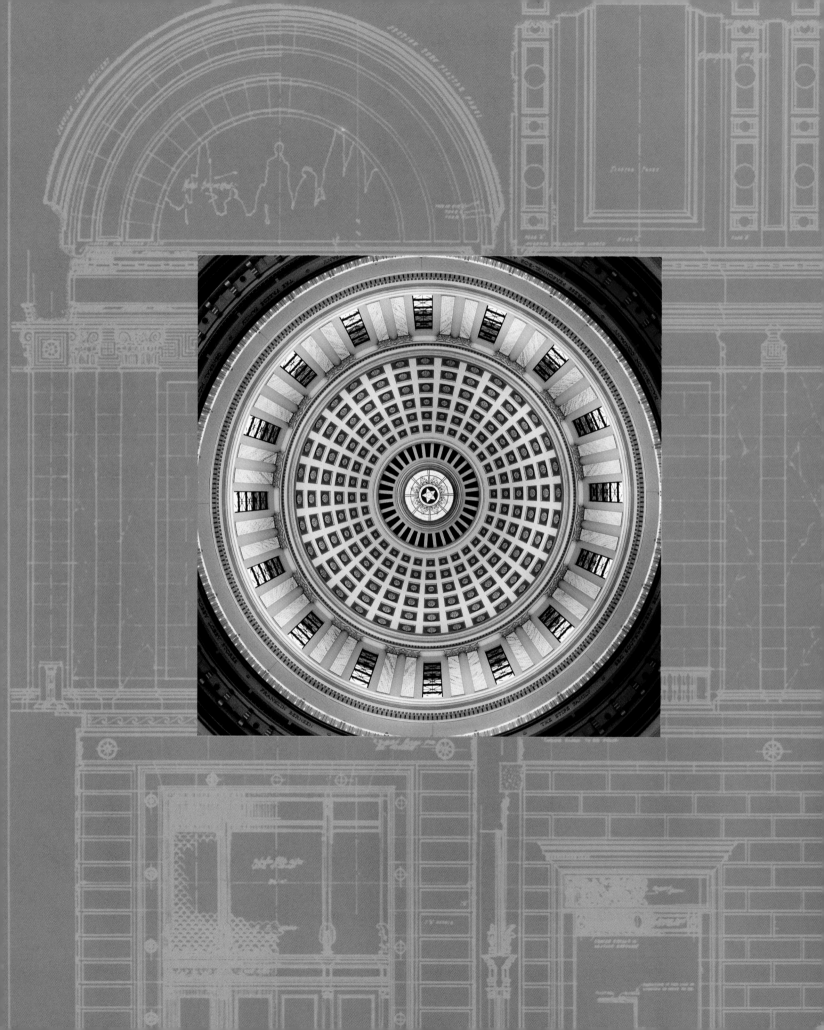

FUTURE PROJECTS

4

THE CAPITOL IN THE TWENTY-FIRST CENTURY: FUTURE PROJECTS

Even though Oklahoma's State Capitol Art Collection is already one of the most majestic and diverse collections of historical and portrait art, many new projects are scheduled for the next few years.

A larger-than-life sculpture planned for the East Oval is that of Te Ata (Mary Thompson), the famous Oklahoma Chickasaw storyteller. She was born at Emet in Indian Territory and began telling stories in her dormitory room at Oklahoma College for Women. She changed her major from education to drama and presented a program on Indian lore. Te Ata was a legend on the Chautauqua circuit and appeared in several Broadway shows in New York City. Her graceful hands and pine tree–straight posture created many characters. With slight variations of body movement, she could transform from warrior to old woman to medicine man. Her stories explored and explained Indian ways of looking at love, birth, death, and the meaning and origins of life.

Te Ata was a favorite of President Franklin D. Roosevelt and his wife, Eleanor. The Oklahoma

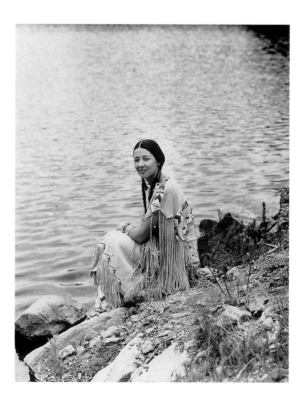

OKLAHOMA CULTURAL TREASURE TE ATA, SITTING BESIDE THE LAKE IN NEW YORK NAMED FOR HER BY GOVERNOR FRANKLIN D. ROOSEVELT.

storyteller appeared at the White House at Roosevelt's first state dinner in 1933. Te Ata later married Dr. Clyde Fisher, curator of the Hayden Planetarium at the New York Museum of Natural History. She died in 1995, only a few days before her hundredth birthday.

The sculpture of Te Ata will be in the Te Ata garden designed to honor all of Oklahoma's Cultural Treasures, an official recognition for Oklahomans who have contributed greatly to the culture of the Sooner State. Officially, an honoree must be a bearer of intangible cultural assets, have received prior recognition for his or her talent, and have outstanding artistic or historical worth.

The Oklahoma Cultural Treasure designation is patterned after the Japanese Living Treasure program. Those recognized to date are Te Ata, Doc Tate Nevaquaya, Marjorie Tallchief, Maria Tallchief, Moscelyne Larkin, Rosella Hightower, Yvonne Chouteau, N. Scott Momaday, Charles Banks Wilson, and Wilson Hurley.

CULTURAL TREASURES
MOSCELYNE LARKIN, MARJORIE
TALLCHIEF, MARIA TALLCHIEF,
ROSELLA HIGHTOWER, AND
YVONNE CHOUTEAU, WITH BETTY
PRICE AND GOVERNOR FRANK
KEATING, AT THE CAPITOL.

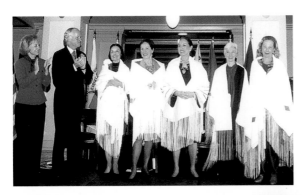

Portraits planned for the senate include depictions of Osage woman Mohongo, agricultural scientist and founder of Tuskegee Institute George Washington Carver, diplomat Jeane Kirkpatrick, and presidential advisor Bryce Harlow. Subjects of other historical paintings scheduled for display include Tinker Field in Midwest City, the last farewell of aviator Wiley Post and humorist Will Rogers, an early mail pilot, scenes from the University of Oklahoma, and the Trail of Tears.

OKLAHOMA CULTURAL TREASURES, FROM LEFT, N. SCOTT MOMADAY, CHARLES BANKS WILSON, AND WILSON HURLEY.

Mahongo was an Osage woman who lived at the Chouteau camp in Indian Territory. She was among eight Osage who were taken to Europe under false pretenses in 1827 by a French adventurer and confidence man. They had been told they were going to Washington, D.C. to meet the president. Instead, they were exploited and forced to appear in a Wild West show that toured Europe.

Whe popularity of the show waned, Mahongo and the other Osage were abandoned on the streets of Paris, France. Without money, they wandered the streets until they were discovered by Lafayette, who paid their passage back to the United States. On the way to America, Mahongo's husband and two other tribal members died of smallpox.

Colonel Thomas McKenney came to Mahongo's rescue after she arrived in Virginia. President Andrew Jackson awarded her a peace medal, and she and her child were painted by Charles Bird King. Eventually, Mahongo was returned to her people in Indian Territory and two of her children were given a section of land in the Osage Treaty of 1825.

Jeane Kirkpatrick, born in Duncan, Oklahoma, appeared on the cover of the *Saturday Evening Post* in 1984 when she was United States ambassador to the United Nations. Kirkpatrick had a remarkable impact upon American foreign policy during the administration of President Ronald Reagan as a member of his cabinet and in her prominent role at the United Nations.

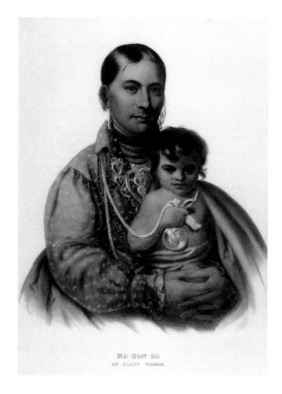

MAHONGO WITH HER CHILD.

JEANE KIRKPATRICK.

Kirkpatrick is an accomplished author, scholar, syndicated columnist, diplomat, and expert on world politics and international affairs. Among her many honors is receipt of the Presidential Medal of Freedom, the highest civilian award given by the United States government. She holds degrees from Stephens College and Barnard College, and MS and Ph.D. degrees from Columbia University. She has been awarded more than a dozen honorary doctorates, including degrees from Georgetown University and Tel Aviv University.

ADA LOIS SIPUEL FISHER, WITH
AMOS T. HALL, NAACP
ATTORNEY, LEFT, AND
THURGOOD MARSHALL, RIGHT.

An important project to be completed in the near future is a portrait of Ada Lois Sipuel Fisher. This young Chickasha, Oklahoma, girl became the most famous plaintiff in a series of lawsuits in the 1940s that crumbled the barriers of desegregation in higher education in America. Because she was black, Fisher was denied admission to the University of Oklahoma School of Law. In the litigation that followed, later United States Supreme Court justice Thurgood Marshall, then a lawyer for the National Association for the Advancement of Colored People, represented her. Fisher's case, decided in just four days by the United States Supreme Court, was the first blow in striking down Oklahoma's prohibition against the admission of African Americans to state institutions of higher learning. The Fisher case was a blueprint for the fight against segregation in the nation's colleges and universities. In 1992, forty-five years after she was denied admission to the University of Oklahoma School of Law, Fisher was appointed a member of the OU Board of Regents by Governor David Walters. She died in 1995.

State senator Penny Williams of Tulsa is the sponsor of the portrait of Fisher by Mike Wimmer. The painting will be based on a photograph taken by the Oklahoma Publishing Company during the legal proceedings.

Other future projects include providing a permanent gallery for the Oklahoma State Art Collection in space on the first floor of the capitol now occupied by the office of the attorney general. That office will be relocated to a renovated building west of the capitol.

ART

AT THE OKLAHOMA STATE CAPITOL

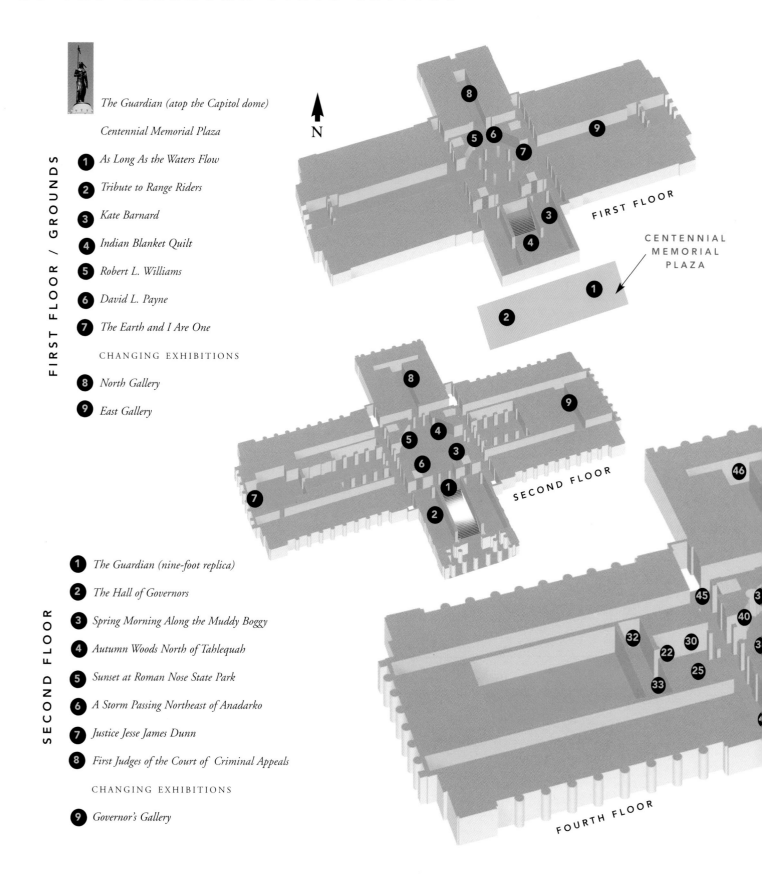

The Guardian (atop the Capitol dome)

Centennial Memorial Plaza

FIRST FLOOR / GROUNDS

1. *As Long As the Waters Flow*
2. *Tribute to Range Riders*
3. *Kate Barnard*
4. *Indian Blanket Quilt*
5. *Robert L. Williams*
6. *David L. Payne*
7. *The Earth and I Are One*

CHANGING EXHIBITIONS

8. *North Gallery*
9. *East Gallery*

SECOND FLOOR

1. *The Guardian (nine-foot replica)*
2. *The Hall of Governors*
3. *Spring Morning Along the Muddy Boggy*
4. *Autumn Woods North of Tahlequah*
5. *Sunset at Roman Nose State Park*
6. *A Storm Passing Northeast of Anadarko*
7. *Justice Jesse James Dunn*
8. *First Judges of the Court of Criminal Appeals*

CHANGING EXHIBITIONS

9. *Governor's Gallery*

FOURTH FLOOR

1. The Pro Patria Murals
2. The Debate
3. Last Address
4. City Towers
5. Prairie Castles
6. Washington Irving Meets the Osage
7. Battle of Round Mountain
8. Community of Boling Springs
9. Friends for a Day
10. Traffic Jam at Limestone Gap
11. Senator Henry S. Johnston
12. Senator Stratton Taylor
13. Medicine Bluff at Fort Sill
14. Great Western Cattle Trail
15. President Theodore Roosevelt
16. Colonel Robert S. Johnston
17. Surrender of General Stand Watie
18. Indian Code Talkers
19. 101 Ranch

20. Osage Treaty of 1825
21. George W. Gardenhire
22. Bronze Roundels
23. William Bill Tilghman
24. Frank Eaton, Pistol Pete
25. Oklahoma City April 29, 1889
26. Ceremonial Transfer of the Louisiana Purchase
27. Will Rogers
28. Senator Cal Hobson
29. McKenney and Hall Lithographs
30. Dugout Soddy on the Prairie
31. Alice Robertson
32. Alfalfa Bill Murray
33. Arthur Daniels
34. Nathaniel Pryor and Sam Houston
35. Will Rogers

36. Sequoyah
37. Robert S. Kerr
38. Jim Thorpe
39. Carl Albert
40. Angie Debo
41. Wiley Post
42. Roscoe Dunjee
43. Edward P. McCabe
44. Benjamin Harrison Hill
45. Albert Comstock Hamlin
46. 45th Infantry Memorial
47. Theodore Roosevelt Signing Proclamation

FIFTH FLOOR

1. Flight of Spirit
2. Oklahoma Black Gold
3. We Belong to the Land
4. Discovery and Exploration
5. Frontier Trade
6. Indian Migration
7. Non-Indian Settlement
8. Tallgrass Prairie
9. Creek Council Oak Tree
10. Whitetail Deer in Choctaw County
11. Elk Herd in the Wichita Mountains
12. Game Birds at Glass Mountain
13. Attack of Battleship Oklahoma
14. 45th Division at Pork Chop Hill
15. Woodhouse at Lost City

WORKS IN
SENATE
VESTIBULE

BIBLIOGRAPHY

NEWSPAPERS AND PERIODICALS

Arts Oklahoma, Oklahoma City, Oklahoma

Friday, Oklahoma City, Oklahoma

Garden Magazine, Phoenix, Arizona

Globe Democrat, Topeka, Kansas

Harlow's Weekly, Oklahoma City, Oklahoma

Lawton Constitution, Lawton, Oklahoma

New York Times, New York, New York

Nichols Hills News, Nichols Hills, Oklahoma

Norman Transcript, Norman, Oklahoma

Oklahoma City Downtown, Oklahoma City, Oklahoma

Oklahoma City Times, Oklahoma City, Oklahoma

Oklahoma Gazette, Oklahoma City, Oklahoma

Oklahoma Legislative Reporter, Oklahoma City, Oklahoma

Oklahoma Monthly, Ponca City, Oklahoma

Oklahoma Today, Oklahoma City, Oklahoma

Orbit, Oklahoma City, Oklahoma

Persimmon Hill, Oklahoma City, Oklahoma

State Senate Journal, Oklahoma City, Oklahoma

Shawnee News Star, Shawnee, Oklahoma

Southwest Art, Tucson, Arizona

The Artist's Magazine, Santa Fe, New Mexico

The Daily Oklahoman, Oklahoma City, Oklahoma

The Downtowner, Oklahoma City, Oklahoma

The Oklahoma Journal, Midwest City, Oklahoma

The Oklahoma News, Oklahoma City, Oklahoma

The Sunday Oklahoman, Oklahoma City, Oklahoma

Tulsa Cityscape, Tulsa, Oklahoma

Tulsa Magazine, Tulsa, Oklahoma

Tulsa Tribune, Tulsa, Oklahoma

Tulsa World, Tulsa, Oklahoma

Weatherford Daily News, Weatherford, Oklahoma

COLLECTIONS

Melton Art Reference Library archives, Oklahoma City, Oklahoma

National Cowboy and Western Heritage Museum archives, Oklahoma City, Oklahoma

Oklahoma Arts Council archives, Oklahoma City, Oklahoma

Oklahoma City Museum of Art archives, Oklahoma City, Oklahoma

Oklahoma Department of Central Services archives, Oklahoma City, Oklahoma

Oklahoma Department of Libraries vertical files, Oklahoma City, Oklahoma

Oklahoma Heritage Association archives, Oklahoma City, Oklahoma

Oklahoma Historical Society vertical files, Oklahoma City, Oklahoma

University of Central Oklahoma Newspaper Archives, Edmond, Oklahoma

Will Rogers Memorial archives, Claremore, Oklahoma

Woolaroc Museum archives, Bartlesville, Oklahoma

BOOKS

Baird, W. David and Danney Goble. *The Story of Oklahoma.* Norman: University of Oklahoma Press, 1994.

Briggs, Walter. *Without Noise of Arms. Oil Paintings by Wilson Hurley.* Flagstaff: Northland Press, 1976.

Burke, Bob. *Oklahoma: The Center of It All.* Encino, California: Cherbo Publishing Company, 2002.

Carpenter, Joan. *Jean Richardson.* New York: John Szoke Graphics, 1998.

Dale, Edward Everett. *The West Wind Blows.* Oklahoma City: Oklahoma Historical Society, 1984.

Dary, David. *The Santa Fe Trail.* New York: Alfred A. Knopf, 2001.

Debo, Angie. *Oklahoma, foot loose and fancy free.* Norman: University of Oklahoma Press, 1949.

Dunn, Dorothy. *American Indian Paintings of the Southwest and Plains Areas.* Albuquerque: University of New Mexico Press, 1968.

Ellison, Ralph. *Going to the Territory.* New York: Random House, 1986.

Foreman, Grant. *The Five Civilized Tribes.* Norman: University of Oklahoma Press, 1934.

Franks, Kenny A. *You're Doin' Fine Oklahoma!* Oklahoma City: Oklahoma Historical Society, 1983.

Franks, Kenny A. and Paul Lambert. *Oklahoma: The Land and Its People.* Helena, Montana: Unicorn Publishing, 1994.

Franks, Kenny A. *The Oklahoma Petroleum Industry.* Norman: University of Oklahoma Press, 1980.

Goble, Danney. *Progressive Oklahoma: The Making of a New Kind of State.* Norman: University of Oklahoma Press, 1981.

Goble, Danney with James R. Scales. *Oklahoma Politics: A History.* Norman: University of Oklahoma Press, 1982.

Green, Richard. *Te Ata, Chickasaw Storyteller.* Norman: University of Oklahoma Press, 2002.

Hamilton, Ann, ed. *Oklahoma Almanac 2001-2002.* Oklahoma City: Oklahoma Department of Libraries, 2001.

Highwater, Jamake. *Song From the Earth: American Indian Paintings.* New York: Little, Brown & Company, 1976.

Highwater, Jamke. *The Sweet Grass Lives On: Fifty Contemporary North American Indian Artists.* New York: Lippincott & Crowell, 1980.

Horan, James D. *The McKenney-Hall Portrait Gallery of American Indians.* New York: Crown Publishers, Inc., 1972.

Humphreys, George G. *A Century to Remember: A Historical Perspective on the Oklahoma House of Representatives.* Oklahoma City: Oklahoma House of Representatives, 2000.

Hunt, David C. *The Lithographs of Charles Banks Wilson.* Norman: University of Oklahoma Press, 1989.

Hurley, Wilson. *An Exhibition of Oil Paintings.* Kansas City: Lowell Press, 1977.

Hurst, Irvin. *The 46th Star.* Oklahoma City: Semco Color Press, 1957.

Jacka, Loise Essary and Jerry Jacka. *Beyond Tradition, Contemporary Indian Art and its Evolution.* Flagstaff, Arizona: Northland Publishing Co., 1988.

Jacobson, Oscar B. and Jeanne d 'Ucel. *American Indian Painters.* Nice, France: C. Szwedzicki, 1950.

Keating, Frank and Mike Wimmer. *Will Rogers: An American Legend.* New York: Silver Whistle/Harcourt Inc., 2002.

Kirkpatrick, Samuel A. *The Legislative Process in Oklahoma.* Norman: University of Oklahoma Press, 1978.

Kovinick, Phil and Marian Yoshiki Kovinick. *An Encyclopedia of Women Artists of the American West.* Austin: University of Texas Press, 1999.

Lambert, Paul F., Kenny A. Franks, and Bob Burke. *Historic Oklahoma.* Oklahoma City: Oklahoma Heritage Association, 1999.

Matus, Roger, ed. *St. James Guide to Native North American Artists.* New York: St. James Press, 1998.

Morgan, Anne Hodges, and H. Wayne Morgan. *Oklahoma: A Bicentennial History.* New York: W.W. Norton, 1977.

Morgan, David R., Robert E. England, and George G. Humphreys. *Oklahoma Politics and Policies: Governing the Sooner State.* Lincoln: University of Nebraska Press, 1991.

Palmer, Barbara. *Art of the State of Oklahoma, The Spirit of America.* New York: Harry N. Abrams, Inc., Publishers, 1999.

Perlman, Barbara H. *Allan Houser.* Boston: David R. Godine, 1987.

Shirley, Glenn. *Law West of Fort Smith.* New York: Henry Holt and Company, 1957.

Troccoli, Joan Carpenter. *Turning Toward Home, The Art of Jean Richardson.* New York: John Szoke Graphics, 1998.

Wade, Edwin L. ed. *The Arts of the North American Indian.* New York: Hudson Hills Press, 1986.

Wilson, Charles Banks. I*ndians of Eastern Oklahoma.* Afton, Oklahoma: Buffalo Publishing Col, 1964.

Wilson, Charles Banks. *Search for the North American Purebloods.* Norman: University of Oklahoma Press, 2001.

Wright, Muriel. *The Story of Oklahoma.* Oklahoma City: Webb Publishing Company, 1929.

Wyckoff, Lydia I. ed. *Visions and Voices, Native American Painting from the Philbrook Museum of Art.* Tulsa: The Philbrook Museum of Art, 1996.

173

Photo Credits: Photographs in sections one and two courtesy of Oklahoma Arts Council and Legislative Service Bureau photographers Stu Ostler, Travis Caperton, and Erin McGregor, unless otherwise cited in the following list. Image selection and technical advisor Scott A. Cowan, Oklahoma Arts Council.

Photographs in sections one, two, and four: Shane Culpepper: 80, 81, 82, 83, 84, 85, 91; John Jernigan: 10, 11, 17, 21, 27, 28, 29, 31, 42, 44, 62-63, 64-65, 68-69, 70-71, 72-73, 74-75, 87, 88, 89, 92, 93, 94, 95, 97, 99; Karl Lee: 66 (top); Fred Marvel: 67 (bottom); Oklahoma Publishing Company: 18, 19, 20, 57, 167; A. Y. Owens: 67 (Wilson at work); Betty Price: 32, 56; Richard Reed: 21, 33; Richard Ruddy: 48-49, 50-51, 52-53, 54-55. Photos courtesy of Senator Helen Cole (page 164, Te Ata); Wilson Hurley (page 165); Lou Kerr (page 40); Paul Meyer (page 41); N. Scott Momaday (page 165); and Charles Banks Wilson (165).

Photographs in section three were furnished by the Oklahoma State Senate Historical Preservation Fund, Inc., from the following photographers: Legislative Service Bureau photographers Stu Ostler, Travis Caperton, and Erin McGregor; Sanford Mauldin Photography, Keith Ball Photography, Inc., and KC Inc. Photographic Services. Other photographs of artworks were supplied courtesy of the artist.

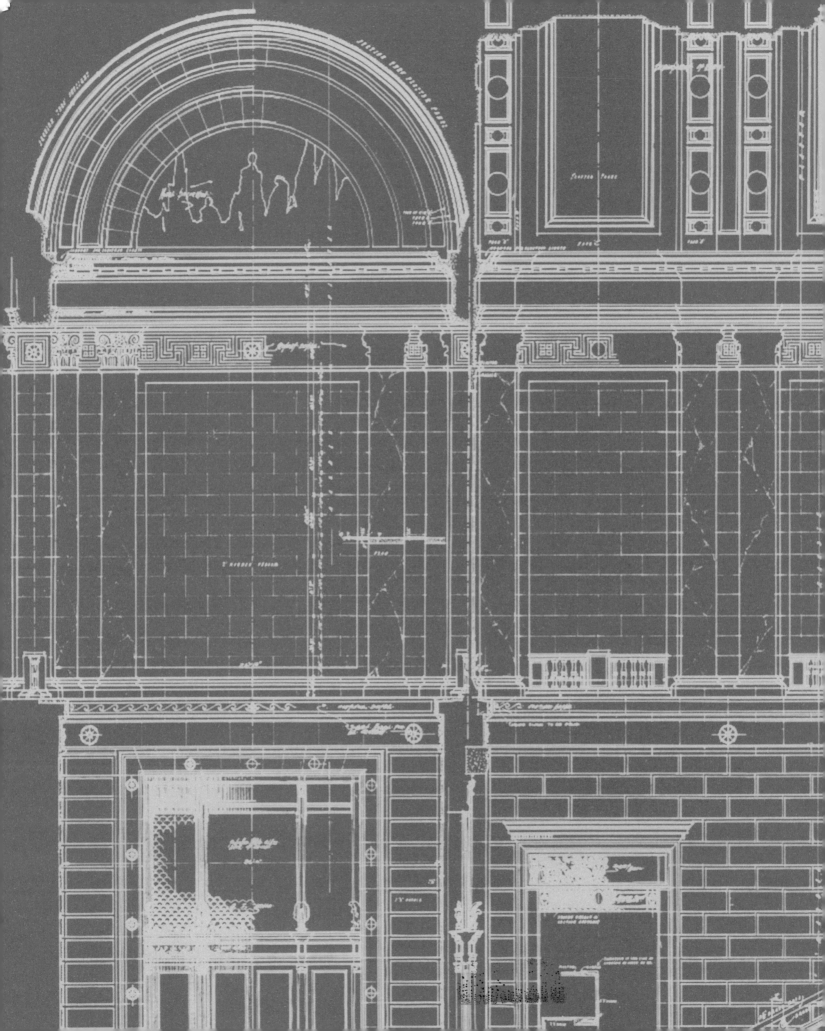